THE

VISUAL INDEX

OF

ARTISTS' SIGNATURES

AND

MONOGRAMS

THE
VISUAL INDEX
OF
ARTISTS' SIGNATURES
AND
MONOGRAMS

by

Radway Jackson
introduction by
Andrew Festing

Publishers of Fine Art Books

NEW YORK, NEW YORK

ACKNOWLEDGEMENTS

The author and publishers are grateful to the following for their assistance:

CASTLE MUSEUM NORWICH: THE WALLACE COLLECTION: FITZWILLIAM MUSEUM CAMBRIDGE: CITY OF MANCHESTER ART GALLERIES: LEICESTER MUSEUMS: THE BOOKLYN MUSEUM: NATIONAL GALLERIES OF SCOTLAND: THE NATIONAL GALLERY OF CANADA: DEPARTMENT OF THE ENVIRON-MENT: WASHINGTON NATIONAL GALLERY OF ART: NATIONAL PORTRAI GALLERY: ASHMOLEAN MUSEUM: STADT KOLN WALLRAF RICHARTZ MUSEUM: THE METROPOLITAN MUSEUM OF ART, NEW YORK: CITY MUSEUM & ART GALLERY BIRMINGHAM: CITY ART GALLERY BRISTOL: NATIONAL MUSEUM OF WALES: GLASGOW MUSEUMS & ART GALLERIES: BIBLIOTHEQUE NATIONALE: SOVRINTENDENSA ALLE GALLERIE-MILANO: ABERDEEN ART GALLERY & MUSEUM: COURTALUD INSTITUTE OF ART: IMPERIAL WAR MUSEUM: WALKER ART GALLERY, LIVERPOOL: VICTORIA AND ALBERT MUSEUM: THE LOUVRE: HENRY E. HUNTINGTON LIBRARY & ART GALLERY, CALIFORNIA: THE BRITISH MUSEUM: BERLIN NATIONAL GALLERY: CITY OF SHEFFIELD ART GALLERIES: SCOTTISH NATIONAL PORTRAIT GALLERY: NOTTINGHAM MUSEUM & ART GALLERY: THE BOWES MUSEUM: ROYAL ACADEMY OF ARTS: GUILDHALL ART GALLERY, LONDON: SPINK & SON: TATE GALLERY: SOTHEBY LTD., LONDON.

Also, special thanks to LIBRAIRIE GRUND, publishers of the Dictionnaire Benezit.

This edition published in 1991 for USA and Canada by

Cromwell Editions
43A St. Georges Square
London SW1 England

Published under license from the original publishers
W. FOULSHAM & CO. LTD.
Yeovil Road, Slough, Berks, England

Produced in England.

Contents

Preface

T HIS BOOK is intended to serve not merely as a source of information, like a dictionary, but as a practical tool for the amateur collector. The presence of a signature is often the most serious pitfall for anyone who tends to respond eagerly to the question, 'Is it signed?', without asking also, 'Who ascribed that signature?' The contemporary enthusiasm that demands a signature as the most conclusive evidence of authenticity needs to be reinforced by knowledge and experience. A reference book of signatures can give opportunities and prevent mistakes.

Previous information on the subject has been scattered and scanty. If the artist is important enough there exist monographs on his life containing signatures and facsimiles of his letters. Then there are the multi-volume dictionaries of artists, but they are often incomplete in this respect. Some museum catalogues reproduce a signature or two, but very few are as fully detailed as that of the Rijksmuseum in Amsterdam.

The owner of a picture can devote his leisure moments to researching and studying to verify one particular signature, but the collector buying at auction has only a minute or two in which to scrutinize each picture on the viewing day of the sale, then when the porter displays the example he has only a few seconds before, as he hesitates, the picture is knocked down to a more confident bidder. If he buys from a gallery he is under pressure from the gallery salesman at his elbow. In neither case does he have the resources of an art library available.

Most books on art are written from an academic point of view, the author himself being chiefly interested in pictures in famous collections. He does not particularly wish that his book should serve to assist other people to accumulate examples of his own favourite artist. Consequently photographic reproductions pay little regard to

artists' signatures, and where detail is illustrated this is usually to demonstrate a particular phase of the artists' development, or to give delight by exhibiting some stylistic splendour.

In the case of major artists, signed examples are to be seen in the public galleries and the signatures have become general knowledge. But for thousands of minor artists it is difficult for the collector to acquire a standard of authenticity, or even of identification, except by specializing in one painter and advancing his knowledge by purchasing examples. Many years ago, for instance, I was lucky enough to buy a pair of the little panels on which Henry Dawson painted landscapes when he was a coachmaker's assistant. Upon them I discovered tiny, almost microscopic signatures, which had been completely invisible under the old varnish. Knowledge of the signature coupled with identification of the style enabled me to go ahead and buy such little panels whenever the chance arose. I now have six of them. These were acquired over half a lifetime. Had I had the knowledge and information in my earlier collecting days, I might have cornered the artist's whole output of those small panels as they came, gradually and unidentified, upon the art market.

The compilation of some eight thousand signatures in one useful reference volume is intended to take the amateur collector a considerable way towards acquiring his own confidence in identification. Over the years many galleries and auction rooms have built up their own books of artists' signatures and monograms. These are kept as private commercial secrets, the knowledge each stores being intended to give its owner the edge over competitors in the salerooms.

The mere identification of a signature presents its own problems. It has of course first to be found. One begins the search in the bottom right-hand corner, then moves to the bottom left-hand corner, and then on to little unobtrusive places on tree trunks, notice boards, door lintels, tubs and barrels, but never of course in the sky. One is hardly likely to find, as in those Italian paintings of the time of Bellini, the characters floating upon a piece of crumpled paper painted on the bottom ledge at the foot of the picture. It cannot be too strongly emphasized that it is in these obvious places that a forger puts his signature bold and clear. Only a year or two ago, when Thomas Smythe paintings were fetching their highest prices, I was asked to advise down in the country about a pleasant timber waggoning painting. The team and horses

were well proportioned, moving forward in the style of De Leeuw, yet on the wagon head-board was neatly written for all to see 'T. SMYTHE'. The paint had been well matched and seemed to lie in with the tone of the picture, but an ultra-violet lamp inspection revealed disturbance of the varnish and new paint. I was not called upon to shriek the discovery aloud, but the picture could not elude the critical suspicion of the London art trade, for some time later I saw it knocked down in central London for a very small sum. Had the picture been allowed to maintain its integrity (signed or unsigned) and been presented as a De Leuw it could have found a happy home and fetched several hundreds of pounds.

Usually the artist signed his oil paintings in a neutral oil colour, but many dealers after the eighteenth century helped their collector customers to enjoy ownership by carefully writing the name of the artist in one of the bottom corners in red. It would be kind not to regard this as forgery but rather as trade attribution, giving such paintings credence for what they are. When such artists as Rubens ran their painting 'factories', it was no more necessary for the artist to put his name on a product than for a cabinet-maker or a locksmith to do so. If he did, it was rather to please himself, and only as his reputation grew, at the insistence of his client. As collecting spread among the merchant classes and the rivalry of collectors demanded signatures, dealers provided them. It is worth while therefore considering whether a signature is part of the design, and intended to be an intrinsic part of the composition, or merely to provide a name tab for the client's possession. Some painters – I think of the Norwich School and in particular Old Crome who disliked even the intrusion of figures into his landscapes – tended to avoid signatures altogether. When clients insisted on a signature, this school of painters would often sign dark on dark; the passing years have merged the two and made the signature undecipherable.

Old watercolours present a similar problem. If they have been cleaned the signature has sometimes washed into its surroundings, for these artists often signed in watercolour. Pencil and ink signatures upon them should be scrutinized very carefully. These old watercolour men were also teachers and would carry portfolios of their works to be copied by pupils, even hiring out drawings for this purpose. They would occasionally start, and sometimes finish, a pupil's drawing. Once a dealer admitted to me that he had deliberately inserted genuine

signed examples among acquired portfolios of such pupils' work to encourage buyers. I wondered if that was the limit of his deception.

The signature which is in firmest union with its work is that which is incised; when the artist has written with a sharp point into the oil paint before it is dry. This, however, is rare and usually occurs only in modern examples, but, like the sculptor's signature done in the clay to be cast in bronze, it remains as firm as is needed with the assurance of the artist's own hand. It is this assurance in the incised signature, cast in hard bronze with the number of the edition beside it, which makes the nineteenth-century statuette so attractive for those who put security of attribution foremost among the pleasures of a collection.

Quite apart from idiosyncrasies of placing a signature every artist has his own pattern of variations, as indeed have our friends, if we compare the signatures which they append to their letters over the years. Even banks require a new specimen signature for cheques after a period of time. Artists are never exceptions to human variability and a study of the changes in Corot's signature from 1833 until 1874 is instructive. The desire for accuracy has impressed itself so deeply on the art trade that on the Continent the *cachet de vente* or sale stamp is used to reinforce the signature. This, stamped upon the work of a painter like Corot, indicates a perfectly uniform signature, which makes a simple task for the forger because of its very inflexibility, and the five letters 'Corot' at the foot of a nineteenth-century painting are today the reverse of convincing.

The full name, name and surname, abbreviated surname, initials only, or monogram – all these vary, appear or disappear, often with vagaries and eccentricities. A study of them gives a power in authenticating an attribution, though we must still revert to the actual brushwork of the artist before making a final decision. In the case of paintings that have that *finesse* cultivated by the Dutch seventeenth-century master, whose paintings have no apparent brushwork, we have to depend on that subjective judgement we indicate by the term 'style'.

Consequently any dictionary of artists' signatures must be essentially a check-list, not final in itself but the key to open the door to further knowledge, which study of the artist's personal letters, his biography and the topography of his environment will provide.
The collector needs to bear in mind that if a picture

without a signature reveals the authentic brushwork of the master throughout its execution it may be worth far greater esteem than a mere average painting to which he may have quickly added his signature to make a commercial sale. When Ilya Ehrenburg showed me his collection in Moscow, I saw a Chagall which he said, had been bought in Paris for the equivalent of only 150 roubles as when it came to be exhibited certain critics expressed doubts. It lacked a signature and had no answer to that mysterious query, Provenance? The undaunted Ehrenburg sent it to Chagall himself, who promptly signed it for the great writer. 'And now,' Ehrenburg boasted, 'there is the signature. It is priceless.'

When the artist is confident in his genius and knows that his own individual spirit lives in what he executes, a signature must seem superfluous, like a name tab stuck on a relative's lapel at a family party. Until modern times the bolder and more individual the painter, the less essential his signature. Most artists have a considerable stock of works in their studios, unsold, and not to be signed except at the request of a purchaser. After the artist's death all these, of course, eventually come on the market.

A signature is one of the last additions to any work of art. If the picture has been painted in good-quality paint, the linseed oil will have hardened over the centuries and both painted picture and signature will withstand varnish solvent, so that when the painting is cleaned the signature remains. The more scientific eighteenth-century artists caught the experimental fever, with such disastrous results as Reynolds achieved. Softer varnishes were used, varnishes mixed with paint, signatures painted over soluble varnish, often *in* soluble varnish. Then in the nineteenth-century paints and varnishes were no longer made in the studio or by master colourmen, but in factories. Later in that century some pictures were varnished immediately upon completion. Consequently, with a wipe of solvent intended to remove only filthy varnish, a restorer can take away signature, date, inscription, even the last glaze from the picture surface, and have there before him an unsigned picture!

'Yes, he is a very good restorer,' remarked a dealer to me last year, 'but there is one thing about him. He won't put on a signature.'

Only the reality of practical experience can give the collector technical assurance about the relationship of the signature to the age of the picture on which it lies;

but he can soon learn to notice whether it exists above or below the varnish, whether the varnish round it has been disturbed, whether the age and palette of the paint in it is the same as that in the painting.

It is here that this dictionary can fulfil its purpose. He can check the characters, even if only one or two remain, he can identify the signature from the existing traces, bearing in mind that calligraphy varies from century to century, that there are important differences in national alphabets, an extreme case being with modern pictures by the Russian émigrés who came to Paris and wrote their signatures in Cyrillic characters. Similarly, the early Dutch and Flemish monograms are far from easy to pick out and many of them have not been identified to this day.

There are some points I should stress. They are so obvious, but they are so often ignored. Do not despise a good painting because it is unsigned. Do not discredit a picture because some enthusiast has put a later signature on it. Never lightly discard a picture merely because it has a spurious signature which gives it a false attribution.

Some years ago I acquired a picture listed as 'Italian School'. It was dirty and had some rough Italian name which could have been in charcoal, it wiped away so quickly. I was absolutely confident that it was a fine Dutch nativity scene showing the shepherds arriving at the manger. I relined it before giving it a cleaning test. When I did begin to clean it, however, away came all kinds of paint. I found myself looking at a sheep standing with a ticket in its mouth which read clearly enough: 'J. Jordaens 1593-1678. I must confess to feeling my confidence dwindle, but I did not give up. The silly grin came off that sheep's face, while the animal lay down with his head more sensibly aside, as the notice slowly disappeared into the wad of cotton wool. Now today I still have that picture, painted by Nicolaes Berchem, of the angel hovering above the shepherds and the holy family. If only I could be privileged to meet that enthusiast who knew enough of Jordaens to paint his dates on the ticket!

I look forward to using this dictionary myself. Bearing in mind the cautions I have indicated, it will be a valuable check-list for the discriminating collector, giving him opportunities and saving him much time.

STOWERS JOHNSON.

Introduction

COLLECTING pictures is no longer the preserve of the museums and the very rich. Enormously increased interest in the work of minor artists has attracted a growing number of amateur collectors, who sometimes have very limited funds at their disposal, but are increasingly well informed and anxious to broaden their knowledge. Mr Jackson is just such a collector. He has spent ten years in compiling more than 8,000 signatures, which include many examples not previously listed. His pioneer effort in what has until now been a neglected field will certainly extend the amateur's knowledge. Although dealers are already familiar with the many expensive volumes of Benezit and Thieme-Becker as a source of reference, this is the first concise record of signatures that has been made available at a price within the means of the average enthusiast.

Approximately 200,000 western artists have been recorded (excluding contemporary painters), and it would be more than a lifetime's task to find and illustrate a large proportion of their signatures. The sample here includes many of the greatest artists, whose signatures are not only essential to any general treatment, but also appear on prints, copies and even fakes. The signatures of many good minor artists, too, are reproduced, and will prove invaluable to the amateur collector, since they can be seen on work that is readily available within a reasonable price range.

Draughtsmen and watercolour artists are also represented. In the nineteenth century, particularly in England, there existed a highly developed school of watercolour painters, many of whom worked in no other medium. Their pictures were usually finished works of art in themselves and therefore signed. In the field of old master drawings, however, signatures and inscriptions are rare since the work was normally a study or cartoon for a later oil painting rather than a finished piece, and

attribution is a question for experts familiar with the style of the artist.

It is not, of course, uncommon for paintings to remain unsigned. Generally speaking, signatures are more often found on pictures painted in northern Europe than in Italy or Spain, because of the contrasting roles played by the artist in Protestant and Catholic societies. Where the artist was established as a professional craftsman who sold direct to the public, he normally signed his work. Dutch, Flemish and German painters of the seventeenth century frequently added a signature, particularly when the subject depicted was secular – landscapes, seascapes and genre scenes, as opposed to religious paintings. Peter Breughel the Younger, one of the most famous and prolific painters of peasant life, made such a habit of signing that a painting without his name is almost certainly not his.

In Catholic countries, however, the artist often worked on permanent commission to rich patrons – the Church, in many cases – and it was less necessary for him to mark his paintings with an individual sign. Such painters as Titian and Tintoretto hardly ever signed their work. Naturally, there were exceptions, and Giovanni Bellini often added his signature. Fortunately, enough documentation exists to make identification of unsigned works possible in a large proportion of cases. Account books, which are still being discovered in private and public archives, are useful in this respect. Although very few artists in Florence actually signed their paintings, the authorship of much of their work is known, because it was obligatory for them to submit their bills to the state for taxation purposes from the middle of the fourteenth century.

Whether an artist signed his work or not depends very much on his own view of his status. If, in times of low cultural appreciation, he considered himself to be an artisan of no more importance than a gilder, mason or any other skilled worker, he would have been unlikely to expect anyone subsequently to be interested in him as the creator of his painting. In the sixteenth and seventeenth centuries, there were many competent artists in England producing portraits and landscapes for aristocrats and gentry. Many of them are named in contemporary documents, but it is very difficult to sort out which artist painted what, because they seldom signed their work. Only recently has it become possible to distinguish between the work of a large number of Elizabethan and Jacobean portrait painters who failed to sign their

work, despite its high quality. Portraits were often inscribed with the sitter's name and age, as well as the date; landscape artists provided details of the view and of the patron for whom it was painted, but the authentic signature which would interest us today is rarely found. In most cases, an obvious signature on an early portrait is a later addition and cannot be trusted in view of the large number of current reattributions.

Portraiture was highly regarded in Britain during the late seventeenth and eighteenth centuries. Many of the leading exponents, however, presided over large studios which turned out portraits on a huge scale. Lely and Kneller both had many artists working under their supervision, and paintings executed by their assistants are never signed. Kneller invariably signed his own paintings, while a Lely signature is less common.

Artists with individual styles often neglected to sign their work, feeling that their unique handling of paint was sufficient identification in itself. The prolific nineteenth-century English watercolourist, Peter de Wint, signed no pictures. To the practised eye, however, his work is quickly recognizable.

Generally speaking, when a painting has been signed, the signature will be legible even after a great many years, particularly if any cleaning has been carefully carried out. An artist who went to the trouble of writing his name usually ensured that it was discernible. The idea that he may deliberately have obscured his signature is erroneous, and his choice in placing it is normally logical. He will tend to select an area of neutral background and paint his signature in such a way that it is clearly visible and legible, though not obtrusive.

While the accepted convention is to sign landscapes in one of the lower corners, the artist may choose any suitable area, such as a piece of fencing, a stone in the foreground, or the trunk of a tree. In Goya's famous portrait of the Duchess of Alba his name is written in the dust at her feet. The signature on eighteenth-century portraits can generally be found against the background near the sitter's shoulder, In seascapes, it is sometimes placed on a piece of driftwood or across the hull of a boat.

From the beginning of the Renaissance, there have been artists who signed their paintings with monograms. Perhaps the earliest and best known was Albrecht Durer. A number of other examples exist, but the artist's name

is often not known, as in the case of the 'Brunswick Monogramist'. Artists often resorted to the use of a monogram when working on a very small scale, where the writing of a long name would have been unnecessarily obtrusive. The practice commonly occurs on the small panel-pictures of northern Europe, and continued widely in the low countries in the seventeenth century, reaching its height in Victorian England, when artists frequently devised obscure and hideously complicated monograms, inspired by the nineteenth-century preoccupation with medieval art. There are few Italian examples, as the general style of painting in Renaissance Italy was on a large scale and employed a free technique which made the use of mongrams inappropriate.

Many artists included in their works some small detail by which they could be identified. Well-known instances are Henri Met De Bles, who signed with an owl, Swanenburgh (a swan), the Dutch landscape artist, Mattheus Bril (a pair of spectacles), and Lucas Cranach, who invariably employed the device of a serpent. Some artists even included their own portraits in their work. The seventeenth-century Dutch artist, Jan Steen, often depicted himself in the background of his crowded scenes of peasant life.

It is very unfortunate that a high proportion of paintings bear counterfeit signatures. Auction houses in the main art centres of the world come across them in large numbers. The old masters who were most commonly faked are perhaps the Flemish genre painter, David Teniers, and the Dutchman, Philips Wouwerman. Both artists were extremely popular in the eighteenth and nineteenth century and their usual signatures, particularly the monogram 'DT' of Teniers, were very easy to copy.

Basically, there are two kinds of fake: those which are painted with the initial intention of deceiving, when the artist not only makes a pastiche or copy after an original painting, but also reproduces the original signature (there have been many famous cases throughout history), and those which account for the majority of wrongly attributed paintings, where a forger adds the signature of a well known artist to a painting that was not previously signed, or paints over the original signature of a minor artist, adding a better known name. On a number of paintings by a minor early nineteenth century artist called Charles Morris (who painted, broadly speaking, in the style of Patrick Nasmyth), the signature was replaced with the name of Nasmyth.

Of the pictures offered to the London trade, supposedly painted by Birket Foster and David Cox, a high percentage bear a spurious signature. David Cox taught many reasonably competent amateur artists during a long lifetime of painting, with the result that there are in existence a quantity of watercolours which resemble his work closely to the untutored eye. A high proportion bear doubtful inscriptions.

Birket Foster was enormously popular in the late nineteenth and early twentieth centuries, and a number of artists copied his work with the innocent intention of teaching themselves to paint in watercolours. A lot of their drawings now bear spurious Birket Foster monograms. Another interesting example has come to light in the work of a mid nineteenth century sporting artist, Sinclair, who was given the task of copying English sporting paintings for a London dealer. He seems to have executed a large number of paintings, almost all of them straight copies of the work of painters ranging from the early eighteenth-century artist, John. Wootton, through Sartorius, to Ben Marshall and his contemporary, Charles Cooper Henderson. Many of them now bear the signature of the original artist. It is probable that none were added by Sinclair, who sold the paintings as copies. His work is easily recognizable, once you are familiar with his handling of paint. whether he was copying a formalized eighteenth century horse painting or a sophisticated early nineteenth century race horse.

Spotting the wrong signature is largely a matter of experience, and of knowing the sort of painting on which it is most likely to be found. The majority are later additions and will be evident if the faker has used a colour which is untypical of the rest of the work (this usually takes the form of very liquid paint on thick, impasto foreground). What is more, fake signatures are often remarkably unsubtle – with very black lettering that immediately arouses suspicion – and sometimes appear on top of details that are most unlikely to have been covered by the original artist.

Ultra-violet light can be a very useful aid in the detection of spurious signatures, especially where the additions are fairly recent. The light will make any fresh paint look very black. After about twenty years, added inscriptions show up less clearly, and eighteenth or nineteenth century additions are indiscernible. The use of ultra-violet light needs extreme care, as it can often give a misleading impression of the authenticity, or otherwise,

of a signature. In some cases, genuine signatures have been 'strengthened' by restorers – a reprehensible but unfortunately frequent occurrence – with the result that a perfectly good signature which may have become faint with too much cleaning appears false when it has been 'retouched'. On the other hand, a varnish has recently been invented which can be applied over new restoration to prevent its showing up against old paint.

By now, you may be wondering why we bother with signatures at all. The answer is simple: if they are genuine, they are part of the picture and, insofar as they confirm that a painter was sufficiently pleased with his work to add his name to it, they are important. It is a mistake to rely on them exclusively, however, especially when the painting is attributed to an artist whose standing is sufficiently high to render his signature worth faking.

When an expert or connoisseur is faced with the problem of identifying and authenticating a painting, he will rely heavily on his study of the brushwork. The method used by a good artist in applying paint to his canvas is easily recognizable, since each has his own technique. Surface texture, too, has always played an important part in oil painting. Here again, the hand of the artist becomes apparent, whether it is the polished style of Ingres, the vigorous style of Rembrandt, or the distinctive pointillist brushwork of Seurat. Just as a letter from a friend is easily recognizable from the handwriting, so too the brushwork of one painter is easily distinguished from that of another.

The dealer or expert who is primarily interested in paintings by established artists must obviously be able to identify their brushwork, since fakers usually concentrate on pictures by eminent painters. That still leaves many thousands of good paintings that are both collectable and rising in value. They can be found in antique shops, markets, or country salerooms. They are often undervalued, and the keen amateur who can identify the artist may sometimes buy real bargains. In this respect, Mr Jackson's book is a valuable source of information. As a practical aid, it could well help to acquire an art prize that might otherwise be lost.

ANDREW FESTING
SOTHEBY'S

Artists Signatures

AACHEN Johann Von
German 1552-1616

ACH.

ABBATE Nicollo Dell
Italian 1512-1571

ABBE Hendrik
Dutch 17th Century

FA·F.
FA FA.

ABEELE Albyn Van Den
Belgian 1835-1918

Albyn Van Den Abeele

ABELAC Pieter van
Dutch 17th Century

P·V·A

ABELS Jacobus
Dutch 1803-66

ABENT Leonhard
German 16th Century

A·A·

ABRY Leon Eugene
Belgian 1857-1905

LEON ABRY

ACHENBACH Andreas
German 1815-1910

A·Achenbach

ACHENBACH Oswald
German 1827-1905

Osw· Achenbach

ACHTERMANN Theodor
Wilhelm
German 1799-1884

ACQUA Cesare Felix Georges
Austrian 1821-1904

Cesare Dell' Acqua

ADAM Albrecht
German 1786-1862

A A

ADAM Hans
German 1535-1568

HA.

ADAM Heinrich
German 1787-1862

ADAM Tessier
French 20th Century

ADAMOFF Helena
Russian 20th Century

Adamoff
Helena

ADAN Louis Emile
French 1839-1937

L. Emile Adan

ADDA
Italian 16th Century

adda

ADELER Jules
French 19th Century

ADLER Charles
German

JULES ADLER

ADLIVANKIN Samuil Y.
Russian 1897-1966

C. Адливанкин

ADMIRAL B
Dutch 17th Century

AD

ADRIAENSENN Alexander
Dutch 1587-1661

Alex Adriaenssen f.

AA

AELST Nicolaus Van
Dutch 1527-1612

NA , N·V·A·,

NA N· K

AELST Willem Van
Dutch 1626-83

Guill. Van Aelst.

W· V· aelst

AERTSEN Pieter
Dutch 1508-75

R· R· R

AFRO Basadela
Italian 1912–1976

afro

afro

AGNEESSENS Edward Joseph
Alexander
Belgian 1842-85

Ed Agneessens

AGRESTI Livio
Italian 1550-80

Livius For Imetasois

AGRICOLA Christoph Ludwig
German 1667-1719

AGRICOLA Karl Joseph Aloys
German 1779-1852

AGUCCHI Giovanni
Italian 16th Century

G A.

AGUILI Luigi De F
Italian 18th Century

AIGON Antonin
French 1837-85

AIGUIER Louis Auguste Laurent
French 1819-65

AIKMAN William
Scottish 1682-1731

W.A.

AINMILLER Max Emmanuel
German 1807-70

AIZELIN Eugene Antoine
French 1821-1902

E^m. AIZELIN

AKEN Jan Van
Dutch 17th Century

AKEN Leo Van
Belgian 1857-1904

LEOVAN AKEN

ALAUX Francois
French 19th-20th Century

F. Alaux. AX

ALBANI Francesco
Italian 1578-1660

FA. FRA.

ALBEE Percy
American 19th-20th Century

PERCY ALBEE

ALBERTI Cherubino
Italian 1553-1615

ALBERTI Durante (Del Nero)
Italian 1538-1613

NERO.

ALBERTI Francesco
Italian 16th Century

ALBERTINELLI Mariotto
Italian 1474-1515

ALBRACHT Willem
Belgian 19th-20th Century

WILLEM ALBRACHT

ALCORTA Rodolfo
South American 19th-20th Century

R. Alcorta

ALDEGREVER Heinrich
German 1502-1558

ALDEWERELD Herman Van
Dutch 1628-69

H.3%.Alde fait

ALECHINSKY Pierre
Belgian 1927–

ALENI Tommaso
Italian 16th Century

Thomas de alente

ALENZA Y NIETO Leonardo
Spanish 1807-45

L.A.

ALEWYN Abraham
Dutch 1673-1735

AALEWYN

ALEXANDRE
see UBELSQUI Alexandre

ALFANI Domenico
Italian 1479-1553

DOMENICO FECIT

ALGARDI Alessandro
Italian 1602-54

ALGAROTTI Francesco
Italian 1712-64

ALIAMET Jacques
French 1726-88

LA'S.

ALIGNY Claude Felix Theodore
French 1859-98

ALIX Yves
French 19th-20th Century

Yves ALIX

ALKEN Samuel
English 1784-1825

S. Alken

Sam alken

ALKOCK P
Dutch 17th Century

ALLARD Hugo
Dutch 17th Century

ALLEGRAIN Gabriel
French 1733-79

ALLEGRETTI Carlo
Italian 16th Century

AC.

ALLEGRI Lorenzo
Italian 16th Century

A.C

ALLEMAND Hector
French 1809-86

Hllemand

ALLEN F.
see OUWENALLEN Folpert Van

ALMA-TADEMA Sir Lawrence
English 1836-1912

ALMELOVEEN Jan Van
Dutch 17th Century

ALTDORFER Albrecht
German 1480-1538

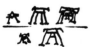

ALTDORFER Erhard
German 1512-61

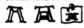

ALTMAN Natan I.
Russian 1889–1970

ALVAREZ Andres Antonio
Venezuelan 1939–

A. ALVAREZ

AMALTEO Pomponio
Italian 1505-88

Poin AMALT
ponpamal.

AMAURY-DUVAL Eugene
Ammanuel
French 1808-85

AMAURY-DUVAL

AMBERGER Christoph
German 1490-1561/2

AMEROM Cornelis Hendrik
Dutch 19th Century

AMMAN Jeremias
German 17th Century

AMMAN Jost
German 1539-91

AMSLER Samuel
Swiss 1791-1849

ANASTASI Auguste Paul Charles
French 1820-89

AUC.ANASTASI67

ANDERSON Laurie
American 1947–

ANDRE Albert
French 1869-1954

ANDRE Jules
French 1807-69

ANDREA Nicolaus
German 16th Century

ANDREA Zoan
Venetian 16th Century

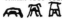

ANDREA del Sarto
see ANDREA d'Agnolo

ANDREANI Andrea
Italian 1560-1623

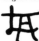

ANDREWS Lilian
English 19th Century

ANDRIESSEN Christiaan
Dutch 18th Century

CA

ANGEL Gheorghe
Romanian 20th Century

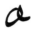

ANGEL Philips
Dutch 1616-83

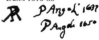

ANGELIKAHOERLE
see HOERLE Angelika

ANGELUS Michel
Italian 16th Century

ANGOLO Del Moro Battista
Italian 16th Century

MΛ M M BM.

ANKER Albert
Swiss 1831-1910

AnKer

ANQUETIN Louis
French 1861-1932

ANDRAEDT Pieter van
Dutch 17th Century

ANNENKOV Yuri Pavlovich
Russian 1889–1974

Ю. АННЕНКОВЬ

ANSDELL Richard
English 1815-85

ANSHUTZ Thomas Pollock
American

ANSIAUX Antoine Jean
French 1764-1840

ansiaux fait 1822

ANTHONISSEN Hendrick van
Dutch 1606-60

HVANTHONISSEN

ANTHONISZ Cornelis
Dutch 1499-1553

ANTIGNA Alexandre
French 1517-75

Antigna

ANTOINE de Liège
Flemish 16th Century

AF

ANTOLINEZ José
Spanish 1635-75

Jossf. ANTOLINES.F 1668.

ANTONELLO (Antonio di
Salvadore d'
ANTONELLO da MESSINA)
Italian 1430-79

*ANTONIVS
MESANESIS*

APPEL Karel
Dutch 1921–

K. appel

APPIAN Jacques Barthélemy
French 1818-98

APPIANI Andrea
Italian 1754-1817

ᴧᴠ 𝒜𝒜

AQILA Pietro
Italian 1650-92

𝑅 P. A qᵃ

ARBO Peter Nicolai
Norwegian 1831-92

P.N Arbo

ARCHIPENKO Alexander
Russian 1887–1964

ARCIMBOLDO Guiseppe
Italian 1527-93

ARDELL James Mac
Irish 1710-65

M M

ARENTSZ Arent
(CABEL)
Dutch 1586-1635

ARETIN Anna Maria
German 19th Century

(a/cs)

ARIS Ernest A
English 19th Century

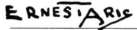

ARMSTRONG James
English 19th Century

J A

ARNOLD Jonas
German 17th Century

ARP Jean Hans
French 1887-1966

ART Berthe
Belgian 19th Century

Berfpe Art

ARTAN Louis
Dutch 1837-90

ARTAN

ARTARIA Karl
German 1792-1866

ᴀ 1811.

ARTHOIS Jacobus van
Flemish 1613-86

Jaegues d'Arthois

ARTZ David A C
Dutch 1837-90

ARTZ.

ASCH Pieter Jansz van
Dutch 1603-78

PA PvASS

ASHLEY Alfred
English 19th Century

𝒜𝒜

ASKEVOLD Anders M
Swedish 1834-1900

A. Askevold.

ASPER Hans
Swiss 1499-1571

ASPINWALL Reginald
English 1858-1900

Reginald Aspinwall

ASSELBERGS Alphonse
Belgian 19th Century

Alp. Asselbergs

ASSELIN Maurice
French 1882-1947

M. ASSELIN

ASSELYN or **ASSELIN** Jan
Dutch 1610-60

JA A A

Jean Asselin

ASSEN Jacob Walter van
Dutch 1475-1555

ASSEN Jan van
Dutch 1635-1707

*AT.23:
A:1666
J.x.A.*

ASSTEYN Bartholomeus
Dutch 17th Century

*B: Assteyn
1647*

AST Balthazar van der
Dutch 1590-1656

ATTAMA J
Dutch 17th Century

AUBE Jean Paul
French 1837-1920

AUBRY Abraham
French 1650-82

AUBRY Etienne
French 1745-81

AUBRY Pierre
French 1610-86

AUDENAERD Robert van
Flemish 1661-1743

AUDER Peter
German 16th Century

AUDRAN Benoit
French 1698-1772

AUDRAN Gérard
French 1640-1703

AUDRAN Jean
French 1667-1756

AUDRAN Karl
French 1594-1674

AUER Hildegard
German 1929–

AUGUSTIN Jean B J
French 1759-1832

AUMONT Louis AF
Danish 1805-79

AUMULLER Xaver
German 18th-19th Century

AUTREAU Louis
French 1692-1760

AUZOU Pauline
French 1775-1835

AVANZI Jacopo
Italian 19th Century

AVED Jacques A J C
French 1702-66

AVEELE Johannes van den
Dutch 18th Century

AVELIN Pierre
French 1656-1722

AVERCAMP Hendrick van
Dutch 1585-1663

AVERY Milton
American 1893–1965

AVONT Pieter van
Flemish 1600-32

AVRIL Jean Jacques
French 1774-1831

AZELT Johann
German 17th Century

BAADE Knude A
Norwegian 1808-79

BAADEN D
German 18th Century

BAANE Johan de
see BAEN Jan de

BABA Corneliu
Romanian 1906–

BABCOCK William P
American 1826-99

BABET Gheorghe
Romanian 1950–

BABUREN Theodor van Dirck
Dutch 17th Century

BACH Alois
German 1809-93

BACH Marcel
French 19th Century

BACHELIER Jean J
French 1724-1806

BACKER Adriaen
Dutch 1635-84

BACKER Jacob A
Dutch 1608-51

BACLER D'Albe
French 1761-1848

BACON Francis
British 1909–

BADALOCCHIO Sisto
Italian 1581-1647

Sisto D.F. S Dino

BADAROCCO Giovanni R
Italian 1648-1726

JRBadarocc.

BADIALE Alesandro
Italian 1623-68

BADILE Antonio
Italian 1517-60

BAELLIER Cornelius
Flemish 1607-71

Cor. D. Baellier · Se.

BAEN Jan de
Dutch 1633-1702

Johan de Baene. f
1684

BAER George
American 19th Century

George Baer

BAER Martin
American 19th Century

Martin Baer

BAERTSOEN Albert
Belgian 1866-1922

a. Baertsoen

BAES Emile
Belgian 19th Century

Emile Baes

BAES Martin
Flemish 17th Century
M.f.

BAGAZOTTI Camillo
Italian 16th Century

BAGER Johann Daniel
German 1734-1815

Johann. Daniel Bager.

BAIL Joseph
French 1862-1921

Bail Joseph

BAILLIE William
Irish 1723-92

W.B.f. WB
W Baillie
W Baillie

BAILLY David
Dutch 1584-1657

D B

D. Bailly. fecit

BAKHUYZEN Hendrick van
Dutch 1795-1860

W S. Bakhuyzen

BAKHUYZEN Ludolf
Dutch 1631-1708

BALAN Maria
Yugoslavian 1923–

Maria Balan

BALACESCU Lucia
Romanian 20th Century

LDB

BALAZS Janos
Hungarian 1905–77

Balázs Janos

BALDACCINI Cesar
French 1921–

Cesar

BALDI Lazzaro
Italian 1624-1703

LB JB

BALDUNG Grien Hans
French 1484-1545

Laz Bul + Barr. LazBal

BALEN Hendrick Van I
Flemish 1575-1632

B

H·V·BALEN:

R

BALEN Hendrick van II
Flemish 1623-61

HBH

BALESTRA Antonio
Italian 1666-1740

BIPR B. AB.f.

BALESTRIERI Lionello
Italian 19th Century

L Balestrieri

BALFOURIER Adolphe Paul
Emile
French 19th Century

Ad. Balfourier.

BALLA Giacomo
Italian 1871-1958

BALLA
BALLA

BALLENBERGER Karl
German 1801-60

R

BALTEN Pieter
Flemish 1525-98

PEETER
BALTEN

BANCK Pieter van
French 1649-97

BANDAC Maiahi
Romanian 20th Century

BANDINELLI Bartolomneo
(Baccio)
Italian 1493-1560

BAQUOY Pierre Charles
French 1759-1829

BARBARI Jacopo de
Italian 1440-1515

BARBIERE Domenico del
(Domenico Fiorentino)
Italian 1506-75

BARBIEREI Francesco
Italian 17th Century

BARBIERS Pieter
Dutch 1798-1848

BARFUSS Ina
German 1949–

BARGAS A F
Flemish 17th Century

BARILLOT Léon
French 1844-1929

BARKER Noel
British 1924–

BARKHAUS Wiesen-Huetten
Charlotte
German 1736-1804

BARLACH Ernst
German 1870-1938

BAROCCI Federico
Italian 1526-1612

BARON Henri C A
French 1816-85

BARON Théodore
Belgian 1840-99

BARRA Johannes
Dutch 17th Century

BARRIERE Dominique
French 17th Century

BARTH Carl W B
Norwegian 19th Century

BARTHOLOME Albert
French 1848-1928

BARTIUS Willem
Dutch 17th Century

BARTOLOMEO
Italian 1472-1517

BARTOLOZZI Francesco
Italian 1725-1815

BARTON W
English 19th Century

BARTSCH Adam von
Austrian 1757-1821

BARTSIUS
see BARTIUS Willem

BARY Hendrick
Dutch 1640-1707

BARYE Antoine Louis
French 1796-1875

BASAITI Marco
Italian 1470-1530

BASELEER Richard
Belgian 19th Century

BASELITZ George
German 1938–

BASQUIAT Jean Michel
American 1960–

BASSE Martin
see BAES Martin

BASSANO F G da P
Italian 1451-1592

BASSANO Jacopo (da Ponte)
Italian 1515-1592

BASSANO L da P
Italian 1557-1622

LEANDOR BASSANENSIS

BASSE Willem
Dutch 1613-72

BASSEN B van
Dutch 1590-1652

BAST Martin
see BAES Martin

BAST Pieter
Flemish 17th Century

BASTIEN-LEPAGE Jules
French 1848-84

BASTIN Mireille
Belgian 1943–

BATIST Karel
Dutch 17th Century

BATONI Pompeo Girolamo
Italian 1708-87

BATTEM Gerrit
Dutch 1636-84

BAUCHANT André
French 1873-1958

BAUDIT Amédée
Swiss 1825-90

BAUDOUIN Eugène
French 1824-93

BAUDOUIN Pierre Antoine
French 1723-69

BAUDRY Paul
French 1828-86

BAUDUIN-GRUN Hans
German 15th Century

BAUGIN Jean
French 17th Century

BAUGIN Lubin
French 1610-63

BAUR Johann Wilhelm
German 17th Century

BAXAITI Marcus
see BASAITI Marco

BAYARD Emile Antoine
French 1837-95

BAYER August von
German 1803-75

BAZILLE Jean Frédéric
French 1841-70

BAZIOTES William
American 1912–

BAZOR Lucien
French 19th Century

BEARDSLEY Aubrey
English 1872-98

BEARE George
English 18th Century

BEATTIE E
English 1845-1917

BEATRIZET Nicolaus
French 1515-65

BEAUDUIN Jean
Belgian 1851-1926

BEAUFAUX Polydore
Belgian 19th Century

BEAUFRERE Adolph M T
French 1876-1960

BEAUMONT Charles
French 1812-88

BEAUREPAIRE Louis
French 17th Century

BEAUX Cecilia
American 1855–1942

BECCARUZZI Francesco
Italian 16th Century

FB.

BECK David
Dutch 1621-56

BECKER Philipp Jacob
German 1759-1829

BECKET Isaak
English 1653-1719

BECKLES Gillian
British 1918–

BECKMANN Max
German 1884-1950

BEECHEY Sir William
English 1753-1839

BEECKMAN Audries
Dutch 17th Century

BEEL C de
Dutch 17th Century

BEELDMAKER Adriaen C
Dutch 1625-1701

BEELT Cornelis
Dutch 18th Century

BEER Arnould
Flemish 1490-1542

BEERBOHM Max
English 1872-1956

BEERNAERT Euphrosine
Flemish 1831-1901

BEERS Jan van
Belgian 19th Century

BEERSTRATEN Abraham
Dutch 17th Century

BEERSTRATEN J A
Dutch 1622-61

BEEST Sybrand van
Dutch 1610-74

BEGA Abraham
see BEGEYN

BEGA Cornelis P
Dutch 1620-64

BEGAS Karl Joseph
German 1794-1854

BEGEYN Abraham J
Dutch 1637-97

BEHAM Barthel
German 1502-40

BEHAM Hans Sebald
German 1500-50

BEICH Joachim Franz
German 1665-1748

BEJOT Eugène
French 1867-1931

BEKHTEEV Vladimir G.
Russian 1878–1971

BEL
see BELLANGE Jacques

BELHATTE Alexandre Nicolas
French 19th Century

BELIN Jean
French 1653-1715

BELLA Stefano Della
Italian 1610-64

BELLANGE Jacques
French 17th Century

BELLAVIA Marc Antonio
Italian 17th Century

BELLAY Charles A P
French 1826-1900

BELLEL F
French 1816-98

BELLENGER Georges
French 1847-1918

BELLEPLEUR Leon
Canadian 1910–

BELLEVOIS Jacob A
Dutch 1621-75

BELLI Jacques
French 17th Century

BELLINI Gentile
Italian 1429-1507

BELLINI Giovanni
Italian 1430-1516

BELLOTTO
see CANALETTO B B

BELLOWS George
American 1882–1925

BELLUCCI Antonio
Italian 1654-1726

BELLY Léon A A
French 1827-77

BELOT Gabriel
French 19th Century

BELTRAN-MASSES Féderico
Spanish 19th Century

BELTRAND Jacques
French 19th Century

BEMMEL Wilhelm von
Dutch 1630-1708

BENAZECH Charles
English 1767-94

BENDEMANN Eduard J F
German 1811-89

BENEDETTI Andries
Flemish 17th Century

BENNER Emmanuel
French 1836-96

BENNETTER John J
Norwegian 1822-1904

BENOIT Camille
French 1820-82

BENSO Giulio
Italian 1601-68

BENSTED John
British 1920–

BENT Johannes van der
Dutch 1650-90

BENT P
Dutch 17th Century

BENTHAM R H
English 19th Century

BER
see PREISTALI Andreas

BERANEK Vaclav
Czechoslovakian 1915–

BERAUD Jean
French 1849-1936

BERCHEM Claes
(or BERGHEM or Nicolaes)
Dutch 1620-83

BERCHER Henri Edonard
Swiss 19th-20th Century

BERCK H
Flemish 17th Century

BERCKHEYDE Gerrit
Dutch 1638-98

BERCKHEYDE Job
Dutch 1630-93

BERCKHOUTH G W
Dutch 17th Century

BERCKMAN Hendrick
Dutch 1629-79

BERESTEYN Claes van
Dutch 1627-84

BERGAGNA Vittorio
Italian 1884–1965

BERGE Auguste Charles de la
French 1807-42

BERGEN Dirck van
Dutch 1645-90

BERGER Ludwig von
Danish 19th Century

BERGHE I J van den
Flemish 1752-1824

BERGHE P Van den
Dutch 17th Century

BERGLER Joseph Sr
German 1718-88

BERGLER Joseph Jr
German 1753-1829

BERGMANN-MICHEL Ella
German 1896–1971

BERGMULLER Johann Georg
German 1688-1762

BERGSI Johannes
Dutch 19th Century

BERGSLIEN Knud Larsen
Norwegian 1827-1908

BERKA Johann
Bohemian 1758-1815

BERLINGHIERI C F
Italian 1596-1635

BERNAERTS Nicasius
Flemish 1620-78

BERNARD Adolphe
Belgian 19th Century

BERNARD Emile
French 1868-1941

BERNARDUS
see PINTURICCHIO
BERNARDUS

BERNIER Camille
French 1823-1902

BEROLDINGEN F von
Swiss 1740-70

BEROUD Louis
French 19th Century

BERETTINI Pietro
(da Cortona)
Italian 1596-1669

BERRUGUETE Alsonso
Spanish 1486-1561

BERTHELEMY Jean S
French 1743-1811

BERTIN F E
French 1797-1871

BERTIN Jean Victor
French 1775-1842

BERTIN Nicolas
French 1668-1736

BERTREN T
French 18th Century

BESCHEY Balthasar
Flemish 1708-76

BESCHEY Jacob A
Flemish 1710-86

BESNARD Paul Albert
French 1849-1934

BESTIEU Jean J
French 1754-1842

BETHUNE Gaston
French 1857-97

BETTINI Domenico
Italian 1644-1705

BETTOU Alexandre
French 1607-93

BEUTLER Mathias
German 16th Century

BEVERLEY William Roxby
English 1824-89

BEWICK Thomas
English 1753-1828

B

BEYER Jan de
Swiss 18th Century

BEYEREN Abraham H van
Dutch 1620-75

BEZZI Bartolomeo
Italian 1851-1925

BGIEM
see BERLINGHIERI Camillo

BIARD Pierre Noel
French 1559-1609

BIDAULD J J X
French 1758-1846

BIE Adrian de
Flemish 1593-1668

·HD·Bïe Fecit·

BIE Cornelis de
Dutch 1621-54

BIEDERMANN Johann Jakob
Swiss 1763-1830

I·I·B·

BIEFVE Edouard de
Belgian 1808-1882

BIERSTADT Albert
American 1830–1902

BIESELINGDEN C J van
Dutch 1558-1600

BILLET Pierre
French 1837-1922

BILLOTTE René
French 1846-1915

BINCK Jacob (Coloniensis)
German 1500-69

BINET Georges Jules Ernest
French 1865–1949

BINET V J BB
French 1849-1924

BINJE Frans
Belgian 1835-1900

BIRCKENHULTZ Paul
German 17th Century

P. B. F.

BIRES Mihaj
Yugoslavian 1912–1980

M. BIRES

BIRKHART Anton
German 1677-1748

A.B.S

BIRNBAUM C
German 16th Century

BISCAINO Bartolommeo
Italian 1632-57

BISCARRA G B
Italian 1790-1852

BISET Charles Emmanuel
Flemish 17th Century

BISI Fra Bonaventura
(adre Pittorino)
Italian 1610-62

PBB.

BISSCHOP Cornelis
Dutch 1630-74

C B
fe s.

C. Bisschop

Fecit 1663 .

BISSOLO P F
Italian 16th Century

Franciscus Bissolu.

BLAINE Neil
American 20th Century

N. B .

BLAIR Oswald
Australian 1900–

BLAKE William
English 1757-1827

WB.

W B Lake

BLANCHARD Jacques
French 1600-37

Blanchard.

BLANCHE Jacques Emile
French 1861-1942

J.E Blanche

BLANKERHOFF Jan T
Dutch 1628-69

Bf J @ Caklos

Gt B

E G

BLARENBERGHE Louis Nicolas
van
French 1716-94

van Blarenberghe

van Blarenberghe

van B

BLEECK Pieter van
Dutch 1700-64

RBe RBrvs. Pn Bx

P.V.B

BLEECK Richard
Dutch 1670-1733

Black

RBleec

BLEKER Dirck
Dutch 1622-72

*Jonge . Bleker f
. 1643.*

1651

BLEKER Gerrit Claes
Dutch 17th Century

CB Cleker facit 1639

BLES Hendrik
(Civelta)
Flemish 1480-1550

H.) B lef.

BLIECK Daniel de
Dutch 17th Century

D.D. Dieck 1651.
D.D.B.1651
D.D. Blieck
ANO 1657

BLIJHOOFT Jacques Zacharias
Dutch 17th Century

Z Blyhooft fe

BLIN Francis
French 1827-66

F. Blin.

BLOCK Anna Katharina
German 1642-1719

ACB.

BLOCK Benjamin von
Austrian 1631-90

Block.

BLOCK Eugene F de
Belgian 1812-93

B

Eug de Bloek

BLOCKLAND Anthonie M van
Dutch 1532-83

B 1578 B.
B 1577. B

BLOEMAERT Abraham
Dutch 1564-1651

Be Be 1561

*Bloemaert. fe.
1626*

BLOEMAERT Adrien
Dutch 1609-66

ABloemaert.

BLOEMAERT Hendrick
Dutch 1601-72

HB fe .1631.
*Hen. Bloemaert fe
1691.*

HB 1633

BLOEMEN Jan Frans
Flemish 1662-1749

FuFB.

BLOEMEN Pieter van
Flemish 1657-1720

VB VB 1700 PB

PB P.V.B.

BLOEMERS Arnoldus
Dutch 1786-1844

BLOIS Abraham de
Dutch 18th Century

BLOMAERTS Heinrich
Flemish 1755-1837

ℍB

BLOMMAERTD Maximilian
Flemish 17th Century

BLONDEEL Lancelot
Flemish 1495-1581

BLOOT Pieter de
Dutch 1602-58

BLOTELING Abraham
Dutch 1640-90

BLUMENFELD Triska
New Zealander 1927–

BOBA George
Dutch 1572-99
By courtesy of the British Museum

BOBINET Jean
French 18th Century

BOCANEGRA Pedro Atanasio
Spanish 1635-89

BOCCACCINO Boccaccio
Italian 1467-1525

BOCCIONI Umberto
Italian 1882-1916

BOCK Hans
Swiss 1550-1624

BOCK T E A
Dutch 1851-1904

BOCKMAN Gerhard
Italian 18th Century

BOCKSBERGER Johann Melchior
German 1540-89

BOCKSBERGER Melchior
German 16th Century

BODECKER Johann Friedrich
Dutch 1658-1727

BODENEHR Gabriel
Swiss 1664-1758

BODOM Erik
Norwegian 1829-79

BOE Franz Didrik
Norwegian 1820-91

BOECKHORST Johann
German 1605-68

J. A. B

BOECKLIN Johann Christoph
German 1657-1704

BOECOP M
Dutch 16th Century

BOELLAARD Margaretha Cornelia
Dutch 1795-1872

BOERNER Johann Andreas
German 1785-1862

BOETIUS Christian Friedrich
German 1706-82

BOEYERMANS Theordor
Flemish 1620-78

BOGAERT Hendricks Z.
Dutch 17th Century

BOGDANI Jacob
Hungarian 18th Century

BOGUET Nicolas Didier
French 1735-1839

BOGUSLAVSKAYA Ksenia
Russian 1892–1972

33

BOHER Francois
French 1769-1825

BOILLEY J I.
French 1796-1874

BOILLY Louis Léopold
French 1761-1845

BOILVIN Emile
French 1845-99

BOIRON Alexandre Emile
French 1859-89

BOIS Willem du
Dutch 17th Century

BOISFREMONT Charles B de
French 1773-1828

BOISSIER André Claude
French 1760-1833

BOISSIEU Jean Jacques de
French 1736-1810

BOITARD Louis Philippe
French 18th Century

BOKK Ida
German 1909–1976

BOKS Evert Jan
Dutch 19th Century

BOL Cornelis
Dutch 17th Century

BOL Ferdinand
Dutch 1616-80

BOL Pierre
Flemish 1622-80

BOLAFFIO Vittorio
Italian 1883–1931

BOLDINI Jean
Italian 1845-1931

BOLDRINI Niccolo
Italian 1510-66

BOLLONGIER Hans
Dutch 1600-44

BOLOMEY Benjamin Samuel
Swiss 1739-1819

BOLSWERT Boetius Adams
Dutch 1580-1633

BOLSWERT S A
Dutch 1581-1659

BOMBOIS Camille
French 1883–1970

BOMPARD Maurice
French 1857-1936

BONACCORSI Antonio
Italian 19th Century

BONASONE G di A
Italian 1498-1580

BONDICINI Alexandre
Italian 16th Century

BONDT Daniel de
Dutch 17th Century

BONE Sir Muirehead
Scottish 1876-
By courtesy of the Imperial War Museum

BONER J A
German 1647-1720

BONFILS Robert
French 19th Century

BONHEUR Marie Rosalie (Rosa)
French 1822-99

BONIFAZIO Natale di Girolamo
Italian 1550-90

BONNINGTON Richard Parkes
English 1801-28
By courtesy of the Wallace Collection

BONINI Gaspard
Italian 15th Century

BONNARD Pierre
French 1867-1947

BONNART Léon J F
French 1834-1923

BONNART Nicolas
French 1646-1718

BONNET Rudolph
Dutch 19th-20th Century

BONO da Ferrara
Italian 15th Century

BONONI Leonello
Italian 17th Century

BONSER Jean
Dutch 17th Century

BONVIN Francois
French 1817-87

BONZI Pietro Paolo
Italian 16th Century

BOOM Karel
Dutch 19th Century

BOONE Daniel
Flemish 1630-1700

BOONEN Arnold
Dutch 1669-1729

BOONS P van
Dutch 17th Century

BOR Paulus
Dutch 17th Century

BORCH Gérard
Dutch 1617-81

BORCHT Anton van den
Dutch 17th Century

BORCHT Hendrik van der
Dutch 1583-1660

BORCHT Hendrik
Dutch 17th Century

BORCHT Peter van der
Flemish 17th Century

BORCHT Peter van der
Flemish 1600-1633

BORDONE Paris
Venetian 1500-71

BORES Francesco
Spanish 19th-20th Century

BORESOM Abraham van
Dutch 17th Century

BORGHT Jan ver der
Flemish 18th Century

BORGIANI Orazio
Italian 17th Century

BORMAN Johannes
Dutch 17th Century

BORRAS N
Spanish 1530-1610

BORSSOM Anthonie van
Dutch 1630-77

BOS B van den
(or BOSCH)
Flemish 18th Century

BOS Jacobus
(Boss or Bassius)
Flemish 16th Century

BOSBOOM Johannes
Dutch 1817-91

BOSCH Cornelis
Dutch 16th Century

BOSCH Jerome van AA
(Hieronymus)
Dutch 1450-1516

BOSELLI Antonio
Italian 1496-1536

BOSIO Gian Antonio
Italian 17th Century

BOSS Eduard
Swiss 19th Century

BOSSE Abraham
French 1602-76

BOSSHARD Rodolphe T
Swiss 19th-20th Century

BOSSI Benigno
Italian 1727-93

BOSSIUS
see Bos Jacobus

BOSTOCK John
English 1826-69

BOTH A D
Dutch 1608-50

BOTH Dirks Z Jan van
Dutch 1618-52

BOTH Dirks Z Jan van
Dutch 1618-52

BOTTICELLI Pierre Francois
Italian 16th Century

BOTTICELLI Sandro
Florentine 1444-1510

BOTTINI Georges
French 1873-1906

BOTTSCHILD Samuel
German 1640-1707

BOUCHARDON Edme
French 1698-1792

BOUCHE Louis Alexandre
French 1838-1911

BOUCHER Francois
French 1703-70

BOUCHER Joseph Félix
French 1853-1937

BOUCHOT Francois
French 1800-42

BOUCKHORST J P van
Dutch 1588-1631

BOUDEWYNS Adriaen Frans
Flemish 1644-1711

BOULOGNE Louis Jr
French 1654-1733

BOUT Peeter
Flemish 1658-1702

BOUDEWYNS Nicolas
Flemish 18th Century

BOUDIN Eugène Louis
French 1824-98

BOURBON Isabelle Marie Louise
French 18th Century

BOUTIGNY Paul Emile
French 1854-1929

BOURGE Henri Jacques
Flemish 19th Century

BOUVIER Paul
Swiss 19th Century

BOWNESS-BURTON William
English 1851-1926

BOZE Joseph
French 1744-1826

BOURDELLE Emile Antoine
French 1861-1929

BOUDRY Alois
Belgian 19th Century

BRACQUEMOND Félix
French 1833-1914

BOURDON Pierre Michel
French 1778-1841

BOUDGUEREAU William
Adolphe
French 1825-1905

BOURDON Sébastien
French 1616-71

BOUHOT Etienne
French 1780-1862

BRADDON Paul
English 19th Century

BOURGEOIS Charles G A
French 1769-1832

BOULANGER Clément
French 1805-42

BRAEKELEER A F
Belgian 1818-1904

BOURGEOIS Du Castelet F F C
French 1767-1836

BOULARD Auguste
French 1825-97

BRAEKELEER Ferdinand
Belgian 1792-1883

BOURGOGNE Pierre
French 1838-1904

BOULOGNE Louis
French 1609-74

BRAEKELEER Henri
Belgian 1840-88

BOUSSINCAULT Jean Louis
French 1883-1943

BRAEU Claes
Dutch 17th Century

BRANGWYN Frank
English 1867-1943

FRANK BRANGWYN

BRAKENBURG Richard
Dutch 1650-1702

BRAMBILLA Ambrosius
Italian 16th Century

BRAMBINI Ambrosio
Italian 16th Century

BRAMER Léonard B
Dutch 1596-1674

L.B L.Bramer

BRANDEGEE Robert B.
American 1849–1922

Robert Brandegee

BRANDI Giacinto
Italian 1623-91

Hiac Brp.

BRANDMULLER
Austrian 18th Century

BRANDON Jacques Emile
Edouard
French 1831-97

Ed. Brandon

VENTE BRANDON 1897

BRANDT Friedrich Auguste
Austrian

BRANDT Johann Christian
Austrian 1722-95

Brandfeci A 1750

J.Ch.B.

BRAQUE Georges
French 1882-1963

BRASCASSAT Jacques Raymond
French 1804-67

Brascassat J.R.

BRASIC Janko
Yugoslavian 1906–

BRASS Italico
Italian 1870–1943

BRASSAUW Melchior
Flemish 1709-57

BRASSAUW: MELCHIOR. FECIT

BRASSER Leendert
Dutch 1727-93

B.F.

BRAUNER Victor
French 1903–1966

VICTOR BRAUNER

BRAUWERE Paschatius
Dutch 17th Century

PDB

BRAY Dirck de
Dutch 17th Century

BRAY Jan de
Dutch 1627-97

Bray 1563

Joh. Bray. 1658

BRAY Salomon de
Dutch 1597-1664

S.Bray 1635

BRAYER Yves
French 20th Century

YVES BRAYER

BREA de
French 18th Century

BREA

BREDAEL Jan Peter van
Flemish 1654-1745

J.P.van-Bredal

BREDAL Josef van
(or BREDA)
Flemish 1688-1739

J BREDA F.

BREDAEL Peter van
(or BREDA)
Flemish 1629-1719

PVB F

BREE Mathieu Ignace van
Flemish 1773-1839

Mg VanBrée 1827

BREENBERG Bartholomaus
Dutch 1599-1659

B Breenborch
c.p.

B BBf

B ft 1639, B B

BREKELENKAM Quiringh G van
Dutch 1620-68

BRENET Nicolas Guy
French 1728-92

BRENTEL Friedrich
French 1580-1651

BRENTEL Georg
French 16th-17th Century

BRESANEK Hans
German 16th Century

BRESLAU M L C
Swiss 1856-1928

BRESSLER Emile
Swiss 20th Century

BRETON Emile Adélard
French 1831-1902

BRETON J A A L
French 1827-1905

BRETSCHNEIDER Andreas
German 16th Century

BREUIL Thomas du
French 17th Century

BREUNINGK J
Dutch 17th Century

BREYDEL Frans
Flemish 1679-1750

BREYDEL Karel
Flemish 1678-1733

BREYER Jan Hendrik
Dutch 19th Century

BRIARD Gabriel
French 1729-77

BRICKDALE Eleanor Fortescue
English 19th-20th Century

BRIGHT Henry
English 1814-73

BRILL Mattheus Jr
Flemish 1550-84

BRILL Paul
Flemish 1554-1626

BRINCKMANN P H
German 1709-61

BRINI Francesco
Italian 16th Century

BRIOT Nicolas
French 1579-1646

BRIZE Cornelis
(or BRISE)
Dutch 1622-70

BROCHART Constant Joseph
French 1816-99

BROECK Crispin van den
Flemish 1524-91

BRIECK Elias van den
(or BROEK)
Dutch 1650-1708

BRODSKY Isaac I.
Russian 1884–1939

BROERS Jaspar
Flemish 1682-1716

BRONERE J de
15th Century

BRONCKHORST Gerrit van
Dutch 1637-73

BRONCKHORST Jan Gerrit van
Dutch 1603-77

BROSAMER Hans
German 1506-54

BROUGH Alan
English 19th-20th Century

BROULET Pierre André
French 1857-1920

BROUWER Adriaen
Flemish 1606-38

BROWN Cleveland
British 1943–

BROWN Ford Madox
English 1821-93
By courtesy of the Manchester City
Galleries

BROWN John George
British 1831–1913

BROWN John Lewis
French 1829-90

BRUANDET Lazare
French 1755-1804

BRUEGHEL Abraham
(Ringraf)
Flemish 1631-90

BRUEGHEL Abraham
Flemish 1631-90

BRUEGHEL Ambrosis
Flemish 1617-75

BRUEGHEL Jan
Flemish 1568-1625

BRUEGHEL Pieter
Flemish 1528-69

BRUEGHEL Pieter II
Flemish 1564-1638

BRUGGEN Jan ver der
Flemish 17th Century

BRUGGINK Jakob
Dutch 1801-55

BRUHL Carl
German 1772-1837

BRUMATTI Gianni
Italian 1901–

BRUNIN Léon de M
Belgian 19th Century

BRUSSEL Hermanus van
Dutch 1763-1815

BRUSSEL Paul Theodor van
Dutch 1754-95

BRUYN Abraham de
Dutch 1540-87

BRUYN Bartholomaeus
Dutch 1493-1553

BRUYN Nicolas de
Flemish 1565-1652

BRY Johann Theodor de
German 1561-1623

BUECKELEAR Joachim
Flemish 1530-73

BUFFET Bernard
French 1928–

BUFFET Paul
French 19th Century

PAVL BVFFET

BUGIARDINI Giuliano
(Florentinus)
Florentine 1475-1554

IVL FLO FEC.

IVL·FLO·FAC+

BUHOT Félix H
French 1847-98

BUKEN Jan van
Flemish 1635-94

BUNDSEN Jes
Danish 1766-1829

BURLIUK David D.
Russian 1882–1967

BUONARROTI
see MICHELANGELO

BURCHFIELD Charles
American 1893–1967

BURGAT Eugène
French 19th-20th Century

BURGERS Michael
Dutch 17th Century

BURGH Hippolyte van der
French 19th Century

BURGH R van
Dutch 17th Century

BURGKMAIR Hans
German 1473-1559

·H· BVRGKMAIR

BURI Max Alfred
Swiss 1868-1915

MAXBURI

BURMAN M
Dutch 19th Century

BURNAT Ernest
Swiss 19th Century

EARNEST BURNAT

BURNE-JONES Sir Edward
English 1833-98
By courtesy of the City of
Birmingham Museum & Art Gallery

BUTIN U L A
French 1837-83

BUTTNER Werner
German 1954–

BUYS Cornelis
Dutch 1524-46

BUYS Jacobus
Dutch 1724-1801

BUYTEWECH William Pietersz
Dutch 1585-1626

BYLERT Jan van
Dutch 1603-71

BYRNE Sam
Australian 1883–1978

BYRON William
English 1669-1736

CABANEL Alexandre
French 1824-89

CABANEL Pierre
French 19th-20th Century

CABAT Nicolas Louis
French 1812-93

CABEL Adrian van der
(or **KABEL**)
Dutch 1631-1705

CACHOUD Francois Charles
French 19th-20th Century

CALDER Alexander
American 1898–1976

CALLEBOTTE Gustave
French 1848-94

CALAME Alexandre
Swiss 1810-64

CALANDRUCCI Giacinto
Italian 1646-1707

CALDARA Polidoro
(Polidoroda Caravaggio)
Italian 1492-1543

CALDERARI G M Z
Italian 1600-65

CALIARI Carlo
Venetian 1570-96

**CALLANDE DE
CHAMPMARTIN** C E
French 1797-1883

CALLCOTT Sir Augustus Wall
English 1779-1844

CALLET Francoise Antoine
French 1741-1823

CALLOT Jacques
French 1592-1635

CALS Adolphe Félix
French 1810-80

CALVERT Edward
English 1799-1883
By courtesy of the British Museum

CAMASSEI Andrea
Italian 1601-48

CAMBIASO Luca
Italian 1527-85

CAMERARIUS Adam
Dutch 17th Century

CAMERON David Young
Scottish 1865-1945

CAMOIN Charles
French 1879-1965

CAMPAGNOLA Domenico
Italian 1484-1550

CAMPAGNOLA Guilio
Italian 1481-1500

CAMPANA Ferdinando
Italian 18th Century

CAMPHUYSEN D R
Dutch 1586-1627

CAMPHUYSEN G D
Dutch 1623-72

CAMPI Antonio
Italian 1536-91

CAMPION DE TERSAN C P
French 1736-1819

CANALETTO Antonio C
Venetian 1697-1768

CANALETTO Bernardo Bellotto
Venetian 1724-80

CANALLA Guiseppe
Italian 1788-1847

CANO Alonso
Spanish 1601-67

CANO DE CASTRO Manuel A M
American 19th-20th Century

CANOVA Antonio
Italian 1757-1822

ANT·CANOVA·F·A·

CANTAGALLINA Remigio
Florentine 1582-1630

CANTARINI Simone
Italian 1612-48

CANTIUS D
see DILLIS Cantius von

CANUTI Domenico M
Italian 1620-84

CAP Constant Aime Marie
Belgian 19th Century

CAPITELLI Bernardino
Italian 1589-1639

BCF.

CAPRIOLI Aliprando
Italian 17th Century

CARAGLIO Giovanni Jacopo
Italian 1500-70

CARATIUS
see CARRACEI Annibale

CARAVAGGIO Michelangelo
Merisi
Italian 1562-1609

CARBONATI Antonio
Italian 19th Century

CARDI Lodovico
Florentine 1559-1613

CARDON A A J
Flemish 1739-1822

CARDUCCI Vicente
Florentine 1578-1638

VINCEINT?
CARDVCH?

CARESME Jacques Phillippe
French 1734-96

CARESMES?:

CARLEGLE Charles Emile
Swiss 1877-1940

Carlègle

CARLETH Mario
Italian 20th Century

CARLONE G B
Italian 1592-1677

CARLONE Marco
Italian 1742-96

CARO Baldassare de
Italian 18th Century

CAROLUS-DURAN C E A D
French 1838-1917

CARON Antoine
French 1521-99

CAROSELLI Angelo
Italian 1585-1653

CAROTO Giovanni Francesco
Italian 1480-1555

CARPACCIO Vittore
Italian 1450-1525

VICTORIS
CARPATIO
VENETI OPVS.

CARPEAUX Jean Baptiste
French 1827-75

CARPENTIER Evariste
Belgian 19th Century

CARPI Ugo da
Italian 1480-1520

VGO. ℭ.

CARPIONI Giulio
Italian 1611-74

CARRA Carlo
Italian 19th-20th Centuries

c.carrà

CARRACCI Agostino
Italian 1557-1602

CARRACCI Annibale
Italian 1560-1609

CARRACCI Antonio Marciale
Italian 1583-1618

CARRACCI Francesco
Italian 1559-1622

CARRACCI Lodovico
Italian 1555-1619

CARRE Abraham
Dutch 1694-1758

CARRE Franciscus
Dutch 1630-69

CARRE Michael
Dutch 1657-1747

CARRENO DE MIRANDA Don
Juan
Spanish 1614-85

CARRIERA Rosalba
Venetian 1675-1757

CARRIERE Eugène
French 1849-1906

CASANOVA Giovanni Battista
Italian 1730-95

CASEMBROT Abraham
Dutch 17th Century

CASIMIR Laurent
Haitian 1928–

CASOLANO Alessandro
Italian 1552-1606

Alex Casola.

CASORATI Felice
Italian 19th-20th Century

.F. CASORATI.

CASSATT M
American 1844-1926

CASSE René Marie Roger
French 19th-20th Centuries

CASSIERS Hendrick
Belgian 19th-20th Centuries

CASTAN Gustav Eugène
Swiss 1823-92

CASTELEYN Abraham
Dutch 17th Century

CASTELLAN Antoine Laurent
French 1772-1838

CASTELLO Bernardo
Italian 1557-1629

CASTELLUCI Salvo
Italian 1608-72

CASTELNAU Alexandre Eugène
French 1827-94

CASTERA Bazile
Haitian 1923–65

CASTIGLIONE Guiseppe
Italian 19th-20 Centuries

CASTIGLIONNE Giovanni
Benedetto
Italian 1616-70

CASTRES Edouard
Swiss 1838-1902

CAVALLIER Louis
French 19th-20th Centuries

CAVEDONE Giacomo
Italian 1577-1660

CAXES Eugenio
Spanish 1577-1642

CAZES Pierre Jacques
French 1676-1754

CAZIN Jean Charles
French 1841-1901

CELSO Lagar
Spanish 19th-20th Centuries

CENTO IB da
see PASQUALINI Johann Battista

CEREZO Mateo
Spanish 1635-85

CERIA Edmond
French 1884-1955

CERQUOZZI Michelangelo
(delle BATTAGLIE or delle
BAMBOCCIATE)
Italian 1602-60

CERVERA B de
Spanish 17th Century

CESAR
see BALDACCINI Cesar

CESARI Giuseppe
(Cavaliere d'Arpino)
Italian 1560-1640

CESPEDES Pablo de
Spanish 1538-1608

CEULEN Cornelis Hanssens
(Jonsonvan)
Dutch 1593-1664

CÉZANNE Paul
French 1839-1906

CÉZANNE Paul
French 1839-1906

CHABAS Paul
French 1869-1937

CHAGALL Marc
French 19th-20th Centuries

CHAIGNEAU Jean Ferdinand
French 1830-1906

CHALLE Noël
French 18th Century

CHALLES Charles Michel Ange
French 1718-78

CHALON Alfred Edward
English 1780-1860

CHAMBERS George Sr
English 1803-40

CHAMPAIGNE Philippe de
Flemish 1602-74

CHAMPMARTIN E.
see CALLANDRE de
CHAMPMARTIN

CHAPELAIN-MIDY Roger
French 20th Century

CHAPLIN Charles
French 1825-91

CHAPPEL Edouard
French 19th-20th Centuries

CHAPRON Nicolas
French 1612-56

CHARDIN Jean Baptiste Siméon
French 1699-1779

CHARLET Franz
Belgian 1862-1928

CHARLET Nicolas Toussaint
French 1792-1845

CHARLIER Jacques
French 18th Century

CHARLOT Louis
French 1878-1951

CHARMIER J C
French 17th Century

CHARTIER H G J
French 1859-1924

CHAS Laborde
French 1886-1941

CHASE William M.
American 1849–1916

CHASSERIAU Théodore
French 1819-56

CHAUVEAU Francois
French 1613-76

CHAUVIER DE LEON Ernest
Georges
French 19th-20th Centuries

CHAVENNES Alfred
Swiss 1836-94

CHAZAL Charles Camille
French 1825-75

CHEBOTAREV Konstantin K.
Russian 1892–1974

CHECA Y SANZ Ulpiano
Spanish 1860-1916

CHEDDEL Q P
French 1705-62

CHELMINSKI Jan
Polish 19th-20th Centuries

CHÉRET Jules
French 1836-1933

CHERON Louis
French 1660-1715

CHESHER A.W.
British 1895–1972

CHESNAU Nicolas
French 16th Century

CHEVREUSE M C L de A
French 1717-67

CHIA Sandro
Italian 1946–

CHIA

S. Chia

CHIARI Fabrizio
Italian 1621-95

F C.

CHIESA Pietro
Swiss 19th-20th Centuries

P.CHIESA

CHIGOT E H A
French 1860-1927

CHINTREUIL Antoine
French 1816-73

CHIRICO Giorgio de
Italian 19th-20th Centuries

g. de Chirico

CHOCARNE-MOREAU Paul
Charles
French 1855-1931

CHOCARNE-MOREAU

CHODOWIECKI Daniel Nicolas
German 1726-1801

D.Chodowieckl

D.C.

CHOFFARD Pierre Phillippe
French 1730-1909

CHOLLET Marcel
Swiss 19th-20th Centuries

CHOMETON Jean Baptiste
French 18th-19th Centuries

CHRIST Johann Friedrich
German 1700-56

CHRISTO
see JOVACHEFF Christo

CHRISTUS Pietro
Belgian 15th Century

⊹ PETRVS·XPĪ·
ME·FECIT·IX̄I·

CHUDANT Jean Adolphe
French 19th-20th Centuries

Ad.Chadant

CIAMBERLANO Luca
Italian 1580-1641

CIARDI Guglielmo
Italian 1843-1917

G. CjARDI.

CIGNANI Carlo
Italian 1628-1719

G. CI.

C.Cig:.

CIPRIANI Giovanni Battista
Italian 1727-85

GB⁰Cipr.

Cipriani

CIRCIGNANO Niccolo
(Il Pomarancia)
Italian 1519-91

A.Poma.

CLAEISSINS Pieter
Flemish 17th-18th Centuries

Petrus Claeis
fecit

CLAESSENS Jacobs
Dutch 16th Century

JACOB· CLAESZ
TRAIECTENSISF.

CLAESZ Pieter
Dutch 1590-1661

CLAIRIN Georges Jules Victor
French 1843-1919

G.Clairin

CLAM-GALLAS Christian
German 18th Century

CLARA José
Spanish 19th-20th Centuries

*José
Clara*

CLARIS Antoine Gabriel Gaston
French 1843-99

Gaston Claris

CLAUDE Lorrain
see GELEE

CLAUDOT Jean Baptiste Charles
French 1733-1805

Claudotjee

CLAUS Emile
Belgian 1848-1924

*Emile
Claus*

CLAUSEN George
English 1852-1912

CLAUSEN

CLAYS Jean Paul
Belgian 1819-1900

P.J Clays

CLEMENT Félix Auguste
French 1826-88

FÉLIX
CLEMENT

CLERCK Hendrick de
Flemish 1570-1629

·H·de·CLerck·

CLERGE Auguste Joseph
French 19th-20th Centuries

Clergé

CLESINGER Jean Baptiste
Auguste
French 1814-83

J. Clesinger.

CLEVE Hendrick van
Flemish 1525-89

CLEYNHENS Théodore Joseph
Flemish 19th Century

Cleynhens

CLOUET Francois
(Jenannet or Jan(n)et)
French 1522-72

IANNET

CLYFFORD
see STILL Clyfford

COCHIN Charles Nicolas
French 1715-90

NCf, N,
N.

COCK César de
Flemish 1823-1904

Cesar De Cock

COCK Pieter
Flemish 1502-1550

COCK Xavier de
Flemish 1818-96

Xavier De Cock

COCKSON Thomas
English 1591-1636

COCLERS Jean Baptiste Bernard
Flemish 1741-1817

L.B.C.

COCLERS Philippe
Flemish 1660-1736

P. Coclers fec:

COCTEAU Jean
French 1889-1963

Jean

CODDE Pieter Jacobs
Dutch 1599-1678

Podde

COELLO Alonso Sanchez
Spanish 1515-1590

*Sanchez.F
.A.*

CELLO Claudio
Spanish 1630-93

CLAVDIO.
COELLO.
F
C Coello

COENE Jean Henri de
Flemish 1798-1866

Henri Decoene.

COGELS Joseph Charles
Flemish 1786-1831

COGNIET Léon
French 1794-1880

COGNIET Marie Amelie
French 1798-1869

COIGNARD Louis
French 1810-83

COL F
see COLLANTES Francisco

COL Jean David
Belgian 1822-1900

COLAS Alphonse
French 1818-87

COLASIUS Johan Georg
Dutch 18th Century

COLBENSIUS Etienne
Austrian 16th-17th Centuries

COLE Charles Frederick
Australian 1875–1959

COLI Giovanni
Italian 1643-81

COLIN Gustave Henri
French 1828-1910

COLKETT Samuel David
English 1806-63

COLLAERT Hans Baptist
Flemish 16th-17th Centuries

COLLANTES Francisco
Spanish 1599-1656

COLLART Marie
Belgian 19th-20th Centuries

COLLIER Evert
Dutch 18th Century

COLLIGNON Jean Baptiste
(Francois)
French 1609-57

COLLIN Louis J R
French 19th-20th Centuries

R· COLLIN

COLLINGWOOD William
Gersham
English 1819-1903

COLOMBANO Antonio Maria
Italian 16th-17th Centuries

COLOMBEL Nicolas
French 1644-1717

COLOMBINI Cosmos
Italian 18th-19th Centuries

COLOMBO Aurelio
Italian 18th-19th Centuries

COLONIA Adam
Dutch 1634-85

COLONIA Adam Louisz
Flemish 1574-1651

COLSON Guilaume Françoise
French 1785-1850

COMMERRE Léon François
French 1850-1916

COMIN Joan
Italian 17th Century

COMITIBUS Bernardinus de
see CONTI Bernardine dei

COMPAGNO Scipione
Italian 1624-80

COMPE Jan Ten
Dutch 1713-61

CONCA Sebastiano
Italian 1679-1764

CONCHILLOS y Falco Juan
Spanish 1641-1711

CONDO George
American 1957–

CONEGLIANO Giovanni Battista
da
Italian 15th Century

CONGIO Camillo
Italian 17th Century

CONGNET Gilis
Dutch 1538-99

CONINCK David de
Flemish 1636-99

CONINCK Pierre Louis Joseph de
French 1828-1910

CONINXLOO Gillis van
Flemish 1544-1607

CONINXLOO Jan Van
Flemish 15th Century

CONJOLA Carl
German 1773-1831

CONSAGRA Pietro
Italian 1920–

CONSTABLE John
English 1776-1837

CONSTANT Benjamin Jean Joseph
French 1845-1902

CONTARINI Giovanni
Italian 1549-1604

CONTEL Jean Charles
French 1895-1928

CONTI Bernardine Dei
Italian 1450-1525

COOG
see KOEGHE Abraham de

COOHGHEN Leendert van
Dutch 1610-81

COOK Beryl
British 1927–

COOPER Abraham
English 1787-1868

COOPER Alexander
English 1605-60

COOPER Edward
English 18th Century

COOPER George
English 20th Century

COORNHERT Dirk Volkertsz
Dutch 1519-90

COORNHOUSE Jacques van den
Flemish 16th Century

COORTE Adriaen
Dutch 1685-1723

COOSEMANS Alexander
Flemish 1627-89

COOSEMANS Joseph Théodore
Belgian 1828-1904

COOTWICX Jurriaan
Dutch 18th Century

J Cwf.

COPLEY Bill
American 1919–

c p ل y

COPE Charles Vest
English 1811-90

COQUES Gonzales
Flemish 1614-84

GONSALES·F.

CORBUTT Charles
English 18th Century

CORMON Fernand A P
French 1845-1924

F.Gourron

CORNEILLE Jean Baptiste
French 1649-95

JC sculp

CORNEILLE Claude
French 16th Century

CORNEILLE Guillaume
Belgian 1922–

Corneille

CORNEILLE Michael
French 1642-1708

M Corneille.

CORNELIS van Gouda
Dutch 16th Century

CG.F.

CORNELISZ Cornelis van
(Haarlem)
Dutch 1562-1638

 , CH,

, (C.mel.,

CORNELISZ Jacob van
(d'Amsterdam)
Dutch 1477-1533

IAA A

CORNELISZ Lucas C de Kok
Dutch 1493-1552

CORNELIUS Peter
German 1783-1867

P .P .

CORNELL Joseph
American 1903–1972

Joseph Cornell

CORNET Jacobus Ludovicus
Dutch 1815-82

JL Cornet f

CORONA Jacub Lucius
(Transilvanus)
Russian 16th Century

IT. IT.

CORONA Leonardo
Italian 1561-1605

COROT Jean Baptiste Camille
French 1796-1875

Corot . C.C.

COROT.

C Corot.

COROT.

CORREA Diego
Spanish 16th Century

Corres

CORREGIO Antonio Allegri
Italian 1494-1534

CORT Cornelis
Dutch 16th Century

C. C.

CORT Hendrick Frans de
Dutch 1742-1810

cHenri De Cort .

CORTBEMDE Balthasar van
Flemish 1612-63

B.V.CORTBEMDE

CORTE Franceso de la
Spanish 17th Century

F F

CORTE Juan de la
Spanish 1597-1660

H DE Cort.

COSTA Lorenzo
Italian 1460-1535

COSTA
LAVRETIVS

COSWAY Maria C L C
English 1759-1838

Maria C del.

COSWAY Richard
English 1742-1821

CR

COSYP
Flemish 17th Century

Co/yp.f.

COT Pierre Auguste
French 1837-83

COTELLE Jean
French 1607-76

COTMAN John Sell
English 1782-1842

COTMAN Miles Edmund
English 1810-58

COTTET Charles
French 1863-1924

COUBINE Othon
Czechoslovakian 19th Century

COUDER Jean A R
French 1808-79

COUDER Louis C A
French 1790-1873

COURANT Maurice F A
French 1847-1925

COURBET Gustave
French 1819-77

COURDOUAN Vincent J F
French 1810-93

COURT Catherine A de la
Dutch 18th Century

COURT Johannes F de la
17th Century

COURTENS Franz
Belgian 19th Century

COURTIN Jacques François
French 1672-1752

COURTOIS Gustave C E
French 1853-1924

COURTOIS Jacques R
French 1620-76

COUTAUD Lucien
French 20th Century

COURTURIER Philibert Léon
French 1823-1901

COUTURE Thomas
French 1815-79

COX David
English 1783-1859

COXIE Michael
Flemish 1499-1592

COYLE Carlos Cortes
American 1871–1962

COYPEL Antoine
French 1661-1722

COYPEL Charles A
French 1694-1752

COYPEL Noël
French 1628-1707

COYPEL Noël Niccolas
French 1690-1734

COZENS Alexander
English 1717-86

COZENS John Robert
English 1752-97
By courtesy of the City of
Birmingham Museum and Art
Gallery

CRABBELS Florent Nicolas
Flemish 1829-96

CRABETH Adrian P
Dutch 1553-1581

CRABETH W P
Dutch 16th Century

CRAEN Laurens
Dutch 1655-64

CRAESBEECK Joos van
Flemish 17th Century

C B

CRAEY Dirck
Dutch 17th Century

CRANACH Lucas
German 1472-1553

CRAPELET Louis A
French 1822-67

Am-Crapelet

CRAWHALL Joseph
English 1861-1913

J. Crawhall.

CRAYER Caspar de
Flemish 1584-1669

D.C.
DC.

CRESPI Daniele
Italian 1590-1630

DCrespi

CRESPI Giovanni Battista (il
Cerano)
Italian 1557-1633

M.D.C.
EDEBAT

CRESWICK Thomas
English 1811-69

CRETI Donato
Italian 1671-1749

Creti-D-

CREUTZBERGER Paul
German 16th Century

CREUTZFELDER Johann
German 1570-1636

CROISSANT Jean
Flemish 16th Century

CROIX Pierre F de la
French 1709-82

CROME John
English 1768-1821

Crome

CROOS Anthony J van dew
Dutch 17th Century

N.CROOS.F.

CROSBY Caresse
American 19th-20th Centuries

CROSSLEY Ralph
British 1884–1966

R. Crossley

CROTTI Jean
French 1878-1927

Jean Crotti

CRUGER Théodore
German 17th Century

J.C.

CRUIKSHANK George
English 1792-1878

CRUYL Lievin
Belgian 1640-1720

CSIMIN Josef
Hungarian 1920–

CUERENHERT Dirck V
Dutch 1522-90

CUMPATA Alexandru
Romanian 20th Century

CURRY John Steuart
American 1897–1946

CURTI Bernardino
Italian 17th Century

CURZON Paul Alfred de
French 1820-95

CUSTODIS François
German 18th Century

CUSTOS Raphael
German 1590-1651

CUYLENBORCH Abraham van
Dutch 1620-58

CUYP Abraham Gerritsz
Dutch 17th Century

CUYP Aelbrecht
Dutch 1620-91

CUYP Benjamin G
Dutch 1612-52

CUYP Jacob Gerritsz
Dutch 1594-1651

CZECHOWICZ Simon
Polish 1689-1775

DABLER Antoine
French 16th Century

DABOS Laurent
French 1761-1835

DADD Richard
English 1819-87

R.Dadd

DADDI Bernardo
Italian 1512-70

DAEGE Eduard
German 1805-83

DAEYE Hippolyte
Belgian 19th-20th Centuries

DAGNAUX Albert M
French 19th-20th Centuries

DAHL Johan C C
Norwegian 1788-1857

DAHLSTEIN August
German 18th Century

DALE François van
Dutch 17th Century

DALE Hans
Flemish 16th Century

DALEM Hans van
Flemish 17th Century

DALEN Cornelis van
Dutch 17th Century

DALENS Dirk
Dutch 1600-76

DALI Salvador
Spanish 20th Century

DALLAIRE Phillippe
Canadian 1916–1965

DALLINGER VON DALLING
A J
Austrian 1783-1844

DALL'OCA Bianca Angelo
Italian 1858-1930

DAMERON Emile Charles
French 1848-1908

DAMOYE Pierre E
French 1847-1916

DANCE George
English 1741-1825
By courtesy of the National
Portrait Gallery London

DANLOUX Henri P
French 1753-1809

DANVIN Victor M F
French 1802-42

DARAGNES Jean G
French 1886-1950

DARAGNES

DARDANI Antonio
Italian 1677-1735

DARET Jean
Flemish 1613-68

DARET DE CAZENEUVE Pierre
French 1604-78

DARONDEAU Stanislas HB
French 1807-41

DASSONNEVILLE Jacques
French 17th Century

DASVELDT Jan
Dutch 1770-1850

I D.

DAUBIGNY Charles F
French 1817-78

DAUBIGNY Karl Pierre
Fench 1846-86

DAUCHEZ André
French 1870-1943

d'AUDELIN Charles
Canadian 1920–

DAUMIER Honoré
French 1808-79

55

DAUVERGNE Louis
French 1828-99

DAUZATS Adrien
French 1804-1868

A DAUZATS

DAVID Antonio
Italian 17th Century

DAVID Charles
French 17th Century

DAVID Hermine
French 19th-20th Century

DAVID Jacques Louis
French 1748-1825

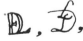

DAVID Jérôme
French 1605-70

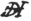

DAVID Louis
French 1667-1718

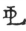

DAVID Ludovice
Swiss 1648-1730

David.

DAVIDSON Ezechiel
Dutch 18th Century

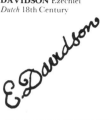

DAVIDSON Jo
American 19th-20th Centuries

Jo DAVIDSON

DAVIE Alan
British 1920–

Alan Davie

DAVIES Thomas
English 1737-1812
By courtesy of the National
Portrait Gallery London

Thomas Davies

DAVIS Stuart
American 1894–1964

Stuart Davis

DAWANT Albert Pierre
French 1852-1923

A·Dawant.

DEBAT PONSON Edouard
Bernard
French 1847-1913

E. DEBAT- PONSAN

DECAMPS Gabriel A
French 1803-60

DECAMPS Maurice Alfred
French 1892–1896

DECANIS Théophile Henri
French 19th Century

DECHENAUD Adolphe
French 1868-1929

A.Déchenaud.

DE CILLIA Enrico
Italian 1910–

de Cillia

DECKER Coenraet
French 1651-1709

De, D,
DER

DECKER Cornelis G
Dutch 17th Century

C Decker
CD

DECKER Frans
Dutch 1684-1751

F DECKER.

DECKER Jan W
Dutch 1553-1613

DEFRANCE Leonard
Flemish 1735-1805

DEFREGGER Franz von
German 19th Century

DEGAS Hilaire Germain Edgar de
Gas
French 1834-1917

Degas,

Degas.

DEGOUVE de NUNQUES
William
French 1867-1935

WD.
de
N

WD.
de
N

DEHODENCQ Edme Alexis Alfred
French 1822-82

Dehodencq
alfred

DEINEKA Alexander A.
Russian 1899–1969

АД

DE KOONING Willem
American 1904–

L Kooning

DELACROIX Ferdinand Victor
Eugene
French 1798-1863

Eug. Delacroix

EUG· DE LA CROIX

Eug. Delacroix

E. D.
Eugène Delacroix

DELANOY Hippolyte Pierre
French 1849-99

Delanoy

hippolyte

DELAROCHE Charles Ferdinand
French 19th Century

de La Roche

DELASALLE Angèle
French 1867-1938

A. Delasalle

DELAUNAY Jules Elie
French 1828-91

ELIE DELAUNAY-

DELAUNEY Robert
French 1885-1941

R. delauney

DELEN Dirk van
Dutch 1605-71

dedelen
D. D.
D.V.DELEN

DELFF Cornelis Jacobsz
Dutch 1571-1643

DELFF Jacob Wilemz
Dutch 1619-61

fecit.

Jacobus Delfins

DELFF Willem Jacobsz
Dutch 1580-1638

fecit

Delff

DELFOS Abraham
Dutch 1731-1820

ADfecit

DELGADO Pedro
Spanish 16th Century

PDelgado

DELIN J J N
Flemish 1776-1811

J. Delin

DELOBE François Alfred
French 1835-1920

A. Delobbe

DELORME Pierre C F
French 1783-1859

Delorme

DELPY Hippolyte Camille
French 1842-1910

H.C.Delpy.

DELUERMOZ Henri
French 1876-1943

Deluermoz

DEMARNE Jean Louis
French 1744-1829

De Marne

DEMARTEAU Gilles
Flemish 1729-76

DEMONT Adrien Louis
French 1851-1920

Adrien Demont

DEMONT-BRETON Virginie
French 1859-1935

Virginie Demont-
-Breton

DEMORY Charles Théophile
French 1833-95

CH.DEMORY

DEMUTH Charles
American 1883–1935

C. Demuth

DENANTO Francesco
Italian 15th Century

DI N

DENIS Maurice
French 1870-1943

Maurice Denis,

MAUD,

MAU.DENIS

MAV.D

DENIS Simon J A C
Flemish 1755-1813

D.

Denis.

DENNER Balthazar
German 1685-1749

Denner feci B.

DENNEULIN Jules
French 1835-1904

J. Denneulin

DENON Vivant Dominique
French 1747-1825

DVF.

DENTE Marco (da Ravenna)
Italian 16th Century

R.

DEPRAETERE Henri
Belgian 19th Century

E.DE PRATERE

DERAIN André
French 1880-1954

DERICKX Louis
Belgian 1835-95

DE ROCCO Federico
Italian 1918–1962

DERTINGER Ernst
German 1816-65

DERUET Claude
(or DERVET)
French 1588-1662

DESANGIVES Nicolas
French 16th Century

DESAVARY Charles Paul
French 1837-85

DESBOUTIN Marcellin Gilbert
French 1823-1902

DESBROSSES Jean Alfred
French 1835-1906

JEAN DESBROSSES.

DESCAMPS G D J
French 1779-1858

G. DESCAMPS

DESCHAMPS Louis Henri
French 1846-1902

DESCOURS Michel Hubert
French 1707-75

DESFRICHES A Thomas
French 1715-1800

DESGOFFE Blaise A
French 1830-1901

DESHAYS Jean Baptiste Henri
French 1729-65

DESNOVER François
French 19th-20th Century

DESPLAU Charles
French 1874-1946

DESPORTES Alexandre François
French 1661-1743

DESVALLIERES Georges
French 1861-1950

DETAILLE Jean Baptiste Edouard
French 1848-1912

DETHIER Hendrik
Dutch 17th Century

DETREZ Ambroise
French 1811-1863

DETTMANN Ludwig Julius
Christian
German 19th-20th Centuries

DEUREN D van
Dutch 17th Century

DEVAMBEZ André V E
French 1867-1943

DEVEDEUX Louis
French 1820-74

L.DEVEDEUX

DEVEMY Louis Joseph
French 1808-74

L.DEVEMY

DEVERIA A J J M
French 1800-57

DEVETTA Edoardo
Italian 1912–

devetta

DEVILLY Louis Theodore
French 1818-86

T.Devilly

DEVIS Anthony
English 1729-1816

At.Devis

DEVIS Arthur William
English 1762-1822

ADevis

DEVOSGE François
French 1732-1811

fDevosges.

DEWING Thomas Wimer
American 1851–1938

T.W. Dewing

DEYRIEUX Georges
French 1820-68

G.DEYRIEUX

DEYROLLE Theophile Louis
French 19th Century

HDeyrolle

DIAMANTINI Guiseppe
Italian 1621-1705

FGDIAMA

DIAZ Gonzalo
Spanish 16th Century

GDiaz.

DIAZ DE LA PENA Narcisse Virgile
French 1807-76

N·DIAZ

N.Diaz.

N.Diaz

N.D-

DICHTEL Martin
German 16th Century

MDf

DICKSEE Sir Frank Bernard
English 1853-1928

FRANK DICKSEE

DICKSON James
English 1887-1914

D. James

DIDIER Martin
French 16th-17th Centuries

MD,

MD,

M·D·P·P,

M.DI .

DIDIER-POUGET William
French 1864-1959

Didier-Pouget

DIELMAN Pierre Emmanuel
Belgian 1800-58

P.E.D.

DIEPENBEECK Abraham van
Flemish 1596-1675

BC, B,
AB, D.

DIEPRAAM Abraham
Dutch 1622-70

Diepraam.

AD. D.

DIERCKX Pierre Jacques
Belgian 19th Century

Dierckx

DIEST Adriaen van
Dutch 1655-1704

Diest

DIEST Willem van
Dutch 1610-73

WVDIEST

DIETRICH C W Ernest
German 1712-74

Dietricyf

Cg Dietricy.

CWED.

DIETRICH Johann Georg
German 1684-1752

D.Dietrig.

DIGNIMONT André
French 1891-1965

dignimont

DILLIS Cantius von
German 1785-1856

Cantius D.

DILLIS Georg van
German 1759-1841

DILLON Frank
English 1823-1909

F. Dillon.

DITTENBERGER Gustav
German 1794-1879

DIX Otto
German 19th-20th Century

DIXON Charles
English 1872-1934

Charles Dixon

DIXON Charles Thomas
English 19th Century

DO Giovanni
Italian 17th Century

JD o-p-.

DOBSON Frank
English 1889-1963

Frank Dobson/45.

DOBSON William
English 1610-46
By courtesy of the City of
Birmingham Museum & Art Gallery

Guliet Dobson.

DOCLEAN Sofia
Yugoslavian 1931–

Doclean Sofia

DOES Jacob van der
Dutch 1623-73

DOES Simon van der
Dutch 1653-1717

DOESBURG Theo van
Dutch 1883–1931

DOLCI Carlo
Italian 1616-86

C Dolci.

DOLENDO Zacharias
Dutch 17th Century

DOLLMAN John Charles
English 1851-1934

J. C. Dollman

DOMERGUE Jean Gabriel
French 1889-1962

Jean Gabriel Domergue

DONCK G van
Flemish 1610-40

Gonck.

DONCKER Herman M
Dutch 1620-56

Domker

HD

DONCRE G D J
French 1743-1820

D. Doncre

DONGEN Kees van
French 1877-1968

van Dongen

DONKER Pieter
Dutch 1635-68

DONNE Walter
English 19th-20th Centuries

·WALTER DONNE·

DONTONS Paul
Spanish 1600-66

PDontons.

DOOMER Lambert
Dutch 1623-1700

Doomer.f.

DORAZIO Piero
Italian 1927–

piero DORAZIO

DORE P G L C
French 1832-83

Gv. Dorg

GD

DORMIDONTOV Nikolai I.
Russian 1898–1962

Н.Дормидонтов

DORN Joseph
German 1759-1841

DORNEL Jacques
German 1775-1852

DORNER Johann Jakob
German 1741-1813

DOSSI Battista
Italian 1474-1548

DOU Gerrit
(or DOV)
Dutch 1613-75

G. Dov.,

Dov., D,

GD,

DOUBOURG V
see FANTIN-LATOUR Victoria

DOUCET Henri
French 1856-95

L Doucet

DOUDYNS Willem
Dutch 1630-97

Guilielmo Doudijns

DOUFFET Gerrard
Flemish 1594-1660

GER. DOVFFET

DOVE Arthur G.
American 1880–1946

Dove

DOUVEN F B
German 1688-1726

B Douver

DOUVEN Jan Frans van
German 1656-1727

F Douver

DOUW S J van
Flemish 1639-77

SV. Douw

DOUWEN A van
Dutch 17th Century

DOUZETTE Louis
German 19th Century

L. Douzette

DOYEN G P
French 1726-1806

G.F.Doyen.

DRECHSLER Johann Baptist
Austrian 1756-1811

DREVER Adrian van
Dutch 17th Century

DRIELST Egbert van
Dutch 1746-1818

C.van Drielst

E.V.Dt

DRIFT J A van der
Dutch 1808-83

DRILLENBURG Willem van
Dutch 17th Century

W vDielen B

DROLLING Martin
French 1752-1817

DROLLING Michael Martin
French 1786-1851

Drolling-th..

DROOGSLOOT Cornelis
Dutch 1630-73

S. droogsloot

c . d .

DROOGSLOOT Joost Cornelisz
Dutch 1586-1666

ƒ Droogh Sloot., ƒJS.

DORSTE Willem
Dutch 17th Century

NDorste:fec:

DROUAIS Jean Germain
French 1763-88

Drouais J.

DUBBELS Hendrick Jacobsz
Dutch 1620-76

Dubbels.

Dubbels

DYBBELS

H.

DUBOIS Ambroise
French 1543-1614

A Dvbois.

Ħ

DUBOIS François
French 1790-1871

FRANÇOIS DVBOIS

DUBOIS Paul
French 1829-1905

DUBOIS Simon
Flemish 1632-1708

S. dü Bois fec.

DUBORDIEU Pieter
Flemish 17th Century

HD

DUBOURCQ Pierre Louis
Dutch 1815-73

DUBOURG Louis F
Dutch 1693-1775

LFDB .

LFD ,

LFD .

DUBUFFET Jean
French 1901–

J . Dubuffet

DUBUS H B
French 19th Century

HyB Dubus

DUCERCUE Jacques A
French 1510-84

/·A·DC·

DUCHAMP Marcel
French 1887-1967

MARCEL DUCHAMP

DUCHASTEL François
Flemish 1625-94

f Duchastel

DUCIS Louis
French 1775-1847

L Ducis.

DUCK Jacob
Dutch 1600-60

JDuck.

Jacob Duck

DUCORNET Louis Joseph César
French 1806-56

C. DUCORNET

DUCQ Johan
Dutch 1630-76

JLcDucq

DUCREUX Joseph
French 1735-1802

Du Creux

Ducreu.

DUEZ Ernest Ange
French 1843-96

Eoue

DUFAU Clémentine Helene
French 19th-20th Century

[HDufau

DUFAI Fortuné
French 1770-1821

f Dufau.

DUFLOS Philothée François
French 1710-1764

DUFLOS Pierre
French 1742-1816

DUFRENOY Georges Léon
German 1870-1942

DUFY Raoul
French 1877-1953

DUGARDIN Guilliam
Dutch 16th Century

DUGHET Gaspard
French 1615-75

DUGUAY Rodolphe
Canadian 1891–1973

DUHEM Henri Aimé
French 19th-20th Centuries

DUJARDIN Edward
Flemish 1817-89

DUJARDIN Karel
Dutch 1622-78

DULAC Edmond
French 19th-20th Century

DULIN Pierre
French 1669-1748

DUMONSTIER Daniel
French 1574-1646

DUMONT Augustin 18
French 1801-84

DUMOUCHEL Albert
Canadian 1916–1971

DUNANT Jean François
French 1780-1858

DUNKER Balthasar Anton
German 1746-1807

DUNLOP Ronald Ossory
English 19th-20th Century

DUNOUY Alexandre H
French 1757-1841

DUNOYER DE SEGONZAC
André Albert Marie
French 19th-20th Centuries

DUNZ Johannes
Swiss 1645-1736

DUPERAC Etienne
French 1525-1601

DUPLESSIS Joseph S
French 1725-1802

DUPONT François Léonard
French 1756-1821

DUPRE Jules
French 1811-89

DUPRE Julien
French 1851-1910

DUPOY Paul Michel
French 19th-20th Centuries

DURAND Asher B
English 1796-1886

DURER Albrecht
German 1471-1528

DURER Jean Hans
German 1478-1538

DURINGER Daniel
Swiss 1720-86

DURLET Franciscus Andreas
Flemish 1816-67

DURY-VASSELON Hortense
French 19th Century

DUSART C J
Flemish 1618-81

DUSART Cornelis
Dutch 1660-1704

DUTHOIT Paul Maurice
French 19th-20th Centuries

DUTILLEUX H J C
French 1807-65

DUVELLY Charles
French 1800-74

DUVIVIER Jean
French 1687-1761

DUYSTER Willem C
Dutch 1600-35

DUYTS Gustave den
Belgian 1850-97

DUYTS Jan de
Flemish 1629-76

DUYVEN Steven van
Dutch 17th Century

65

DYCE William
English 1806-64
By courtesy of Mr F. Sebbick
Osborn House

DYCK Anton van (Sir Antony)
Flemish 1599-1641

DYCK Daniel van den
Flemish 17th Century

DYCK Floreus van
Dutch 1575-1651

DYCKMANS Josephus Laurentius
Flemish 1811-88

DYK Philip van
Dutch 1680-1753

EARL Ralph
American 1751-1801

EARLOM Richard
English 1743-1822

EBEL Fritz Carl Werner
German 1835-1895

EBERLE Adolf
German 1843-1914

ECHTLER Adolf
German 1843–1914

ECKENBRECHER Karl P T von
German 19th Century

ECKERT Henri Ambros
German 1807-1840

EDELFELT Albert G A
Finnish 1854-1905

E DELFET

EDELINCK Gerard
Flemish 1640-1707

EECKELE Jan van
Flemish 16th Century

EECKHOUT Gerbrand van den
Dutch 1621-74

EECKHOUT Jakob Joseph
Flemish 1793-1861

EHRENBERG Wilhelm von
Dutch 1630-76

EHRMANN Françoise Emile
French 1833-1910

F. EHRMANN

EICHEL Emmanuel
German 1717-82

EISEN C D J
French 1720-78

Eisen.
CGEisJ

EISENHOUT Anton
German 1554-1603

Anton Eisenli.

EKELS Jan
Dutch 1724-81

I. Ekels. f.

EKELS Jan
Dutch 1759-93

I. EKELS. F.

ELANDTS Cornelis
Dutch 17th Century

Cornelis Elandt

ELEUTHERIADE Micaela
Romanian 1900–1982

Eleutheriade

ELIAERTS Jan Frans
Belgian 1761-1848

J. F. Eliaerts

ELIAS Nicolaes
(ELIASZ Picknoy)
Dutch 1590-1653

NE·P

ELIOT Maurice
French 19th-20th Centuries

Maurice Eliot

ELLE Louis
French 1612-89

F. elle.

ELLENRIEDER Maria
Swiss 1791-1863

ME

ELLIGER Ottmar
Swedish 1633-79

Ottmar Elliger

ELLIGER Ottmar
German 1666-1735

Elliger X.

ELLIS Edwin
English 1841-95

ELMORE Alfred
English 1815-81

ELSEN Alfred
Belgian 1850-1900

A. Elsen

ELSEVIER L A
Dutch 1617-75

L'Elsevier

ELSHEIMER Adam
German 1574-1620

Æ., Æ.

ELWELL Frank Edwin
American 19th-20th Century

Fred Elwell

ENGALIERE Marius
French 1824-57

Engalière

ENGELBERTSZ Cornelis
Dutch 1468-1533

ENGELBERTSZ Luc
Dutch 1495-1522

ENGELEN A F L van
Belgian 19th-20th Centuries

Louis van Engelen

ENGELEN Piet van
Belgian 19th-20th Centuries

Piet van Engelen

ENSOR James
Belgian 1860-1949

JAMES ENSOR

EPISCOPIO Giustino
Italian 17th Century

J. Episcopio

EPISCOPIUS Johannes
Dutch 1628-71

ERLER Fritz
German 1868-1940

Erler

ERMELS Johann Franciscus
German 1621-93

HE f.

ERNST Max
German 19th-20th Centuries

max Ernst

ERNST Rudolph
Austrian 19th-20th Centuries

R.Ernst.

ES fopsen (Jacob van)
Flemish 1596-1666

I.V·E·S·

ESCALENTE Juan Antonio de
Frias y
Spanish 1630-70

Escalente.

ESPAGNAT Georges d'
French 1870-1950

ESPINAL Juan de
French 18th Century

ESPINOSA Jeronimo R de
Spanish 1562-1638

ESPINOSA Jeronimo Jacinto
Spanish 1600-80

ESSELENS Jacob
Dutch 1626-87

ETCHEVERRY Hubert Denis
French 19th-20th Centuries

EVELYN John
English 1620-1706

EVERDINGEN Albert
Dutch 1621-75

EVERGOOD Philip
American 1901–1973

FABRE François Xavier
French 1766-1837

FABRIANO Gentila da
Italian 1370-1450

FABRITIUS Bernaert
Flemish 17th Century

FABRITIUS Carolius
Dutch 1622-54

FACCINI Pietro
Italian 1560-1602

FAIVRE-DUFFER Louis S
French 1818-97

L. FAIVRE -DUFFER

FALBE Joachim Martin
German 1709-82

FALCINI Domenico
Italian 16th Century

FALCKEISEN Theodor
Swiss 1765-1814

FALCONE Aniello
Italian 1607-56

FALDONI Antonio Giovanni
Italian 1690-1770

A.F.

FALENS Carel van
Dutch 1683-1733

FALGUIERE Jean Alexandre Joseph
French 1831-1900

FALK Jeremias
Polish 1619-77

FALK Robert R.
Russian 1886–1958

FALLER Louis Clement
French 1819-1901

FANTIN-LATOUR Ignace Henri Jean Théodore
French 1836-1904

FANTIN-LATOUR Victoria (Doubourg)
French 19th-20th Centuries

FANTONI Tonci
Yugoslavian 1898–

TONCI FANTONI

FARASYN Edgard
French 19th-20th Centuries

FARINATI Paolo
Italian 1524-1606

FARINGTON Joseph
English 1747-1821

FARNY Henry F.
American 20th Century

FARRE Thomas G.
British 1839–1891

FARRER Henry
British 1843–1903

FASOLO Bernardino
Italian 16th Century

FAUCONNET Guy Pierre
French 1882-1920

FAULTE Michel
French 17th Century

FAVANNE Henri Antoine de
French 1668-1752

FAVART A P C
French 1784-1867

FAVORY André
French 1888-1937

A.FAVORY.

FAVRE Marcel
French 1900–72

FEARNLEY Thomas
Norwegian 1802-42

FEDDES Pieter (van Harlingen)
Dutch 1586-1634

FEHLING Heinrich Christoph
German 1657-1725

FEHLING-WITTING Ilse
German 1896–

FEJES Emerik
Yugoslavian 1904–1969

FELLINI G Cesare
Italian 1600-56

FELLNER F A Michael
German 1799-1859

FELON Joseph
French 1818-96

FELS Elias
Swiss 1614-55

FENINGER Lionel
American 1871–1956

FENNITZER Michael
German 1641-1702

FENTZEL Gregor
German 17th Century

FERG Franz de Paula
Austrian 1689-1740

FERGUSON James
English 1833-59

FERNANDEZ Franciso
Spanish 16th Century

FERRAMOLO Floriano
Italian 1480-1528

FERRARI Gaudenzio
Italian 1484-1546

FERRARI Pietro Melchiorre
Italian 1735-87

FERREN John
American 1905–1970

FERRIER Gabriel J M A
French 1847-1914

FESELEN Melchior
German 16th Century

FETI Domenico
Italian 1589-1624

FEUERBACH Anseleme
German 1829-80

FEYEN Jacques Eugène
French 1815-1908

FIACCO Orlando
Italian 16th Century

FIALETTI Odoardo
Italian 1578-1638

FICHEL Benjamin Eugène
French 1826-95

FICTOR
see VICTOR Jacomo

FIELING Lodewyk
Italian 18th Century

FILIPPONI Sandro
Italian 1909–1931

FILIPOVIC Franjo
Yugoslavian 1930–

FILOSI G B
Italian 16th Century

FINSON Louis
Flemish 16th-17th Centuries

FIORENTINO Luca
Italian 16th Century

FIORA Cesare
Italian 1636-1702

FIRENS Jodocus
Dutch 17th Century

FIRENS Pierre
Flemish 16th-17th Century

FISCHER Johan
German 17th Century

FISCHER Joseph
Austrian 1769-1822

FISCHER M A
German 18th Century

FISEN Englebert
Flemish 1655-1733

FITTKE Arturo
Italian 1873–1910

FLACK Audrey
American 1931–

FLAD Georg
German 1853-1913

FLAMEN Albert
Flemish 17th Century

FLAMENG François
French 1856-1923

FLAMENG Léopold
French 1831-1911

FLANDIN Eugène Napoleon
French 1803-76

FLANDRIN Hippolyte Jean
French 1809-64

FLANDRIN Jules Léon
French 1871-1947

FLANDRIN Paul Jean
French 1811-1902

FLEISCHBERGER Johann
Friedrich
German 17th Century

FLEISCHMANN A C
German 18th Century

FLEISCHMANN A J
German 1811-78

FLINCK Govaert
Dutch 1615-60

FLORES Frutos
Spanish 16th Century

FLORIS Cornelis
Flemish 1514-75

FLORIS Frans
Flemish 1516-70

FLORIS Jacob
Flemish 1524-81

FLOTNER Pieter
German 1485-1546

FONDA Enrico
Italian 1892–1929

FONTANA Giambattista
Austrian 1525-87

FONTANA Lavinia
Italian 1552-1614

FONTANA Prospero
Italian 1512-97
By courtesy of the Bowes Museum
Barnard Castle

FONTENAY Louis Henri de
French 19th Century

FONTEYN Adriaen Lucasz
Dutch 16th Century

FOORT Karel
Flemish 1510-62

FORAIN Jean Louis
French 1852-1931

FORBIN L N P A
French 1777-1841

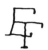

FORSTER Ernest Joachim
German 1800-85

FORTIN Charles
French 1815-65

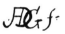

FORTIN Marc Aurelle
Canadian 1888–1970

FOSSATI Davido Antonio
Italian 1708-80

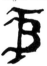

FOSTER-BIRKETT Myles
English 1825-99

FOUGERAT Emmanuel
French 19th-20th Centuries

FOUGERAT

FOUJITA Tsugouharu
Japanese 19th-20th Centuries

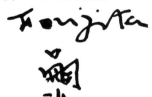

FOUGUERAY Charles D
French 1872-1956

FOURMOIS Théodore
Belgian 1814-1871

FOURNIER Jean
French 1700-65

FOUS Jean
French 1901–1970

Jean Fous

FOY André
French 19th-20th Centuries

FRAGONARD Jean Honoré
French 1732-1806

FRANÇAIS François Louis
French 1814-97

Frago.

FRANCAIS

FRANCHESCHINI Marco Antonio
Italian 1648-1729

MAF in

FRANCHOYS Peter
Flemish 1606-54

FRANCIABIGIO
Italian 1482-1525

FRANCIS Sam
American 1923–

FRANCK C F
Dutch 1758-1816

FRANCK Hans Ulrich
German 1603-80

FRANCKEN Ambrosius
Flemish 1544-1618

FRANCKEN Frans (den Onden)
Flemish 1542-1616

FRANCKEN Frans (den Jorgen)
Flemish 1581-1642

FRANCKEN Frans
Flemish 1607-67

FRANCKEN Hieronymus
Flemish 1540-1610

FRANCKEN Hieronymus
Flemish 1578-1628

JERONIMUS FRANCKEN

FRANCKEN Hieronymus
Flemish 17th Century

FRANCKEN Maximilien
Flemish 17th Century

MF.

FRANCKEN H P
Flemish 17th Century

FRANCO Angelo
Italian 15th Century

FRANCO Giovanni Battista
(Venetus)
Italian 1510-80

FRANÇOIS Jean Charles
French 1717-69

FRANÇOIS Simon
French 1606-71

FRANCQUART Jacques
Flemish 1577-1651

FRANCUCCI Innocenzo di Pietro
Italian 1494-1550

INNOCENTIVS
FRANCALIVS
IMOLENSIS

FRANK F F
German 1627-87

FRANQUE Jean Pierre
French 1774-1860

FRANQUELIN Jean Augustin
French 1798-1839

FRANS Hans
Flemish 17th Century

FRANS Nicolaus
Flemish 16th Century

FRAPPA Jose
French 1854-1904

FRATREL Joseph
French 1730-83

FRAYE André
French 19th-20th Century

FREDERIC Leon Henri Marie
Belgian 19th-20th Century

FREMINET Martin
French 1567-1619

FREMONT C D S
French 19th-20th Centuries

FRENZ Rudolf R.
Russian 1888–1956

FRENZEL Georg
German 1595-1650

FRERE Charles Theodore
French 1814-88

FREY Johannes Pieter de
Dutch 1770-1834

FREY M J
German 1750-1813

FREYBERG M E von (nee Stuntz)
German 1797-1847

FREYBERG Johann
German 1571-1631

FRIANT Emile
French 1863-1932

FRIES Ernst
German 1801-33

FRIESZ Achille Emile Othon
French 1879-1949

FRIQUET de Vauroze J A
French 1648-1718

FRISCH J C
German 1738-1815

FRISIUS S W
Flemish 1580-1628

FRITH William Powell
English 1819-1909

FROHLICH Anton
German 1776-1841

FROMANTIOU Hendrik de
Dutch 1633-94

FROMENTIN Eugène
French 1820-76

FRONTIER Jean Charles
French 1701-63

FRYE Thomas
Irish 1710-62

FRYTON Frederik van
Dutch 17th Century

FUCHS Adam
German 1542-80

FUCHS L J
Belgian 1814-73

FUES C F
German 1772-1836

FUGER F H
German 1751-1818

FUHRICH Josef von
Austrian 1800-76

FULCARUS Sebastian
German 1589-1666

FUMICELLI Lodovice
Italian 16th Century

FURINI Francesco
Italian 1604-46

FURNERIUS Abraham
Dutch 17th Century

FURNIUS P J
Flemish 1540-1625

FUSSLI Jean Henri (or FUSELI)
Swiss 1741-1825

FUSSLI Mathias
Swiss 1671-1739

FYT Jan
Flemish 1609-61

GAAL Barend
Dutch 1620-87

GABBIANI Antonio Domenico
Italian 1652-1726

GABET Franz
Austrian 1765-1847

GABRON Guilliam
Belgian 1619-78

GASEBEECK Adriaen van
Dutch 1621-50

GAGLIARDI Bartolommeo
Italian 1555-1620

GAGLIARDINI Julien Gustave
French 1846-1927

GAGNEREAUX Benigne
French 1756-95

GAILLARD Claude Ferdinand
French 1834-87

GALAND Léon Laurent
French 19th-20th Centuries

GALANIS Dometrius Emmanuel
French 1882-1966

GALARD Gustave
French 1777-1840

GALESTRUZZI Giovanni Battista
Italian 1615-69

GALLAIT Louis
Belgian 1810-87

GALLE Cornelis
Flemish 16th-17th Century

GALLE Gieronimo
French 19th Century

GALLE Joan
Flemish 1600-72

GALLE Philipp
Dutch 1537-1612

GALLI G A
Italian 17th Century

GALLIS Pieter
Dutch 1633-97

GALLOCHE Louis
French 1670-1761

GALVAN Juan Ferez
Spanish 1586-1658

GAMBARO Lattanzio
Italian 1530-74

GAMELIN Jacques
French 1738-1803

GANDARA Antonio de la
French 1862-1917

GANDOLFI Gaetano
Italian 1734-1802

GANZ J P
German 18th Century

GARBIERI Lorenzo
Italian 1580-1654

GARDELLE Robert
Swiss 1682-1766

GAREIS Puis
German 19th Century

GARGALLO Pablo
Spanish 1881-1939

GARIBALDO Marco Antonio
Flemish 1620-78

GARNERAY Ambroise Louis
French 1783-1857

GARNIER Jules Arsène
French 1847-89

GARRAND Marc
Flemish 1561-1635

GARZON Juan
Spanish 18th Century

GASPERS Jan Baptiste
Flemish 17th Century

GASSEN Francisco
Spanish 1598-1658

GASSIES Jean Bruno
French 1786-1832

GASTALDI Andrea
Italian 1810-89

GATINE Georges Jacques
French 1773-1824

GAUCHEREL Léon
French 1816-86

GAUDENZIO
see FERRARI Gaudenzio

GAUDIN Louis Pascal
Spanish 1556-1621

GAFFIER Louis
French 1761-1801

GAUGIN Paul
French 1848-1903

GAULTIER Léonard
French 1561-1641

GAUTHEROD Claude
French 1729-1802

GAUTIER Armand Désiré
French 1825-94

GAUTIER L F L
French 19th Century

GAUVREAU Pierre
Canadian 1922–

GAVARNI Sulpice Guillaume
Chevalier
French 1804-66

GEBLER Friedrich Otto
German 1883-1917

GEDDES Andrew
Scottish 1783-1844
By courtesy of the National
Gallery of Scotland

GEEL J J van
Dutch 1585-1638

GEEST Joost van
Dutch 1631-98

GEEST W S
Dutch 1592-1659

GEETS Willem
Belgian 19th Century

GEFFELS Frans
Flemish 17th Century

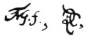

GEISSLER J M F
German 1778-1853

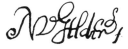

GELDER Aart de
Dutch 1645-1727

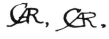

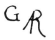

GELDER Nicolaes van
Flemish 1620-77

GELDORP Gortzius
Flemish 1553-1618

GELEE Claude (Lorrain)
French 1600-82

CLAVDE GELEE,
CLAVDI, CLA.G.CLA
Claudes Lorrain
Claudes fecit

GELTON Toussaint
Dutch 1630-80

GENDRON Ernest Augustin
French 1817-81

A.GENDRON

GENERALCIC Josip
Yugoslavian 20th Century

GENERALIC Ivan
Yugoslavian 20th Century

GENILLION J B F
French 1750-1829

Genillion

GENNARI Bernardetto
Italian 1570-1610

B G IN

GENNARI Cesare
Italian 1637-88

C Gennari.

GENOELS Abraham
Flemish 1640-1723

A.G.fecit.

GENSOLLEN Victor Emmanuel
French 1859-97

GENTI Francesco
Italian 16th Century

GENTILI Aldo
Italian 1906–

A.GENTILI

GEORGET Jean
French 1763-1823

G.G

GERARD F P S (Baron)
French 1770-1837

Bron Gérard

GERARD Théodore
Belgian 1829-95

Theodore Gerard

GERARDS Marcus
Flemish 1530-90

M G.

GERASIMOV Alexander M.
Russian 1881–1963

А. Терасимов

GERASIMOV Sergei V.
Russian 1885–1964

Сергеи
Терасимов

С. ТЕРА
СИМОВ

GERBO Louis
Flemish 1761-1818

GERICAULT Jean Louis Andre
Theodore
French 1791-1824

GERKE J P
German 19th Century

GERNEZ Paul Elie
French 1888-1948

GERRIT Lundens
Dutch 17th Century

GEROME Jean Léon
French 1824-1904

J.L.GEROME

GERUNG Mathias
German 1500-68

GERVAISE Jacques
French 1622-70

J gervaise

GERVEX Henri
French 1852-1929

H.C.Gervex
H. Gervex.

GESSNER Salomen
Swiss 1730-88

GEYSER F C G
German 1724-1803

GHANDINI Alessandro
Italian 17th Century

A G

GHERARDI Antonio
Italian 1644-1702

Anto Cher Reatius

GHERING Jan
Flemish 17th Century

GHERINGH Anthon Gunther
Flemish 17th Century

GHERWEN Reynier van
Dutch 17th Century

GHEYN Guilliam de
Flemish 17th Century

GHEYN Jacob
Dutch 1530-82

GHEYN Jacob de
Dutch 1565-1629

GHISI Adamo
Italian 1530-74

GHISI Diana
Italian 1536-90

GHISI Giogio (Mantovano)
Italian 1520-82

GHISI Giovanni Battista)
Italian 15th-16th Centuries

GHISLANDI Fra Vittore
Italian 1655-1743

GHISOLFI Giovanni
Italian 17th Century

GIACOMETTI Alberto
Swiss 1901–1966

Alberto Giacometti

GIACOMOTTI Felix Henri
French 1828-1909

GIAROLA Giovanni
Italian 16th Century

J Giarola

GIETL Josua von
German 19th-20th Centuries

GIETL-

GIETLEUGHEN Joss van
Flemish 16th Century

GIGOUX Jean François
French 1806-94

GILARTE Mateo
Spanish 1620-80

GILBERT & GEORGE
British 1943– & 1942–

GILBERT Sir John
English 1817-97

GILBERT Victor Gabriel
French 1847-1933

GILL Edmund
English 1820-94

GILLIG Jacob (or **GELLIG**)
Dutch 17th Century

GILLIS Herman
Flemish 18th Century

GILLOT Claude
French 1673-1722

GILLOT Eugène Louis
French 19th Century

GILMAN Harold
English 1876-1919
By courtesy of the Walker Art
Gallery Liverpool

GILPEN Sawrey
English 1762-1843
By courtesy of the Royal Academy of
Arts London

GILSOUL Victor Oliver
Belgian 19th-20th Centuries

GIMIGNANI Giacinto
Italian 1611-81

GINGELEN Jacques van
Flemish 19th Century

GINNER Charles
English 1878-1952

C. GINNER

GIOLFINO Niccolò (Veronensis)
Italian 1476-1555

GIOLITO DE FERRARI Gabriele
Italian 16th Century

GIONOMO Simone
Austrian 1655-1730

S G

GIORDANO Luca
Italian 1632-1705

GIOVANNI Antonio da Brescia
Italian 16th Century

GIOVANNI Maria da Brescia
Italian 16th Century

GIOVENONE Girolamo
Italian 1490-1553

IHERONIMI
IVVENONIS
OPIFICIS

GIOVENONE P B G
Italian 1524-1609

IOANNES IOSEPH
IVVENONO.

GIRARD Paul Albert
French 1839-1920

GIRARDET Eugène Alexis
French 1853-1907

GIRARDET Jules
French 19th-20th Century

GIRAUD Victor Julien
French 1840-71

**GIRODET DE ROUCY
TRIOSON** Anne Louis
French 1767-1824

GIRTIN Thomas
English 1775-1802
By courtesy of the British Museum

GLACKENS William
American 1870–1938

GLAIN Léon
French 18th Century

GLAIZE Auguste Barthelemy
French 1807-93

GLASER Hans Heinrich
Swiss 17th Century

GLAUBER Johannes
Dutch 1646-1726

GLAUBNER Jan Gotlief
Dutch 1656-1703

GLEHN W G de
English 19th-20th Centuries

GLEIZES Albert
French 1881-1953

ALBERTGLEIZES ,

GLINK Franz Xavier
German 1795-1873

GLOCKENDON Albrecht
German 15th Century

GODEFROY A P F
French 1777-1865

GODERIS Johan
Dutch 17th Century

GOEDELER F. Johann
Austrian 1620-93

E Goedeler.

GOEIMARE Joos
Flemish 1575-1610

GOENEUTTE Norbert
French 1854-94

Norbert Goeneutte

GOERG Edouard Joseph
French 19th-20th Centuries

GOES Hugo van der
Flemish 1420-82

GOESIN P F A de
Flemish 1753-1831

GOETSCHBUER Petrus Jacobus
Flemish 1788-1866

GOETZ G B
German 1708-71

GOGH Vincent Willem van
Dutch 1853-90

GOINGS Ralph
American 1928–

GOINGS

GOLE Jacob
Dutch 1660-1737

GOLLING Leonard
German 1604-67

GOLTZ Franciscus de
Dutch 17th Century

GOLTZIUS Conrad
German 16th-17th Centuries

GOLTZIUS Hendrik
Dutch 1558-1616

GOLTZIUS Hubert
Flemish 1526-83

GOLUB Leon
American 1922–

GOMEZ y PASTOR Jacinto
Spanish 1746-1812

GONCHAROVA Natalia S.
Russian 1881–1962

GONDOLACH Matthaus
German 1566-1653

GONDOUIN Emmanuel
French 1883-1934

GONTCHAROVA Natalia
Russian 1881-1962

GONTIER Léonard
French 1575-1642

GONZALES
see COQUES Gonzales

GONZALES Juan Antonio
Spanish 19th-20th Centuries

GONCHAROV Andrei D.
Russian 1903–1979

GONZALES Julio
Spanish 1876–1942

GOODALL Frederik
English 1822-1904

GOODWIN Albert
English 19th-20th Century

GOOL Jan van
Dutch 18th Century

GOOSSENS Jan Baptist
Flemish 17th Century

GORBITZ Johan
Norwegian 1782-1853

GORDON John
American 1911–

GORE Spencer F
English 1878-1914
By courtesy of City Art Gallery

GORKY Arshille
American 1904–1948

GOSSAERT Jan (Mabuse)
Flemish 1478-1533

GOSSELIN Charles
French 1834-92

GOTCH Thomas Cooper
English 19th Century

GOTTING Andreas
Dutch 17th Century

GOTTLIER Leopold
Polish 1883-1930

GOTWALD Christof
German 17th Century

GOUBAU Antoon
Dutch 1616-98

GOUBAU Frans
Flemish 1622-78

GOUBIE Jean Richard
French 1842-99

GOUDT Hendrick
Dutch 1585-1630

GOULINAT Jean Gabriel
French 19th-20th Centuries

GOUPIL Léon Lucien
French 1834-90

GOURMONT Jean de
French 16th Century

GOVAERTS Abraham
Flemish 1589-1626

GOVAERTS Hendrick
Flemish 1669-1720

GOYA y LUCIENTES Francisco
José de
Spanish 1746-1828

GOYEN Jan Josefoz van
Dutch 1596-1665

GOZZOLI Alessio
Italian 1420-1497

GRAAT Barend
Flemish 1628-1709

GRAEF T de
Dutch 17th Century

GRAFF Antoine
German 1736-1813

GRAFF Johann Andreas
German 1637-1701

GRAHAM John D.
French 1881–1961

GRAN Daniel
Austrian 1694-1757

GRANACCI Francesco
Italian 1477-1543

GRANDI E di G
Italian 1465-1531

GRANDON Charles
French 1691-1762

GRANET François Marius
French 1775-1849

GRASDORP Willem
Dutch 1678-1723

GRASSI Candido
Italian 1910–1969

GRAVELOT H F
French 1699-1773

GREAVES Walter
English 1846-1930

W.Greaves

GREBBER Frans Pietersz
Dutch 1573-1649

GREBBER Pieter Fransz de
Dutch 1600-92

P. DG..

PDG, PDG,

PDG

GREEN Charles
English 1840-98

CG

GREENWOOD Orlando
English 19th-20th Centuries

GREGORY Edward John
English 1850-1909

E.J.G.

GRENIER de SAINT MARTIN
E M F
French 1793-1867

f. Grenier.

GREUTER Giovanni
Italian 1600-60

GG, FGF,
FGF.

GREUTER Matthaus
French 1564-1638

GREUZE Jean Baptiste
French 1725-1805

J.B.Greuze.

GREVEDON Pierre Louis Henri
French 1776-1860

Grevedon,

G., G., G.

GREVENBROECK Orazio
Dutch 1670-1730

Orago Greverbrouch

GRENT Cornelis de
Dutch 1691-1783

CovgCa.

GRIFFIER Jan
Dutch 1652-1718

G.GRIFFIER;

G.

GRIFFIER John
English 18th Century

J, C,

GRIFFIER Robert
English 1688-1750

RCRIFFIER.

GRIGORIEV Boris D.
Russian 1886–1939

Борисъ
Григорьевъ

GRIGORIEV Nikolai M.
Russian 1890–1943

Н.Г.

GRIMALDI Giovanni Francesco
Italian 1606-1680

G F G.

GRIMALDI Maurice
French 19th-20th Centuries

M. fim.

GRIMER Abel
Flemish 16th-17th Centuries

A.

GRIMER Jakob
Flemish 1526-89

CM

GRIMM Samuel Hieronymous
Swiss 1733-94

S.H.Grimm

GRIMOU Jean
French 1680-1740

Grimou
f

GRIMSHAW Atkinson
English 1836-93

Atkinson Grimshaw

GRIS Juan
Spanish 1887-1972

Juan Gris,

Juan Gris.

Ivan Gris.

GRISCHENKO Alexei V.
Russian 1883–1977

A.Г.

GROL Rudolf van
Dutch 17th Century

R croLf,

GROMAIRE Marcel
French 19th-20th Centuries

Gromaire.

M.Gromaire,

G

GRONINGEN Gerhard de
Flemish 16th Century

GRONLAND Theude
German 1817-76

Th. Grönland.

GROOT Johan de
Dutch 18th Century

GROS Antoine Jean (Baron)
French 1771-1835

GROSJEAN Henry
French 19th-20th Centuries

GROSPIETSCH Florian
German 1789-1830

GROSZ Georg
German 1893-1959

GROUX C C A de
Belgian 1825-70

GRUN Jules Alexandre
French 1868-1934

GRUN Maurice
French 19th-20th Century

GRUND N J C
German 1717-67

GRUNDLER Marcus
German 1560-1613

GRUNER W H L
German 1801-82

GRUNEWALD Hans
German 16th Century

GRUNEWALD Matthias
German 1455-1528

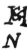

GRUNHUT Isidoro
Italian 1862–96

GRYEF Adriaen
Flemish 1670-1715

GUARDI Francesco
Italian 1712-93

Fran.co
Guardi

GUARDI Giovanni Antonio
Italian 1698-1760

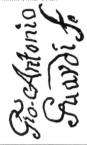

GUCKEISEN Jakob
German 16th Century

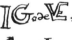

GUDE Hans Frederick
Norwegian 1825-1903

GUDIN J A T (Baron)
French 1802-80

GUELDRY Ferdinand Joseph
French 19th-20th Centuries

F.GUELDRY.

GUERCINO Giovanni Francesco
Barbieri il
Italian 1591-1660

GUERIN C F P
French 1875-1939

Charles Guérin.

GUERIN Pierre Narcisse (Baron)
French 1774-1833

GUERIN Ft

GUERRI Dionisio
Italian 1598-1640

GUESLAIN Charles Etienne
French 1685-1765

GUET Edmond Georges
French 19th Century

GUERVA Juan Nino
Spanish 1632-86

GUFFENS Godfried Egide
Belgian 1823-1901

GUIBAL Nicolas
French 1725-84

GUIDUCCI Angelo
Italian 18th Century

GUIGNET Jean Adrien Jr
French 1816-54

GUIGOU Paul Camille
French 1834-71

GUILLAIN Simon I
French 1581-1658

GUILLAUMET Gustave Achille
French 1840-87

GUILLAUMIN Jean Baptiste
Armand
French 1841-1927

GUILLEMET Jean Baptiste
Antoine
French 1843-1918

GUILLEMINET Claude
French 19th Century

GUILLONNET O D V
French 19th-20th Century

GUILLOU Alfred
French 19th Century

ALFRED-GUILLOU-

GUINIER Henri Jules
French 1867-1927

H.Guinier

GUIRRO Francisco
Spanish 1630-1700

GULDENMUND Hans
German 16th Century

HG,

HG.

GUNTHER Christian August
German 1759-1824

GUNTHER Matta M
German 1705-88

GUSCAR Henri
French 1635-1701

H.GuscAR.

GUSTON Philip
American 1913–1980

Philip Guston

GUYOT Georges Lucien
French 19th-20th Centuries

guyot

GYSAERTS Gualterus
Flemish 1649-1674

F.G. GYSAERTS. MIN.F.
en D.F.

GYSBRECHTS Cornelis Norbertus
Flemish 17th Century

GYSELAER Nicolas de
Dutch 1590-1654

NDGISELAER F.

GYSELAER Philip
Flemish 17th Century

GYSELS Peeter
Flemish 1621-90

PEETER GYSELS

HAAG T P C
German 1737-1812

HAANSBERGEN Johannes van
Dutch 1642-1705

HAAS J H L de
Flemish 1832-1908

HABERLE John
American 1856–1933

HABERMANN Hugo (Baron) von
German 19th-20th Centuries

HABERSTUMPF Karl Johann
German 1656-1724

HACK Jan II
Dutch 16th Century

HACKAERT Jan
Dutch 1629-99

HACKAERT P
German 18th Century

HAETEN Nicolas van
Dutch 1663-1715

HAELBECK Jan van
Dutch 17th Century

HAELWEGH Adriaen
Dutch 17th Century

HAELWEGH Albert
Dutch 17th Century

HAEN Abraham I de
Dutch 17th Century

HAEN Abraham II de
Dutch 1707-48

HAEN Gerrit de
Dutch 17th Century

HAGBORG A N W
Swedish 1852-1925

HAGEDORN C L von
German 1712-80

HAGEN Joris van der
Dutch 1620-69

HAGHE Louis
Belgian 1806-85

HAINZMANN Karl Friedrich
German 1795-1846

HALEN Peter van
Flemish 1612-87

HALL Oliver
English 1869-1957

HALLE Claude Guy
French 1652-1736

HALLE Nöel
French 1711-81

HALLION Eugène
French 19th Century

HALOMEN Pekka
Finnish 19th-20th Centuries

HALS Dirk
Dutch 1591-1656

HALS Frans
Dutch 1580-1666

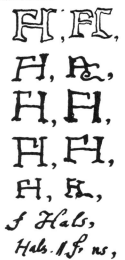

HALS Frans Franszoon
Dutch 1618-69

HALS Jan or Johannes Fransz
Dutch 17th Century

HALS Nicoles Claes Fransz
Dutch 1628-86

HALS Reynier Fransz
Dutch 1627-71

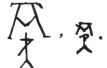

HAMEEL Alart
Flemish 1449-1509

HAMILTON F F de
Flemish 1664-1750

C W DH .

HAMILTON Franz de
German 17th Century

S.R.M.C.D

HAMILTON Johann Georg de
Flemish 1672-1737

HAMILTON Wilhelm de
Austrian 1668-1754

HAMMAN Edouard Jean Conrad
Belgian 1819-88

HAMON Jean Louis
French 1821-74

L Hamon

HANICOTTE Augustin
French 19th-20th Centuries

HANNAS Marc Anton
German 16th Century

HANNEMAN Adriaen
Dutch 1601-71

HANNOT Jan
Dutch 17th Century

HANOTEAU H C A O C
French 1823-90

HANSEN Carl F S
Norwegian 1841-1907

HANSTEEN Asta
Norwegian 1824-1908

HAQUETTE G J M
French 1854-1906

HARDIME Pieter
Flemish 1677-1758

HARDORFF Gerald
German 1769-1864

HARDY Carel
Dutch 17th Century

HARINGH Daniel
Flemish 1636-1711

HARINGS Mathys
Flemish 17th Century

HARLAMOFF Alexei A.
Russian 1842–1917

HARMS Johann Oswald
German 1643-1708

HARNETT William
American 1848–1892

HARPIGNIERS Henri Joseph
French 1819-1916

HARREWIJN François
Flemish 1700-64

HARRISON Lowel Birge
American 19th-20th Centuries

HARTMANN Johann Joseph
German 1753-1830

HARZEN George Ernest
German 1790-1863

HARTIGAN Grace
American 1922–

HASSAM Childe
American 1859–1935

HATHAWAY Rufus
American 18th Century

HATTICH Petrus van
Dutch 17th Century

HAUBLIN Nicolaus
German 17th Century

HAUCK A C
German 1742-1801

HAUDEBOURT A C H nee Lescot
French 1784-1845

HAUER Johann
German 1586-1660

HAUSSOULLIER Guillaume
(William)
French 1818-91

HAVERMAET Piet van
Belgian 1834-97

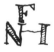

HAYDEN Henri
French 19th-20th Centuries

HAYDON Benjamin Robert
English 1786-1846
By courtesy of Spink & Son Ltd
London

HAYE Reinier de la
Dutch 1640-84

HAYM Niccolò Francesco
Italian 1688-1729

HAZARD James (Coll)
English 1748-87

HEADE Martin Johnson
American 1819–1904

HEBERT A A E
French 1817-1908

HEBERT Adrien
Canadian 1890–1967

HECK C D van der
Dutch 17th Century

C. Heck
fecit

HECKE Jan van der
Belgian 1620-84

J. VECKE

HECKEL Erich
German 1883-
By courtesy of Städtische
Kunstammlung Gelsenkirchen

Heckel

HECKEN Abraham van der
Flemish 17th Century

A. B. Hecken,

B van der Heck.

HEDA Willem Claesz
Dutch 1594-1670

HEDA,

J onae HEDA .

HEDOUIN P E A
French 1820-89

Edmond Hédouin

HEEM Cornelis de
Dutch 1631-95

C DEHEEM

HEEM David de
Dutch 1570-1632

D. BHEEM

HEEM David de
Dutch 1610-69

D DE HEEM

HEEM Jan Davidsz de
Dutch 1606-84

J. D. De Heem f.

J. D. Heem f.

IOANNES DE HEEM. F.

D. De Heem

J.D., J.D.,

*Johann di de
Heem*

HEEMSKERK Egbert van
Dutch 1610-80

ER, HK,

E Heemsker .

HEEMSKERK Martens Jacobsz
van veen
Dutch 1498-1574

*MAERTŸNVS
VAN
HEEMSKERCK.*

M Heemßerck ,

M, JM, JM. .

HEEMSKERK Sebastiaen
Dutch 18th Century

B. Heemskerck

HEENEQUIN Philippe Auguste
French 1762-1833

Hennequin

HEERE Lukas
Flemish 1534-84

HE, AD.

HEEREMANS Thomas
Dutch 17th Century

FMANS

HEERSCOP Hendrik
Flemish 1620-72

H HEERSCHOP

HEES Gerrit van
Flemish 1629-1702

G. van Hees.

HEICHERT Otto
German 19th-20th Centuries

Otto Heichert

HEIDECK Karl Wilhelm von
German 1788-1861

VHDK

HEIL Daniel van
Flemish 1604-62

DVH

HEILBUTH Ferdinand
French 1826-89

Heilbnth.

89

HEILMAIER Emil
German 1802-36

HEIM François Joseph
French 1787-1865

HEINCE Zacharie
French 1611-69

HEINSIUS Johann Ernst
German 1740-1812

HEINZ Joseph
Swiss 1564-1609

HELDT A
German 18th Century

HELION Jean
French 1904—

HELLEU Paul César
French 1859-1927

HELMBRECKER Dirk Theodor
Flemish 1633-96

HELMONT Luc (Lucas van Gassel)
Flemish 1480-1555

HELMONT Matheus van
Flemish 1623-79

HELMSAUER Carl August
German 1789-1844

HELST Bartholomeus van der
Dutch 1613-70

HELST Bartholomeus van der
Dutch 1613-1670

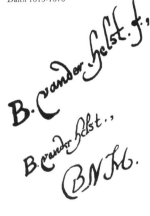

HELST Lodewyck van der
Dutch 1642-80

HELT Nicolaes van (Stocade)
Flemish 1614-69

HELWIG Paul
German 17th Century

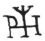

HEMERT Jan van
Dutch 17th Century

HEMESSEN Catherina van
Flemish 16th Century

HEMMESSEN Jan Sanders van
Flemish 16th Century

HEMLING
see MEMLING Hans

HENDRIKS Wybrand
Dutch 1744-1831

HENNEBERGER Georg
German 16th Century

HENNEBERGER Georg Jr
German 16th Century

HENNER Jean Jacques
French 1829-1905

HENNESSY William John
Irish 1839–1917

HENNING Christoph Daniel
German 1734-95

HENRIQUES Francisco
Portuguese 16th Century

HENRIQUEZ DE CASTRO
Gabriel
Dutch 19th Century

HENRY Robert
American 1865–1929

HENS Frans
Belgian 19th Century

HENSEL Wilhelm
German 1794-1861

HERBELIN Jeanne Martilde
French 1820-1904

HERBERT John Rogers
English 1810-90

HERBIN Auguste
French 1882-1960

HERDER G van
Dutch 1550-1609

HEREAU Jules
French 1839-79

HERKOMER Sir Hubert von
English 1849-1914

HERLIN Auguste Joseph
French 1815-1900

HERLIN Friedrich
German 1435-1500

HERLIN Lucas
German 16th Century

HERNANDEZ Mateo
Spanish 1885-1949

HEROUX Bruno
German 19th Century

HERP Willem van
Flemish 1614-77

HERR Michael
German 1591-1661

HERRERA Alonso de
Spanish 16th Century

HERRERA Christophe de
Spanish 16th Century

HERRERA Francisco
Spanish 1576-1656

HERREYNS Willem Jacob
Flemish 1743-1827

HERRING George Frederick
English 1795-1865
By courtesy of the City of
Nottingham Castle Museum and Art
Gallery

HERRLIBERGER David
Swiss 1697-1777

HERTEL Johann Georg
German 18th Century

HERTERICH Heinrich Joachim
German 1772-1852

91

HERVIER Louis Adolphe
French 1818-79

A. HERVIER

HERVIEU L J A
French 1878-1954

HERZ Johann
German 1599-1635

HERZLINGER Anton
Austrian 1763-1826

HESS Carl
German 1801-74

HESS H M von
German 1798-1863

HESS Ludwig
Swiss 1760-1800

L. Hess,
Louis Hess.

HESS P H L von
German 1792-1871

HESSE-CASSEL W L von
German 18th Century

HEUMANN Georg Daniel
German 1691-1759

G DH.

HEUR Cornelis Joseph D
Flemish 1707-62

C.J AHeur

HEUSCH Guilliam de
Dutch 1638-92

HEUSCH Jacob de
Dutch 1657-1701

HEUZE Edmond Amedee
French 19th-20th Centuries

HEUZÉ.

HEVISSEN Cornelis
Dutch 16th Century

HEYDEL Paul
German 19th Century

PAUL HEYDEL

HEYDEN Jacob van der
French 1573-1645

HH, Ji,
Hij.

HEYDEN Jan van der
Dutch 1673-1712

Jv.d.Heyde.,
Janvan de Heyden,
VH.

HEYLBROUCK Michael
Flemish 1635-1733

M.B., M.b.

HEYMANS Adriaan Josef
Flemish 1839-1921

A.J.Heymans.

HICKEL Joseph
Austrian 1736-1807

J Hickel

HILDEBRANDT Ferdinand
Theodor
German 1804-74

G. H.

HILL John Henry
American 1839–1922

J. Henry Hill

HILL John William
American 1812–1879

J. W. Hill

HILLE Pierre
German 16th Century

PF.

HILLEGAERT François
Dutch 17th Century

PVH.f.

HILLEGAERT Pauwels van
Dutch 1595-1640

HILLEGAERT Pauwels van Jr
Dutch 1631-58

HILLEMACHER Eugène Ernest
French 1818-87

HILLIARD Nicolas or
HILLIYARDE
English 1547-1619

HIMPEL Abraham ter
Dutch 17th Century

HIRSHFIELD Morris
American 1872–1946

HIRSCHVOGEL Augustin
German 1503-53

HIRSHFIELD Morris
American 1872–1946

HISBENS P
German 17th Century

HOARE Prince
English 1755-1834

HOBBEMA Meindert
Dutch 1638-1709

HOCH Hannah
German 1889–1945

HOCH Kate
German 1873–1933

HOCHARD Gaston
French 1863-1913

HOCKNEY David
British 1937–

HODGES Charles Howard
English 17th Century

HODLER Ferdinand
Swiss 1853-1918

HOECKE Jan van den
Flemish 1611-51

HOECKERT J F
Swedish 1826-66

HOECKE Robert van den
Flemish 1622-58

HOEFNAGEL Georg
Flemish 1542-1600

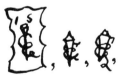

HOERLE Angelika
German 1899–1923

HOET Gerard
Dutch 1648-1733

HOEVENAAR Willem Pieter
Dutch 1808-1863

HOEY J D van
Dutch 1545-1615

HOEY Nikolaus van
Flemish 1631-79

HOFER Karl
German 1878-1955

HOFF Carl Heinrich
German 1866-1904

HOFFMAN Hans
American 19th-20th Centuries

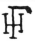

HOFFMANN Johann
German 16th Century

HOFFSTADT Friedrich
German 1802-46

HOGARTH William
English 1697-1764

HOGENBERG J N
Flemish 1500-44

HOGENBERG Nicolas
Flemish 16th Century

HOGERS Jacob
Dutch 17th Century

HOHENHAUSEN Leopold
German 18th Century

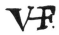

HOLBEIN Hans Jr
German 1497-1543

HOLBEIN Sigmund
German 1465-1540

HOLGATE Edwin
Canadian 1890–1967

HOLLAR Wenzel
Bohemian 1607-77

HOLSTEYN Pieter
Dutch 1580-1662

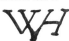

HOLSTYN Cornelis
Flemish 1618-58

HOLZER J E
German 1709-40

HOLZEMYER Peter
German 16th Century

HOMER Winslow
American 1836–1910

HONDECOETER Gillis Claes de
Dutch 16th-17th Centuries

HONDECOETER G G
Dutch 1604-53

HONDECOETER Melchior de
Dutch 1636-95

HONDIUS Abraham Danielsz
Dutch 17th Century

HONDIUS Hendrik
Dutch 1573-1649

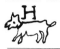

HONDIUS Hendrik Jr
Dutch 1597-1644

HONDIUS Josse
Dutch 1563-1611

HONDIUS Willem
Dutch 1597-1652

HONDT Lambert de
Dutch 17th Century

HONE Nathaniel
Irish 1718-84

HONICH Adriaen
Dutch 17th Century

HONTHORST Gerrit van
Dutch 1590-1656

HONTHORST Willem
Dutch 1594-1666

HOOCH C C. de
Dutch 17th Century

HOOCH Horatius de
Dutch 17th Century

HOOCH Pieter de
Dutch 1629-81

HOOFT Nicolas
Dutch 1664-1748

HOOGSAAT Jan
Dutch 1664-1730

HOOGSTRATEN Dirk van
Flemish 1596-1640

HOOGSTRATEN Samuel van
Flemish 1627-78

HOOK James Clarke
English 1819-1907

HOPFER Daniel
Dutch 1470-1536

HOPFER Hieronymus
Dutch 16th Century

HOPFGARTEN August Ferdinand
German 1807-96

HOPPENHAUT J M
German 18th Century

HOPPER Edward
American 1882–1967

HORATIO
see SAMACHINI Orazio

HOREMANS Jan Josef
Flemish 1682-1759

HORFELIN Antonio de
Spanish 1597-1660

HORNICK Erasmus
Dutch 16th Century

HORST Gerrit W
Dutch 1612-52

HORST Nicolaus van der
Flemish 1598-1646

HOSKINS John Sr
English 17th Century

HOSKINS John Jr
English 17th Century
By courtesy of the Fitzwilliam
 Museum Cambridge

HOUASSE Michel Ange
French 1680-1730

HOUASSE René Antoine
French 1645-1710

HOUBIGANT Gustave Armand
French 1789-1862

HOUBRAKEN Arnold
Dutch 1660-1719

HOUCKGEEST Gerard
Dutch 1600-61

HOUDON Jean Antoine
French 1741-1828

HOUE Friedrich Heinrich von
Dutch 17th Century

HOUEL J P L L
French 1735-1815

HOUTEN C
Dutch 18th Century

HOVE Edmond Theodor van
Belgian 19th Century

HOVE Hubertus van
Dutch 1814-65

HOWARD William
Dutch 17th Century

HOWITT William Samuel
English 1765-1822

HUBER Jean Daniel
Swiss 1754-1845

HUBER Léon Charles
French 1858-1928

HUBERT Wolfgang
German 1490-1553

HUBERTI Adrian
Flemish 17th Century

HUBERTI Eduard Jules Joseph
Belgian 1818-80

HUCHTENBURG Jacob van
Dutch 1639-75

HUCHTENBURG Jan van
Flemish 1647-1733

HUDSON Thomas
English 1701-79

HUE Jean François
French 1751-1823

HUE L J de
Dutch 1623-81

HUEBNER Carl Wilhelm
German 1814-79

HUET Jean Baptiste
French 1745-1811

HUET Paul
French 1803-69

HUGGINS Williams
English 1837-84

HUGO Victor Marie
French 1802-85

HUGUES Paul Jean
French 19th-20th Centuries

HUILLARD Esther
French 19th-20th Centuries

HULSDONCK Jacob van
Flemish 1582-1647

HVLSDONCK

HULSEN Ezajas van
Dutch 1580-1665

E.V H.

HULSEN Friedrich van
Dutch 1580-1665

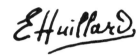

HULSMANN Johann
German 17th Century

J.H.

HULST Frans de
Flemish 1610-61

F. D. HVLST.

HULST P Iv van der
Dutch 1651-1727

PVH f.

HULSWIT Jan
Dutch 1766-1822

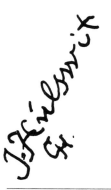

HUMBACH Jonas
German

HUMBERT J F
French 19th-20th Centuries

HUMBERT Jan
Dutch 1734-94

HUMPHRY Ozias
English 1742-1810

HUNT H
English 17th Century

HUNT William Henry
English 1790-1864

HUQUIER Gabriel
French 1659-1772

HURTREL A C N
French 1817-61

HUYGENS F L
Dutch 1802-87

HUYOT Etienne
French 19th Century

HUYSMANS Cornelis
Flemish 1648-1727

HUYSMANS Jan Baptist
Flemish 1654-1716

HUYSMANS Jan Baptist
Belgian 19th-20th Centuries

HUYSMANS P J
Flemish 18th Century

HUYSUM Jan van
Dutch 1682-1749

HUYSUM Jan van
Dutch 1682-1749

HUYSUM Justus van Sr
Dutch 1659-1716

HUYSUM Justus van Jr
Dutch 1684-1707

HUYSUM Michiel van
Dutch 1729-59

HYPPOLITE Hector
Haitian 1894–1948

HYSEBRANT
see ISENBRANT

IJKENS Frans
Flemish 1601-93

IJKENS Peter
Flemish 1648-95

IMBERT Joseph Gabriel
French 1666-1749

IMMENRAET Philips Augustyn
Flemish 1627-79

INDACO Jacopo
Italian 1476-1526

INGEN Willem
Flemish 1651-1708

INGOLI Matteo (Ravennate)
Italian 1587-1631

INGRES Jean Auguste Dominique
French 1780-1867

INJALBERT Jean Antoine
French 1845-1933

INNES James Dickson
English 1887-1914
By courtesy of the National
Museum of Wales

IRALAYUSO Matias Antonio
Spanish 1680-1753

ISAAKSZ Pieter Franz
Dutch 1569-1625

ISABEY Jean Baptiste
French 1767-1855

ISABEY Louis Gabriele Eugène
French 1803-86

ISACSON Isaac
Dutch 1599-1665

ISENBRANT Hysebrant or
YSENBRANT Adriaen
Flemish 16th Century

ISENDYCK Anton van or
YSENDYCK
Belgian 1801-75

ISRAELS Joseph
Dutch 1824-1911

ISSELSTEYN Adrianus van
Dutch 17th Century

IWILL M J L C
French 1850-1923

IUVENOMIS
see GIOVEHONE Girolamo

IUVENONO
see GIOVENONE P B G

JACKSON Alexander Young
Canadian 1882–1974

JACOB Cyprien Max
French 1876-1944

JACOB Julius
German 1811-82

JACOBS Huybrecht
Dutch 1562-1631

JACOBS Jakob Albrecht Michael
(Jacob Jacobs)
Belgian 1812-79

JACOBSEN Juriaen
German 1625-85

JACOBSZ Dirck
Dutch 16th Century

99

JACOBSZ Simon
Dutch 16th Century

JACQUE Charles Emile
French 1813-94

JACQUEMART Jules Ferdinand
French 1837-80

JACQUET Gustave Jean
French 1846-1909

JADIN Louis G
French 1805-82

JAGER Gerard de
Dutch 17th Century

JANNET
see CLOUET François

JANSEN F
Dutch 17th Century

JANSEN Gerhard
Dutch 1636-1725

JANSEN Pieter
Dutch 17th Century

JANSON Johannes
Dutch 1729-84

JANSSENS Abrahams
Flemish 18th Century

JANSSENS Hendrick
Flemish 17th Century

JANSSENS Hieronymus
Flemish 1624-93

JANSSENS Pieter Elinga
Dutch 17th Century

JANSSENS Victor Honore
Flemish 1658-1736

JARNEFELT Eero Nikolai
Finnish 19th-20th Centuries

JOHNS Jasper
American 1930–

JAUREGUY y AGUILAR Juan de
Spanish 1570-1641

JAWLENSKY Alexei
German 1912–

JEAN Jean
French 1877-1948

JEANRON Philippe Auguste
French 1809-77

JEAURAT Edme
French 1688-1738

JEGHERS Jan
Flemish 1618-1667

JELGERHUIS Johannes
Dutch 1770-1836

JELGERSMA Tako Hajo
Dutch 1702-95

JENICHEN Balthasar
German 17th Century

JEROME Ambrosini
English 1840-71

JODE Gerhard de
Flemish 1509-91

JODE Peeter de
Belgian 1570-1634

JOHN Augustus
English 1878-1961

JOHN Gwen
English 1876-1939

JOHNSON David
American 1827–1908

JOHNSON Eastman
American 1824–1906

JOLLAIN Nicolas René
French 1732-1804

JOLLAT G
French 15th-16th Centuries

JOLLIVET Pierre Jules
French 1794-1871

JONCIERE L J V de
French 19th-20th Centuries

JONES Frances
Australian 1923–

JONGH Claude de
Dutch 17th Century

JONGH Frans de
Dutch 17th-18th Centuries

JONGH Ludolf de
Dutch 1616-79

JONGHE Gustave Leonhard de
Belgian 1829-93

JONGKIND Johan
Dutch 1819-91

JONGMAN Wouter
Dutch 17th Century

JONSON
see CEULON Cornelis

JOORS Eugeen
Belgian 19th-20th Centuries

JORDAENS Hans
Dutch 1616-80

JORDAENS III Hans
Flemish 1595-1643

JORDAENS Jacob
Flemish 1593-1678

JORDAN Edouard
German 19th Century

JORISZ Jan (David)
Flemish 1500-56

JORN Asger
Danish 1914–1973

JOSI Christian
Dutch 19th Century

JOUAS Charles
French 1866-1942

JOUBERT Léon
French 19th Century

JOUVE Paul
French 19th-20th Centuries

JOUVENET Jean Baptiste
French 1644-1717

JOVACHEFF Christo
American 1935–

JUAN DE SEVILLA Romero Y
Escalante
Spanish 1643-95

JULIENNE Eugène
French 1800-74

JUNCOSA F Joaquin
Spanish 1631-1708

JUNGWIRTH Franz Xavier
German 1720-90

JUNIUS Isaak
Dutch 17th Century

JURGENS Grethe
German 1899–1951

JUTSUM Henry
English 1816-69

JUVENEL Paul
German 1579-1643

KAA Jan van der
Dutch 1813-77

KABEL
see CABEL Adrian van der

KAGER Johan Mathias
German 1575-1634

KAHLO Frida
American 1910–1954

KAHN Wolf
American 20th Century

KAISER Johan Wilhelm
Dutch 1813-1900

KALDENBACH Johan Anthoni
Dutch 1760-1818

KALF Willem
Dutch 1622-93

KALRAAT Barend van
Dutch 1649-1737

KAMPER Godaert
Dutch 1614-79

KANDEL David
French 1527-87
By courtesy of the Louvre

KANDINSKY Vasily
Russian 1866–1944

KANE John
American 1860–1934

KANNEL David
see KANDEL

KAPPEN Francis van der
Dutch 1660-1723

KARG Georg
German 17th Century

KARLINGEN Pierre van
Dutch 17th Century

KARTARUS Marius
Italian 1540-80

KASHINA Nina V.
Russian 1903–

KASTEELS Peter II
Flemish 17th Century

KATZ Alex
American 1927–

KATZ Mané
Russian 1894–1962

KAUFMANN Angelica Catharina
Maria Anna
Swiss 1740-1807

KAUFMANN Herman
German 1808-89

KAUKE Johann Friedrich
German 18th Century

KEELHOFF Frans
Belgian 1820-93

KEERINCK Alexandre
Flemish 1600-52

KELLEN David van der
Dutch 1827-95

KELLER Ferdinand
German 1842-1922

KELLER Georg
German 1568-1640

KELLER Johann Heinrich
Swiss 1692-1765

KELLERHOVEN Moritz
German 1758-1830

KELLERTHALER Johan
German 16th Century

KEMENY Zoltan
Hungarian 1907–1965

KEMM Robert F
English 19th Century

KEMP Nicolaes de
Dutch 1574-1646

KENT William
English 1684-1758

KERCKHOVE Joseph van der
Flemish 1667-1724

KERNKAMP Anny
Belgian 19th Century

KERRICX Willem Ignatius
Flemish 1682-1745

KERVER Jacob
German 16th Century

KESSEL Jan III van
Dutch 1641-80

KESSEL Theodorus van
Dutch 17th Century

KETEL Cornelis
Dutch 1548-1616

KETTLE Tilly
English 1735-86

KEY Adrien Thomas
Flemish 1544-1590

KEY Willem
Flemish 1515-68

KEYSER Albert de
Belgian 1829-90

KEYSER Hendrik de
Dutch 1565-1621

KEYSER Nicaise de
Flemish 1813-87

KEYSER Thomas de
Dutch 1596-1667

KEYSER Willem II de
Flemish 1647-92

KHODASHEVICH Valentina M.
Russian 1894–1970

KIEFT Jan
Dutch 1798-1870

KIERS Petrus
Dutch 1807-75

KIESER Eberhard
German 17th Century

KIKOINE Michael
Russian 19th-20th Centuries

KINDERMANS Jean Baptiste
Belgian 1822-76

KING Daniel
English 17th Century

KINSOEN François Joseph
Flemish 1771-1839

KIOERBOE Carl Frederik
Swedish 1799-1876

KIRSCHNER Ernst Ludwig
German 1880-1938

KISLING Moise
French 1891-1953

KITAJ Ron B.
American 1932–

KLAPHAUER Johann Georg
German 17th Century

KLASS F C
German 1752-1827

KLEE Paul
Swiss 1879-1940

KLENGEL Johann Christian
German 1751-1824

KLIMT Gustav
Austrian 1862-1918

KLINE Franz
American 1910–1962

KLINGER Max
German 1857-1920

KLIUN Ivan V.
Russian 1870–1942

KLOMP Albert Jansz
Dutch 1618-88

KNAPTON George
English 1698-1778
By courtesy of Sheffield Art Gallery

KNAUS Ludwig
German 1829-1910

KNECHTELMAN Lucas
German 16th Century

KNECHTELMAN Marx
German 15th Century

KNELLER Gottfried (Sir Godfrey)
German 1646-1723

KNELLER J Z
German 1644-1702

KNIGHT Daniel Ridgway
American 1839-1924

KNIGHT John Buxton
English 1843-1908

KNOLLER Martin
Austrian 1725-1804

KNOPF Fernand
German 1858-1921

KNUPFER Nicolaus
German 1603-60

KNYFF Alfred de
Belgian 1819-95

KNYFFE Wouter
Dutch 1607-93

KOBELL Ferdinand
German 1740-99

KOBELL Jan I
Dutch 1756-1833

KOEYDYCK Isaac
Dutch 1616-68

KOEKKOEK Barend Cornelis
Dutch 1803-62

KOEKKOEK Hermanus
Dutch 1815-82

KOELMAN Johan Daniel
Dutch 1831-57

KOENE Jean
Flemish 1532-92

KOETS Roelof Jr
Dutch 1655-1725

KOHL Andreas
German 1624-57

KOKER Anna Maria de
Dutch 17th Century

KOKOSCHKA Oskar
Austrian 19th-20th Centuries

KOELBE Carl Wilhelm
German 1757-1835

KONCHALOVSKY Piotr A.
Russian 1876–1956

KONIG Franz Niklaus
Swiss 1765-1832

KONINCK Jacob I
Dutch 1616-1708

KONINCK Philips de
Dutch 1619-88

KONINCK Salomon
Dutch 17th Century

KOOGHE or **COOG** Abraham de
Dutch 17th Century

KOOI Willem Bartel van der
Dutch 1768-1836

KOOL Wilhelm Gillesz
Dutch 1608-66

KOPP Georg
German 1570-1622

KOTASZ Karoly
Hungarian 19th-20th Centuries

KOVACIC Mijo
Yugoslavian 1935–

KOZLYNSKY Vladimir I.
Russian 1891–1967

KRAFFT Johann Peter
German 1780-1856

KRAHE Lambert
German 1712-1790

KRAUS Georg Melchior
German 1737-1806

KRAUS Johann Ulrich
German 1655-1719

KRAUS P J
German 1789-1864

KRAUSE François
German 1705-52

KREMEGNE Pinchus
Russian 19th-20th Centuries

KREMER Petrus
Flemish 1801-88

KRODEL Matthias Sr
German 16th-17th Centuries

KROHG Per Lasson
Norwegian 19th-20th Centuries

KRUG Ludwig
German 1489-1532

KRUMPIGEL Karl
Austrian 1805-32

KRUSEMAN Cornelis
Dutch 1797-1857

KRUSEMAN J A J
Dutch 1804-62

KUBIN Alfred
German 1877-1958

KUFFNER Abraham Wolfgang
German 1760-1817

KUGELGEN Franz Gerhard von
German 1772-1820

KUHN Walt
American 1877–1949

KUIL Gysbert van der
Dutch 17th Century

KULMBACH Hans S von
German 1480-1522

KUPETZKI Johann
German 1667-1740

KUPKA Frank
Czechoslovakian 1871-1957

KUPREIANOV Nikolai N.
Russian 1894–1933

KURDOV Valentin I.
Russian 1905–

KUYCK F P L
Belgian 1852-1915

KUYCK Jean Louis van
Flemish 1821-71

KUYPER Jacques
Dutch 1761-1808

KUYPERS Dirk
Dutch 1733-96

KUYTENBOUWER Martinus
Antonius Sr
Dutch 1821-97

KUZNETSOV Pavel V.
Russian 1878–1968

KVAPIL Charles
Belgian 19th-20th Centuries

LAAR or **LAER** Pieter Jacobsz van
Dutch 1582-1642

LABAS Alexander A.
Russian 1900–1983

LABISSE Jean
French 20th Century

LABITTE Eugène Léon
French 19th-20th Centuries

LABORDE L E J S
French 1807-69

LABOREUR Jean Emile
French 1877-1943

LACHTROPIUS Nicolas
Dutch 17th Century

LACKOVIC Ivan
Yugoslavian 1932–

LADECQ Jacques
French 1626-74

LADENSPELDER Johann (Hans von Essen)
Dutch 16th Century

LADMIRAL Jacob II
French 1700-70

IL'A un.

LAECK Reynier van der
Dutch 17th Century

LAERMANS Eugène Jules Joseph
Belgian 1864-1940

Eug. Laerman

LA FARGE John
American 1835–1910

La Farge

LA-FAGE Raymond de
French 1650-84

LA FOND Charles Nicolas Rafael
French 1774-1835

LAFOND.

LA FRESNAYE Roger Nöel François du
French 1885-1925

R. de la Fresnaye

LAGAR Celso
Spanish 1891-1966

Lagar

LAGARDE Pierre
French 1853-1910

Pierre Lagarde

LAGIER Eugene
French 1817-92

EVG. LAGIER.

LAGOOR or **LAGSAT** J P
Dutch 17th Century

LAGRENEE Jean Jacques Jr
French 1739-1821

Lagrenée

LAGYE Victor
Belgian 1825-96

V. Lagye

LA HIRE Laurent de
French 1606-56

LH, LH, L de LH., L H.

LAIRESSE Gerard de
Flemish 1641-1711

GD,
GdL, GdL,
G. Lairesse f.

LAIRESSE Renier de
Flemish 1596-1667

R Lairese.

LALAING J de
Belgian 1858-1917

J. de Lalaing

LALIBERTE Alfred
Canadian 1878–1953

a. Laliberte

LALIBERTE Madeleine
Canadian 1912–

Madeleine Laliberte

LALLEMAND Georges
French 1575-1635

G Lallemand.
Ge, LALe.

LALLEMAND Jean Baptiste
French 1710-1803

J B Lallemand.

LALLEMAND Philippe
French 1636-1716

ph Lallemand

LAMA Giovanni Battista
Italian 1660-1740

Bd ama

LAMBEAUX Jules
Belgian 1858-1890

Jules Lambeaux

LAMBERT Jean
Flemish 15th Century

LAm,
LAM.

LAMBERT Louis Eugène
French 1825-1900

L. Eug Lambert

LAMBINET Emile Charles
French 1815-77

LAMBRECHTS Jan Baptist
Flemish 1680-1731

LAMEN Cristoffel Jacobsz van der
Flemish 1615-51

LAMME Arie Johannes
Dutch 1812-1900

LAMORINIERE Jean Pierre
François
Belgian 1828-1911

LAMSWEERDE Stewen van
Dutch 17th Century

LANA DA MODENA Lodovico
Italian 1597-1646

LANCHARES Antonio de
Spanish 1586-1658

LANCRET Nicolas
French 1690-1743

LANDE Willem van
Dutch 17th Century

LANDELLE Charles Zacharie
French 1812-1908

LANDER James Eckford
Scottish 1811-69

LANDERER Ferdinand
Austrian 1730-95

LANDSEER Sir Edwin
English 1802-73

LANDFRANCO G di S
Italian 1582-1647

LANGER Robert Joseph von
German 1783-1846

LANGETTI Giovanni Battista
Italian 1625-76

LANGLEY Walter
English 1852-1922

LANGLOIS Jean Charles
French 1789-1870

LANNES Mario
Italian 1900–

LANQUE Félix Hippolyte
French 1812-72

LANSINCK J W
Dutch 18th Century

LANTARA S M
French 1729-78

LAPARRA W J E E
French 1873-1920

LA PATELLIERE A M D
French 1890-1932

LAPI Niccolo
Italian 1661-1732

LAPIS Gaetano
Italian 1706-58

LAPP Jan Willemsz
Dutch 17th Century

LAPRADE Pierre
French 1875-1932

LAQUY Willem Joseph
German 1738-98

LARGILLIERE Nicolas de
French 1656-1746

LARIONOFF Michel
Russian 19th-20th Centuries

LARIVIERE Charles F A de
French 1798-1876

LARMESSIN Nicolas III Jr
French 1640-1725

LAROCK Evert
Belgian 1865-1901

LAROON Marcel
Dutch 1653-1702

LA RUE Philibert Benoit de
French 1718-80

LA SIZERANNE Max Monier de
French 19th Century

LASNE Michel
French 1590-1667

LAST C C A
Dutch 1808-76

LASTMAN Nicolas Petri
Dutch 1586-1625

LASTMAN Pieter Peitersz
Dutch 1583-1633

LASZLO DE LOMBOS P A de
English 19th-20th Centuries

LA TOUCHE Gaston de
French 1854-1913

LATOUR Jan
Flemish 1719-82

LAUDIN Nöel Sr
French 1586-1681

LAUGEE Desire François
French 1823-96

LAUKO Juraj
Czechoslovakian 1894–1974

LAUR Marie Yvonne
French 19th-20th Centuries

LAURE J F H J
French 1806-61

LAURENCIN Marie
French 1885-1956

LAURENS Henri
French 1885-1954

LAURENS Jean Paul
French 1838-1921

LAURENS Jules Joseph Augustin
French 1825-1901

LAURENT Ernest Joseph
French 1859-1929

LAURENT Jean Antoine
French 1763-1832

LAUREUS Alexander
Danish 1783-1823

LAURI Philipp
Italian 1623-94

LAUTENSACK Hans
German 1524-60

LAUTENSACK Heinrich
German 1522-68

LAUWER Coenraed
Flemish 1632-85

LAVAUDAN Alphonse
French 1796-1857

LAVRUT Louise
French 19th-20th Centuries

LAWRENCE Sir Thomas
English 1769-1830

LAWSON Ernest
American 1873–1959

LAZERGES Jean Raymond
Hippolyte
French 1817-87

LAZZARINI Gregorio
Italian 1655-1730

LEANDRE Charles Lucien
French 1862-1930

LEAR Edward
English 1812-88
By courtesy of the Ashmolean
Museum Oxford

LE BARBIER J J F
French 1738-1826

LEBASQUE Henri
French 1865-1937

LEBEDEV Vladimir V.
Russian 1891–1967

LE BLANT Julien
French 19th-20th Centuries

LE BLON Michael
German 1587-1656

LE BLOND Jean
French 1635-1709

LE BORNE Joseph Louis
French 1796-1865

LEBOURG Albert Charles
French 1849-1928

LEBOUTEUX Pierre Michel
French 1683-1750

LE BRUN Charles
French 1619-90

LEBSCHEE Carl August
Polish 1800-77

LECLAIRE Victor
French 1830–1885

LECLERC David
German 1679-1738

LECLERC Jean
French 1587-1633

LE CLERC Jean
French 17th Century

LE CLERC Sebastien
French 1637-1714

LECOMTE Hippolyte
French 1781-1857

LECOMTE Paul
French 1842-1920

LEDESMA Blas de
Spanish 16th Century

LEDESMA José de
Spanish 1630-70

LEDRU Hilaire
French 1769-1840

LEDUC Fernand
Canadian 1916–

LEEMANS Antonius
Dutch 1631-73

LEEMANS Egide François
Belgian 1839-83

LEEMANS Johannes
Dutch 1633-88

LEEMPUTTEN Cornelis van
Belgian 1841-1902

LEEMPUTTEN Frans van
Belgian 1850-1914

LEEUW Govaert
Dutch 1645-88

LEEUW Pieter van der
Dutch 17th Century

LEEUW Willem van der
Flemish 1603-65

LE FAUCONNIER Henri Victor
Gabriel
French 1881-1946

LEFEBVRE Charles Victor Eugène
French 1805-82

LEFEBVRE Claude
French 1632-75

LEFEBVRE Jules Joseph
French 1836-1911

LEFEVRE R J F F
French 1755-1830

LEFORT Jean Louis
French 19th-20th Centuries

LEGENDRE Louis Félix
French 18th Century

LEGER Fernand
French 1881-1955

LEGI Gaicomo
Italian 17th Century

LEGRAND Jenny
French 19th Century

LEGRAND Louis Auguste Mathieu
French 1863-1951

LEGROS Alphonse
French 1837-1911

LEITCH William Leighton
English 1804-83

LELEN P de
Dutch 17th Century

LELEV Alexandre Félix
French 19th-20th Centuries

LELEUX Adolphe Pierre
French 1812-91

LELIE Adriaen de
Dutch 1755-1820

LELIENBERGH Cornelis
Dutch 17th Century

LELOIR Maurice
French 1853-1940

LELY Pieter van der Faes
English 1618-80

LEMAIRE François
French 1620-88

LEMBKE Johann Philipp
German 1631-1711

LEMETTAY Pierre Charles
French 1726-59

LEMIEUX Jean Paul
Canadian 1904–

LEMIRE Antoine
French 18th-19th Century

LEMONNIER A C G
French 1743-1824

LEMORDANT Jean Julien
French 19th-20th Centuries

LEMOYNE François
French 1688-1737

LEMOYNE Jean Baptiste
French 1704-78

LEMPEREUR Jean Denis
French 1701-65

LE NAIN Antoine
French 1588-1648

LENGERICH Imanuel Heinrich
German 1790-1865

LENNARD Erica
American 1950–

LENS Adries
Belgian 1739-1822

LENS Bernard
English 1659-1725

LENS Johannes Jacobus
Flemish 1746-1814

LEONARDO José
Spanish 1605-56

LEONART Johann Friedrich
Flemish 1633-80

LEPAULLE F G G
French 1804-86

LEPERE Auguste Louis
French 1849-1918

LEPICIE Bernard François
French 1698-1755

LEPICIE Michel Nicolas Bernard
French 1735-84

LEPINE Stanislas Victor Edouard
French 1835-92

LEPOITTEVIN E M Edmond
French 1806-70

LERAMBERT Louis
French 1620-70

LERCHE Vincent
Norwegian 1837-92

LERIUS Joseph Henri François
Belgian 1823-76

LEROLLE Henri
French 1848-1929

LEROUX Georges Paul
French 19th-20th Centuries

LEROUX Jules Marie Auguste
French 19th-20th Centuries

≈AUGUSTE LEROUX

LEROUX M G Charles
French 1814-95

charles le Roux

LEROY Henri
French 16th Century

h.e.R.f.

LESCOT H
see HAUDEBOURT A C H

LE SIDANER Henri Eugene
Augustin
French 1862-1939

LE SiDANeR

LESLIE Alfred
American 1927–

alfredleslie

LESLIE Charles Robert
English 1794-1859

LE SUEUR Eustache
French 1617-55

eustache le Sueur.

LE SUEUR Louis
French 18th Century

LE SUEUR Nicolas
French 17th-18th Centuries

LE SUEUR Pierre III
French 1669-1750

P.S, P.S, PLS.

LETELLIER Pierre
French 1614-76

letellier.

LEU August
German 1852-76

A Leu

LEUR Nicolaas van der
Dutch 1667-1726

NVLeur

LEVIER Adolfo
Italian 1873–1953

LEVIER

LEVINE Jack
American 1915–

JLevine

LEVY Emile
French 1826-90

EMILE LEVY

LEVY Henri Leopold
French 1840-1904

Henri Lévy

LEVY-DHURMER Lucien
French 1865-1953

L.L.Dhurmer

LEWIS John Frederick
English 1805-76

JFLewis.

LEWIS Percy Wyndham
English 1884-1957

wyndham lewis

LEYDEN Lucas van
Dutch 1494-1538

LVL.

LEYS Hendrik (Baron)
Belgian 1815-69

LEYSSENS Nicolaas
Flemish 1661-1700

N Leyssens.

LEYSTER Judith
Dutch 1600-60

LEYVA Diego
Spanish 1580-1637

J.D.Leyva.

LHERMITTE Léon Augustin
French 1844-1925

L.Lhermitte

LHOTE André
French 1885-1962

A.LHOTE.

LIBERI Marco
Italian 1640-87

M Liberi

LICHERIE DE BEURON Louis
French 1629-87

licherie

LICHTENSTEIN Roy
American 1923–

LIEFERINCK Hans I
Dutch 16th Century

H.,HL.

Han Lie.

LIEMACHER Nicolaas de
Flemish 1601-44

LIES Jozef Hendrik Hubert
Belgian 1821-65

LIEVENS Jan
Dutch 1607-74

LIEVENS Jan Andreas
Flemish 17th Century

LIGABUE Antonio
Italian 1899–

LIGARIO G Pietro
Italian 1686-1752

LIGOZZI Jacob
Italian 1547-1632

LILIO (Andrea da Anconanella Marca)
Italian 1555-1610

LIMBORCH Hendrik van
Dutch 1681-1759

LIMOSIN Leonard
French 1505-75

LIN Hans
Dutch 17th Century

LINDEGREN Amelie
Swedish 1814-91

LINDEMANN Christian Philipp
Dutch 1700-54

LINDNER Richard
American 1901–1978

LINDTMAYER Daniel Jr
Swiss 1552-1607

LINGELBACH Johannes
Dutch 1622-74

LINNELL John
English 1792-1882
By courtesy of Glasgow Art Gallery

LINNIG Egidius
Belgian 1821-60

LINNIG Willem Sr
Belgian 1819-85

LINNIG Willem Jr
Belgian 1842-90

LINSCHOTEN Adriaen C van
Dutch 1590-1677

LINT Hendrik van
Flemish 1684-1783

LINT Peter van
Flemish 1609-90

LINTON William James
English 1812-1898

LION Pierre Joseph
Flemish 1729-1809

LIPCHITZ Jacques
Lithuanian 1891–1973

LIPSCHITZ Jacques
French 19th-20th Centuries

LIPPI Fra Filippo di Tomaso
Italian 1406-69

LIPPI Giacomo
Italian 16th Century

LIPPI Lorenzo
Italian 1606-65

LIS Jan
Dutch 1570-1629

LISEBETTEN Peter van
Dutch 1630-78

LISSE Dirck van der
Dutch 17th Century

LIST Georg Nicolaus
German 17th Century

LLOYD James
British 1905–1974

LOARTE Alexandre de
Spanish 17th Century

LOBRE Maurice
French 1862-1951

LOCATELLI Andrea
Italian 1693-1741

LOCATELLI Jacopo
Venetian 1611-59

LOCHOM Bartholomeus van
Dutch 17th Century

LOCHOM Hans van
Dutch 16th Century

LOCHOM Michael van
Flemish 1601-47

LOCHON René
French 1636-75

LODEL Heinrich Burkhart
German 1798-1861

LODGE William
English 1649-89

LOENINGA Allart van
Dutch 17th Century

LOGGAN David
German 1635-92

LOGSDAIL William
English 1859-1944

LOHSE-WACHTLER Elfriede
German 1899–1940

LOIR Luigi
French 1845-1916

LOIR Nicolas Pierre
French 1624-79

LOIS Jacob
Dutch 1620-76

LOISY Jean de
French 1603-70

LOLLI Lorenzo
Italian 1612-91

LOMAZZO Giovanni Paolo
Italian 1538-1600

LOMBARD Pierre
French 1612-82

LOMI Baccio
Italian 16th Century

LONDERSEEL A van
Dutch 1572-1635

LONDERSEEL Jan van
Dutch 16th Century

LONDONIO Francesco
Italian 1723-83

LONGHI Alessandro
Italian 1733-1813

LONGUET Alexandre Marie
French 19th Century

LONS Dirk Eversen
Dutch 17th Century

LOO Charles André (Carle van)
French 1705-65

LOO Jacob van
Dutch 1614-70

LOOFF Jan
Dutch 17th Century

LOON Peter van
Flemish 1600-60

LOON Pieter van
Dutch 1731-84

LOON Theodor van
Flemish 1629-78

LOOTEN Jan
Dutch 1618-81

LOPEZ Cristobal
Spanish 1691-1730

LOPEZ Francisco
Spanish 17th Century

LORCH Melchoir
Danish 1527-94

LORCK Carl Julius
Norwegian 1829-82

LORICHON Constant Louis
Antoine
French 19th Century

LORRAINE Claude
see GELEE Claude

LOTH Johann Karl
German 1632-98

LOTH Johann Ulrich
German 1590-1662

LOTIRON Robert
French 1886-1966

LOTTO Lorenzo
Italian 1480-1556

LOTZE Moritz Eduard
German 1809-90

LOUBON Emile Charles Joseph
French 1809-63

LOUTHERBOURG Philipp Jacob
II de
French 1740-1812

LOUTREUIL Maurice Albert
French 1885-1925

LOVAK Branko
Yugoslavian 1944–1983

LOWRY Laurence Stephen
English 1887-1976

LUBIENIECKI Bogdan Theodor
Polish 17th-18th Centuries

LUCAS-ROBIQUET Marie Aimée
French 19th-20th Centuries

LUCCHESI Michele
Italian 16th Century

LUCE Maximilien
French 1858-1941

LUCINI Antonio Francesco
Italian 17th Century

LUDICK Lodewyck van
Dutch 1629-97

LUINI Bernardino
Italian 1475-1532
By courtesy of Milano
Pinacoteca di Brera

BNAF INVS LOVINȘ
BNAR INVS LOVINȘ

LUKS George
American 1867–1933

LUNDBERG Gustaf
Swedish 1695-1786

LUNDENS Gerrit
Dutch 1622-77

LUNOIS Alexandre
French 1834-91

LUPPEN G J A van
Belgian 1834-91

LURCAT Jean
French 1892-1966

LUST Ade
Dutch 17th Century

LUSURIER Catherine
French 1753-81

LUTGENDORFF F K T C P
(Baron de)
German 1785-1858

LUTMA Janus
Dutch 1624-89

LUTTICHUYS Isaak
Dutch 1616-73

LUYCK Hans van
Dutch 16th Century

LUYKEN Caspar
Dutch 1672-1708

LUYKEN Jan
Dutch 1649-1712

LUYKX or **LUCKX** Carstian
Flemish 1623-53

LUYTEN Jean Henri
Belgian 19th-20th Centuries

LYNCH Thomas
English 1857-62

LYONET Pieter
Dutch 1708-89

MAAS Dirk
Dutch 1659-1717

MCGREGOR Robert
English 1848-1922

MACCHI Florio
Italian 17th Century

MACDONALD WRIGHT
Stanton
American 1890–1973

MACE Charles
French 1631-65

MACKE August
German 1887-1914

MACWHIRTER John
Scottish 1839-1911

MAES Godefridus
Flemish 1649-1700

MAES Jan Baptist Lodewyck
Dutch 1794-1856

MAES or **MAAS** Nicolaas
Dutch 1632-93

MAES Pieter
Dutch 16th Century

MAGANZA Alessandro
Italian 1556-1630

MAGANZA Giovanni Battista
Italian 1513-86

MAGAUD D A J B
French 1817-99

MAGLIOLI G A
Italian 16th-17th Centuries

MAGNELLI Alberto
Italian 19th-20th Centuries

MAGRITTE Rene
Belgian 1898-1967

MAGY Jules Edouard de
French 1827-78

MAHU Cornelis
Flemish 1613-89

MAIGNAN Albert Pierre René
French 1845-1908

MAILLART Diogène Ulysse Napoleon
French 1840-1926

MAILLOL Aristide Joseph Bonaventure
French 1861-1944

MAIR Alexander
German 1559-1620

MAJOR Issac
German 1576-1630

MAKART Hans
Austrian 1840-84

MALEVICH Kazimir S.
Russian 1878–1935

MALI Christian Friedrich
German 1832-1906

MALLERY Philipp van
Flemish 16th-17th Centuries

MALLET Jean Baptiste
French 1759-1835

MALO Vincent
Flemish 1600-50

MAN Cornelis Willem de
Dutch 1621-1706

MANDER Karel van I
Dutch 1548-1606

MANDER Karel van III
Dutch 1610-72

MANDIN Jan
Dutch 1500-60

MANE-KATZ
French 1894-1962

MANET Edouard
French 1832-83

MANETTI Rutilio di Lorenzo
Italian 1571-1639

MANGUIN Henri Charles
French 1874-1949

MANNINI Giacomo Antonio
Italian 1646-1732

MANNOZZI Giovanni (Giovanni di san Giovanni)
Italian 1592-1636

MANSFELD Johann Georg
Austrian 1764-1817

MANTEGNA Andrea
Italian 1431-1506

MANUEL Hans Rudolf (Deutsch)
Swiss 1525-72

MANUEL Niklaus (Deutsch)
Swiss 1484-1531

MARAN Anuica
Yugoslavian 1918–1983

MARATTI Carlo Cavaliers
Italian 1625-1713

MARBEAU Philippe
French 1807-61

MARC Franz
German 1888-1916

MARCH Esteban
Spanish 16th-17th Centuries

MARCH Miguel
Spanish 1633-70

MARCHAL Charles François
French 1825-77

MARCHAND Jean Hippolyte
French 1883-1940

MARCKE-DE-LUMMEN Emile
van
French 1827-90

MARCONI Tocco
Italian 16th Century

MARCOUSSI L C L M
French 1883-1941

MARE André
French 1885-1932

MAREC Victor
French 1862-1902

MARELLI Andrea
Italian 16th Century

MARGARITONE Di Magnano
Italian 1216-1293

MARIA C del
see COSWAY Maria

MARIE Adrien Emmanuel
French 1848-91

MARILHAT Prosper Georges
Antoine
French 1811-47

MARIN John
American 1870-1953

MARINI Marino
Italian 1901–1980

MARINISTCH Christian de
French 19th-20th Centuries

MARINUS Ferdinand Joseph
Bernard
Belgian 1808-90

MARIS Jacob Henricus
Dutch 1837-99

MARIS Matthijs
Dutch 1839-1927

MARIS Willem
Dutch 1844-1910

MARKELBACH Alexandre P D
Belgian 1824-1906

MARLET Jean Henri
French 1771-1874

MARLOWE William
English 1740-1813

MARONIEZ Georges Philibert
French 19th-20th Centuries

MAROT François
French 1666-1719

MARQUET Pierre Albert
French 1875-1947

MARR Joseph Hendrik Ludwig
German 1807-71

MARREL Jacob
Dutch 1614-81

MARSAL Edouard Antoine
French 19th-20th Centuries

MARSEUS Otto
Dutch 1619-78

MARSH Reginald
American 1898–1954

MARSHALL Benjamin
English 1767-1835
By courtesy of the Henry E
Huntingdon Library and Art
Gallery

MARTIN Etienne Philippe
French 1858-1945

MARTIN H J G
French 1860-1943

MARTIN Jean Baptiste
French 1659-1735

MARTIN John
English 1789-1854

MARTIN Pierre Denis
French 1663-1742

MARTINA Umberto
Italian 1880–1945

MARTINEZ Ambrosio
Spanish 1630-74

MARTINEZ Sebastiano
Spanish 1602-67

MARTINI Arturo
Italian 1889-1949

MARTINUS
see KUYTENBROUWER
Martinus

MARUSSIG Guido
Italian 1885–1972

MARUSSIG Piero
Italian 1879–1937

MARVAL Jacqueline
French 1866-1932

MARVY Louis
French 1815-50

MASHKOV Ilya I.
Russian 1881–1958

MASSE Jean Baptiste
French 1687-1767

MASSON Andre
French 1896–

MASSON Henri
Canadian 1907–

MAST Hermann van der
Dutch 1550-1604

MATET C P F
French 1791-1870

MATHAN Jacob
Dutch 1571-1631

MATHEY Paul
French 19th-20th Centuries

MATHIEU Lambert Joseph
Belgian 1804-1861

MATHIEU Paul
Belgian 19th-20th Centuries

MATISSE Henri
French 1869-1954

MATIUSHIN Mikhail V.
Russian 1861–1934

MATON Bartholomeus
Dutch 17th Century

MATOUT Louis
Dutch 17th Century

MATTHIOLI Lodovico
Italian 1662-1747

MAUFRA Maxime Emile Louis
French 1861-1918

MAUPERCHE Henri
French 1602-86

MAURER Christoph
Swiss 1558-1614

MAUVE Anton
Dutch 1838-88

MAUZAISSE Jean Baptiste
French 1784-1844

MAX Gabril Cornelis
Czechoslovakian 1840-1915

MAYAN Théophile Henri
French 19th-20th Centuries

MAYER M F C L M
French 1775-1821

MAYRHOFER Johann Nepomuk
Austrian 1764-1832

MAZEROLLE Alexis Joseph
French 1826-89

MAZZOLA Girolame Francesco
Maria (il Parmigiano)
Italian 1503-40

MAZZUOLI Annibale
Italian 17th Century

MECHAU Jacob W
German 1745-1808

MECKEN Israel van
German 16th Century

MEER Barend van der
Dutch 17th Century

MEER Jan van der
Dutch 1628-91

MEER Jan van der (Vermeer)
Dutch 1632-75

MEER Jan van der Jr
Dutch 1656-1705

MEERHOUT Johan
Dutch 17th Century

MEGAN Renier
Flemish 1637-90

MEHEUT Mathurin
French 1882-1958

MEI Bernardino
Italian 1615-76

MEIER Melchior
Swiss 17th Century

MEIL Johann Wilhelm
German 1733-1805

MEIREN Jan Baptiste van der
Flemish 1664-1708

MEISSONIER Jean Louis Ernest
French 1815-91

MEISSONIER Justin Aurèle
French 1675-1750

MELDEMANN Nicolaus
German 16th Century

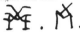

MELLAN Claude
French 1598-1688

MELLERY Xavier
Belgian 1845-1921

MEMLING or **HEMLING** Hans (Jan)
Flemish 1425-94

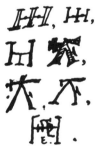

MENA Felipe Gil de
Spanish 1600-74

MENABUOI G di G de
Italian 14th Century

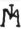

MENAGEOT François Guillaume
French 1744-1816

MENARD Marie Auguste Emile René
French 1862-1930

MENAROLA Crestano
Italian 17th Century

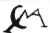

MENPES Mortimer L
English 19th-20th Centuries

MENTON Frans
Dutch 1550-1615

MENZEL Adolf Friedrich Erdmann
German 1815-1905

MENZLER Wilhelm
German 19th-20th Centuries

MERA Josef de
Spanish 19th Century

MERCIE Marius Jean Antonin
French 1845-1916

MERCK Jacob Fransz van der
Dutch 1610-64

MERCKELBACH Pieter
Dutch 1633-73

MEREN Johan van der
Dutch 17th Century

MERIAN Matthaus Sr
Swiss 1593-1650

MERSON Luc Olivier
French 1846-1920

MERYON Charles
French 1821-68

MESANESIS Antonius
see ANTONELLE DE MESSINA

MESDAG Hendrik Wilhem
Dutch 1831-1915

MESPLES Paul Eugène
French 19th-20th Centuries

MESSIN Charles (le Lorrain)
French 1620-49

METSU Gabriel
Dutch 1629-67

METSYS or **MASSYS** Jan
Flemish 1509-80

METSYS Quentin
Flemish 1466-1530

METTENLEITER Johann Jakob
German 1750-1825

METTENLEITER Johann Michael
German 1765-1853

METZINGER Jean
French 1883-1956

MEULIN Adam Frans van der
Flemish 1632-90

MEULEN Edmond van der
Belgian 1841-1905

MEULEN Isaak van der
Dutch 17th Century

MEULENER Pieter
Dutch 1602-54

MEUNIER Constantin Emile
Belgian 1831-1905

MEUSNIER Philippe
French 1655-1734

MEYBURG Bartholomeus
Dutch 1628-1708

MEYER Hendrick de I
Dutch 1600-90

MEYER Hendrick de II
Dutch 1737-93

MEYER Jan van der
Dutch 1681-1741

MEYER Rudolph Theodor
German 1605-38

MEYERHEIN Paul Friedrich
German 1842-1915

MEYERING Albert
Dutch 1645-1714

MICHALLON Achille Etna
French 1796-1822

MICHAU Theobald
Flemish 1676-1765

MICHEL Emile François
French 1818-1909

MICHEL Ernest Barthélémy
French 1833-1902

MICHELANGELO Buonarroti
Michelangelo
Florentine 1475-1564

MICHELIN Jean
French 1623-96

MIDDLETON John
English 1828-56

MIEL Jean
Flemish 1599-1663

MIEREVELD Jan van
Dutch 1604-33

MIEREVELT Michiel Janszoon
van
Dutch 1567-1641

MIERIS Frans van
Dutch 1635-81

MIERIS Frans van Jr
Dutch 1689-1763

MIERIS Jan van
Dutch 1660-90

MIERIS Willem van
Dutch 1662-1747

MIGNARD Paul
French 1639-91

MIGNARD Pierre I
French 1612-95

MIGNON Abraham
German 1640-79

MILDE Carl Julius
German 1803-75

MILICH Abraham Adolphe
Polish 19th-20th Centuries

MILLAIS Sir John Everett
English 1829-96
By courtesy of the Guildhall
 Art Gallery London

MILLET Jean-François
French 1814-75

MINDERHOUT Hendrick van
Dutch 1632-96

MINGUET André Joseph
Belgian 1818-60

MIRO Joan
Spanish 19th-20th Centuries

MIROU Antoine
Flemish 1586-1661

MITELLI Guiseppe Maria
Italian 1634-1718

MOCETTO Girolamo
Italian 1458-1531

MODERSOHN-BECKER Paula
German 1876–1907

MODIGLIANI Amedeo
Italian 1884-1920

MODOTTO Angilotto
Italian 1900–1968

MOEYART Nicolaes Cornelisz
Dutch 1592-1655

MOHEDANO Antonio
Spanish 1560-1625

MOL Pieter
Flemish 1599-1650

MOLANUS Mattheus
Dutch 17th Century

MOLENAER Claes
Dutch 1630-76

MOLENAER Cornelis
Flemish 1540-89

MOLENAER Johannes
Dutch 1610-68

MOLS Robert C G L
Belgian 1848-1903

MOLYN Anthoni de
Dutch 17th-18th Centuries

MOLYN Petrus Marius
Belgian 1819-49

MOLYN Pieter Sr
Dutch 1595-1661

MOMAL Jacques François
French 1754-1832

MOMMERS Hendrik
Dutch 1623-93

MOMPER Frans de
Flemish 1603-60

MOMPER Joos
Flemish 1564-1635

MONAI Fulvio
Yugoslavian 1926–

MONDRIAN Peter Cornelis (Piet)
Dutch 1872-1944

MONDZAIN S F S
French 1890-1914

MONET Claude
French 1840-1926

MONGIN Antoine Pierre
French 1761-1827

MONGINOT Charles
French 1825-1900

MONI Louis de
Dutch 1698-1771

MONNIER Henri Bonaventur
French 1805-77

MONSIAU Nicolas André
French 1754-1837

MONTAGNA Bartholomeo
Italian 1450-1523

MONTAGNE Agricol Louis
French 1879-1960

MONTEN Heinrich Maria Dietrich
German 1799-1843

MONTENARD Frédéric
French 1849-1926

MONTEZIN Pierre Eugène
French 1874-1946

MONTICELLI Adolphe Joseph
Thomas
French 1824-86

MONVOISIN R P J
French 1794-1870

MOOR Carel de
French 1656-1738

MOORE Charles Herbert
American 1840–1930

MOORE Henry
English 1898-

MOR or **MOOR** Antonnis
Dutch 1519-75

MORA Jeronimo
Spanish 1540-99

MORAN Thomas
British 1837–1926

MORANDI Giorgio
Italian 1890-1964

MORBELLI Angelo
Italian 1835-1919

MORDT Gustav Adolph
Norwegian 1826-56

MOREAU-DE-TOURS Georges
French 1848-1901

MOREAU Gustave
French 1826-98

MOREAU Jean Michel Jr
French 1741-1814

MOREAU Luc Albert
French 1882-1948

MOREAU-NELATON A E A
French 1859-1927

MOREELSE Paulus
Dutch 1571-1638

MOREL-FATIO Antonie Léon
French 1810-71

MORENO José
Spanish 1642-74

MORETTO Alessandro Bonvicino
Italian 1498-1554

MORGHEN Rafaello
Italian 1758-1833

MORIN Edmond
French 1824-82

MORISOT Berthe
French 1841-95

MORISSET François Henri
French 19th-20th Centuries

MORLAND George
English 1763-1804
By courtesy of the Manchester
 City Art Galleries

MORLEY Malcolm
British 1931–

MORLON Paul Emile Antony
French 19th Century

MORONI Giovanni Battista
Italian 1525-78

MOROT Aimé Nicolas
French 1850-1913

MORRICE James Wilson
Canadian 1865–1924

MORRIS William
English 1834-96

MORTEL Jan
Dutch 1650-1719

MORTIMER John Hamilton
English 1741-79

MOSER George Michael
English 1706-83

MOSES Ann May Robertson
'Grandma'
American 1860-1961

MOSNIER Jean
French 1600-56

MOSSCHER Jacob van
Dutch 16th-17th Centuries

MOSSETTI Giovanni Pablo
Italian 16th Century

MOSTAERT Gillis
Flemish 1534-98

MOTHERWELL Robert
American 1915–

MOTTA Raphael (Rafaellino de
Reggio)
Italian 1550-78

MOTTEZ Victor Louis
French 1809-97

MOUCHERON Frédéric de
Dutch 1633-86

MOUCHERON Isaac de
Dutch 1667-1744

MOUCHET François Nicolas
French 1750-1814

MOULIGNON Henri Antoine
Léopold de
French 1821-97

MOUTTE J J M A
French 1840-1913

MOZART Anton
German 1573-1625

MOZIN Charles Louis
French 1806-62

C. Mozin

MRAZ Franjo
Yugoslavian 1910–81

F. Mraz

MUCHA Alphonse
Czechoslovakian 1860-1939

MUENIER Jules Alexis
French 19th-20th Centuries

J-A·MUENIER.

MUIRHEAD David
English 1867-1930

David Muirhead

MULICH Hans
German 1515-73

MULIER Pieter Sr
Dutch 1615-70

M .

MULIER Pieter Jr
Dutch 1637-1701

·P·J·

MULLER Charles Louis Lucien
French 1815-92

C.L.MÜLLER.

MULLER Hermann
Dutch 1540-1617

ML , M , M .

MULLER Jacques
Dutch 17th Century

J. Müller f.

MULLER Jan Harmansz
Dutch 1571-1628

IM.S , H f.

MULLER Morten
Norwegian 1828-1911

Morten Müller.

Müller

MUNCH Edvard
Norwegian 1863-1944

E. Munch.,

E M.

MUNGERSTORFF Peter
Austrian 16th Century

NF .

MUNIER Emile
French 19th Century

E.MUNIER.

MUNNINGS Sir Alfred
English 1878-1959

MUNOZ Sebastian
Spanish 1634-1709

Munoz.

MUNSCH Léopold
Austrian 1826-88

L MUNSCH.

MUNTHE Gerhard
German 1848-1929

G.MNE . M .

CM . Gm .

MUNTHE Ludwig
Norwegian 1841-96

L.Munthe,

L.Munthe .

MUNZER Adolf
German 19th-20th Centuries

Ad. Münzer.

MURANT Emmanuel
Dutch 1622-1700

E. M

MURILLO Bartolomé Esteban
Spanish 1618-82

BARME MRI LLO.

MB, BME .

MURRER Johann
German 1644-1713

J Murrer.

MUSI Agostino dei (Veneziano)
Italian 1490-1540

AV, A.V,

AV.

MUSIC Anton Zoran
Italian 1909–

MNSIC

MUSSCHER Mixhiel van
Dutch 1645-1705

M. Mvsscher

MUSSO Nicola
Italian 17th Century

N.MV.

MUTER Marie Mela
French 19th-20th Centuries

Muter

MUTRIE Anne Feray
English 1826-93

MUYKENS J B
Dutch 17th Century

BMuycker.

MUYS Nicolaes
Dutch 1740-1808

N: MUYS P=

MY Hieronymus van der
Dutch 1687-1761

MYN Frans van
Dutch 1719-83

MYN Hermann van der
Dutch 1684-1741

MYTENS Aert
Flemish 1541-1602

MYTENS Daniel Sr
Dutch 1590-1648

MYTENS Jan
Dutch 1614-70

NACHENIUS Jacob Jan
Dutch 18th Century

NAGEL Jan
Dutch 16th-17th Centuries

NAGEL Pieter
Flemish 16th Century

NAIGEON Jean Claude
French 1753-1832

NAIVEU Matthys
Dutch 1647-1721

NAIWINX Hendrik
Flemish 1619-51

NALDINI G B di M
Italian 1537-91

NANTEUIL Robert
French 1623-78

NANTEUIL-LEBOEUF C F
French 1813-73

NARBONNE Eugène
French 19th-20th Century

NARDI Angelo
Italian 1584-1663

NASH John
English 19th-20th Century

NASH John
English 19th-20th Century

NASOCCHIO Francesco
Italian 1478-1550

NASON Pieter
Dutch 1612-88

NATALIS Michael
Flemish 1610-68

NATHAN Arturo
Italian 1891–1944

NATHE Christoph
German 1753-1808

NATOIRE Charles Joseph
French 1700-77

NATTIER Jean Marc
French 1685-1766

NATTIER Marc
French 1642-1705

NATUS Anthony
Dutch 1636-60

NAUDET Caroline
French 1775-1839

NAUDET Thomas Charles
French 1778-1810

NAUDIN Bernard
French 1876-1940

NAUMANN Friedrich Gotthard
German 1750-1821

NAUMOVSKI Vangel
Yugoslavian 1908–1981

NAVARRO Juan Simon
Spanish 17th Century

NAVEZ Francois Joseph
Belgian 1787-1869

NEBBIA Cesare
Italian 1536-1614

NEBOT Balthasar
English 18th Century

NECK Jan van
Dutch 1635-1714

NEEFFS Pieter Sr
Flemish 1578-1656

NEEFFS Pieter Jr
Flemish 1620-75

NEER Aart van der
Flemish 1603-77

NEER Eglon Hendrick van der
Dutch 1634-1703

NEGRE Nicolas Claes van
Dutch 17th Century

NEGRI Pier Martire
Italian 1601-61

NEGRONE Pietro
Italian 1603-65

NELLI Niccolò
Italian 16th Century

NELLIUS Martinus
Dutch 1670-1706

NERENZ Wilhelm
German 1804-71

NERLY Friedrich
German 1807-78

NETSCHER Constantin
Dutch 1668-1723

NETSCHER Gaspar
Dutch 1639-84

NETT Adolphe Frédéric
Belgian 19th Century

NETTER Laurence
German 17th Century

NETTI Francesco
Italian 1834-94

NEUER Thomas
German 1768-1850

NEUHAUS Fritz Berthold
German 19th-20th Centuries

NEUHUYS Jan Anton
Dutch 1832-91

NEUMAN Jan Hendrick
German 1819-98

NEUVILLE Alphonse Marie de
French 1835-85

NEWMAN Henry R.
American 1843–1917

NEWMANN Barnett
American 1905–1970

NEYTS Aegilis
Flemish 1623-87

NEYTS Leonardo
Dutch 16th Century

NICHOLSON Ben
British 1894–1982

NICKELE Isaak van
Dutch 17th-18th Centuries

NICOLAI Jacques
Dutch 1605-78

NICOLIE Paul Emile
Belgian 1828-94

NICOTERA Marco Antonio
Italian 16th-17th Centuries

NIELSEN Amaldus Clarin
Norwegian 19th-20th Centuries

NIEULANDT Adriaen van
Flemish 1587-1658

NIEULANDT Jacob van
Dutch 1592-1634

NIEULANDT Willem II van
Flemish 1584-1635

NIEUWAEL W
Dutch 18th Century

NIWAEL Jan Rutgers van
Dutch 17th Century

NIGG Joseph
Austrian 1782-1863

NISBIEGEL J N
German 1750-1829

NITTIS Guiseppe de
Italian 1846-84

NIVINSKI I I
Russian 19th-20th Centuries

NOCRET Jean
French 1615-72

NOEL Alexis Nicolas
French 1792-1871

NOEL Jules Achille
French 1815-81

NOLDE Emil
German 1867-1956

NOLLEKENS Joseph Frans
Flemish 1702-48

NOLLI Carlo
Italian 18th-19th Centuries

NOLPE Pieter
Dutch 1613-53

NONOTTE Donatien
French 1708-85

NONO Luigi
Italian 1850-1918

NOORT Adam van Sr
Flemish 1562-1641

NOORT Jan van
Dutch 1620-76

NOORT Lambert van
Dutch 1520-71

NOORT Pieter van
Dutch 1602-48

NOOY Wouterus de
Dutch 1765-1820

NORDENBERG Bengt
Sweden 1822-1902

NORMANN Adelsteen
Norwegian 1848-1918

NORTHCOTE James
English 1746-1831

NOTER Pieter Frans de Jr
Belgian 1779-1843

NOTERMAN Emmanuel
Flemish 1808-63

NOTHNAGEL J A B
German 1729-1804

NOUAILHER Nicolas II (Colin)
French 16th Century

NOUAILHIER Sophie (neé DUROSEY)
French 18th Century

NOUTS Michiel
Dutch 17th Century

NOVELLI Francesco
Italian 1767-1838

NOZAL Alexandre
French 1852-1929

NUETZEL Hieronymus
German 16th Century

NUVELONE Carlo Francesco
Italian 1608-61

NYMEGEN Dionys van
Dutch 1705-89

NYMEGAN Gerard van
Dutch 1735-1808

NYPOORT Justus van den
Dutch 1625-92

OCHTERVELT Jakob
Dutch 1635-1710

OCTAVIEN François
French 1695-1736

ODDI Guiseppe
Italian 17th-18th Centuries

ODDI Mauro
Italian 1639-1702

ODERKERKEN Willem van
Dutch 17th Century

OEFELE F I B
Polish 1721-97

OEHLEN Albert
German 1954–

OEHLEN Marcus
German 1956–

OELGAST Thomas
German 16th Century

OESTERREICH Mathias
German 1716-78

OEVER Hendrik ten
Dutch 18th Century

OFFERMANS Anthony Jacob
Dutch 1796-1839

OFHUYS Jean
Flemish 16th Century

OKADA Kenzo
Japanese 1902–1982

O'KEFFE Georgia
American 1887–

OLDELAND Hendrik
Dutch 17th Century

OLDENBURG Claes
Swedish 1929–

OLIBEECK Jacob
Dutch 17th Century

IACOB OLIBEECK

OLIS Jan
Dutch 1610-76

OLIVA Pietre
Italian 15th Century

OLIVER Isaac
English 1556-1617

OLIVER John
English 1616-1701

OLIVIE Léon
French 1833-1901

OLIVIER Friedrich Waldemar
German 1790-1859

OMMEGANCH Balthasar Paul
Flemish 1755-1826

O'NEILL G B
English 1828-1917

GB O'Neill

OOMS Charles
Belgian 1845-1900

OOST Jacomo van
Belgian 1601-71

OOST Jan van Jr
Flemish 1637-1713

OOSTERDIJK Willem
Dutch 17th Century

W' OOSTERDI

OSTERWYCK Maria van
Dutch 1630-93

OPEL Peter
Dutch 1560-1616

OPIE John
English 1761-1807

OPPLER Ernest
German 1867-1929

OPSTAL Jasper Jacob van Sr
Flemish 1654-1717

ORBAN Dezso
Hungarian 19th-20th Centuries

ORIENT Josef
Hungarian 1677-1747

ORIOLO Giovanni de
Italian 15th Century

ORLANDO Bernardo
Italian 17th Century

ORLEY Bernard van
Flemish 1492-1542

ORLEY Jan van
Flemish 1665-1735

ORLEY Richard II van
Flemish 1663-1732

ORMEA Willem
Dutch 17th Century

OROZCO José Clemente
Mexican 1883-1949

ORSI Benedetto
Italian 17th Century

ORTEGA Pedro de
Spanish 16th Century

OS Jan van
Dutch 1744-1808

OS Pieter Gerardus van
Dutch 1766-1839

OSBORNE Walter F
English 1859-1903

OSELLI Casparo
Spanish 16th Century

OSMERKIN Alexander A.
Russian 1892–1953

OSSENBECK Jan van
Dutch 1624-74

OSSENBECK Willem
Dutch 17th Century

OSSINGER Michel
German 16th Century

OSTADE Adriaen van
Dutch 1610-84

OSTADE Isak van
Dutch 1621-49

OSTENDORFER Michael
German 1490-1559

OSTERHOUDT Daniel van
Dutch 1786-1850

OSTERLIND Anders
French 1887-1960

OSWALD Fritz
Swiss 19th-20th Centuries

OTTINI Felice
Italian 17th Century

F. O. F

OTTLEY William Young
English 1771-1836

OUDENDYCK Adrian
Dutch 1648-99

Aoudendyck.

OUDENROGGE J D van
Dutch 1622-53

J Oudenrogge

OUDERAA Jan van der
Flemish 1841-1915

VAN DER OUDERAA

OUDOT Roland
French 1897–1981

Roland Oudot

OUDRY Jacques Charles
French 1720-78

J. C. Oudry

OUDRY Jean Baptiste
French 1686-1755

JB Oudry.

OUTIN Pierre
French 1840-99

OUTIN

OUWATER Isaak
Dutch 1750-1793

J.ᵗ Ouwater.
J.ᵗ Ouwater.

OUWENALLEN Folpert van
Dutch 1635-1715

OUWERKERK Timotheus
Wilhelmus
Dutch 1845-1910

JW Ouwrrkerk.

OVENS Jurgens
German 1623-78

Jn. OVENS

OVERBECK Johann Friedrich
German 1789-1869

OVERLAET Anton
Dutch 1720-74

A, A.

OZANNE Pierre
French 1737-1813

P Q.

OZENFANT Amédée
French 1886-1966

ozenfant,

ozenfant .

PACHECO Francisco
Spanish 1564-1654

PADER Hilarie
French 1607-77

HP

PADTBRUGGE Hermann P
Swedish 17th-18th Centuries

PAEFFGEN C.O.
German 1933–

C. O. P

PAGGI Giovanni Battista
Italian 1554-1627

BP

PAGLIA Francesco
Italian 1636-1713

F Paglia.

PAJOL Pierre
French 1812-91

C P

PALAMEDES Anthonie
Dutch 1601-73

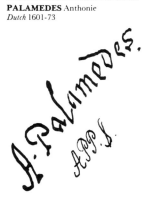

PALENCIA Pedro Honorio de
Spanish 17th Century

PH Palencia.

PALING Izaak
Dutch 1630-1719

I PALING

PALIZZI Guiseppe
Italian 1812-88

PALMA Jacopo (I Giovane)
Italian 1544-1628

PALMER Samuel
English 1805-81

PALMER Sutton
English 1854-1933

PALTHE Jan
Dutch 1719-69

l: PALTHE.

PANDEREN Egbert van
Dutch 1581-1637

PANETTI Domenico
Italian 1460-1513

PANINI Giovanni Paolo
Italian 1691-1765

J·P PANINI,

IB PANINI,

PANTOJA DE LA CRUZ Juan
Spanish 1551-1608

PAOLOZZI Eduardo
British 1924–

EDUARDO
PAOLOZZI

PAPE Abraham de
Dutch 1620-66

A·DE PAPE

PAPE Martin Didier
French 1574-1609

M·P.

PAPETY Dominique Louis
French 1815-49

PAPILLON Jean Baptiste
French 1661-1723

PAPILLON Jean Bicolas
French 1663-1714

PARASOLE Leonardo
Italian 1570-1630

PARAYRE Henri Ernest
French 19th-20th Centuries

PAREDES Jan de
Spanish 18th Century

PARENT Omer
Canadian 1907–

PARENT

PARISINI Agostino
Italian 17th Century

PARROCEL Joseph
French 1646-1704

PARROCEL Pierre
French 1670-1739

PET. PARROCEL.

PARROCEL Stefanus
French 1696-1776

PASCIN Julius P
American 1885-1930

PASINELLI Lorenzo
Italian 1629-1700

L.P.F.

PASINI Alberto
Italian 1826-99

PASQUALINI Johann Battista (da Centsa)
Italian 16th-17th Centuries

I B da Cento

PASRIN Gino
Italian 1876–1944

PASSAROTTI Bartolomeo
Italian 1529-92

PASSAVANT Johann David
German 1787-1861

PASSE Crispin de Sr
Dutch 1564-1637

PASSE Crispin de III
Dutch 17th Century

PASSE Magdalena van der
Dutch 1600-38

PASSE Simon de
Dutch 1595-1647

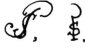

PASSE Wilhelm de
Dutch 1598-1637

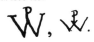

PATEL Antoine Pierre Jr
French 1648-1707

F PATEL

PATEL Pierre
French 1605-76

P·PATEL

PATER Jean Baptiste Joseph
French 1695-1736

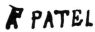

PATINIR Joachim
Flemish 1485-1524

JOACHIM · D · PATINIR

PATISSOU Jacques
French 1880-1925

J. Patissou

PATTISON Robert J.
American 1838–1903

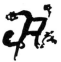

PAUDITZ Christoph
German 1618-67

C Pauditz

PAULEMILE-PISSARRO
French 19th-20th Centuries

Paulémile. Pissarro.
Paulémile.

PAULI Andries Jr
Flemish 17th Century

AD, A

PAULI Jean Antoine
French 17th Century

R·J, AP

PAULUS Melchior
German 1669-1745

MP.

PAULY Horatius
Dutch 1644-86

HP

PAVLOV Semion A.
Russian 1893–1941

PAYNE William
English 1760-1830

W. Payne

PAZZI Pietro Antonio
Italian 1706-66

PEALE Raphaelle
American 1774-1825
By courtesy of the
 Brooklyn Museum

Raphaelle Peale

Raphaelle Peale

PEALE Rembrandt
American 1778-1860

R. Peale

PECHSTEIN Hermann
German 1881-1955

HP. HP.
H.P. . MP.

PEDRINI Giovanni
Italian 16th Century

pedrini

PEE Jan van
Flemish 1640-1710

PEETERS Bonaventura I
Flemish 1614-52

PEETERS Clara
Flemish 16th Century

PEETERS Gillis
Flemish 1612-53

PEETERS Jan I
Flemish 1624-80

PEHAM
see BEHAM Bartel
BEHAM Hans Sebald

PEIC Sava
Yugoslavian 1940–

PELEGRET Tomas de
Spanish 16th Century

PELLAN Alfred
Canadian 1906–

PELLIER Nicolas François
French 1782-1804

PELLIS Joanny Napoleone
Italian 1888–1962

PELLIZZA DA VOLPEDO
Guiseppe
Italian 1868-1907

PELOUSE Leon Germain
French 1838-91

PENCZ Georges
German 1500-50

PENICAUD Leonard
French 1470-1542

PENNE Charles Olivier de
French 1831-97

PENNI Luca (Romano)
Italian 1500-56

PEPYN Marten
Flemish 1575-1642

PEQUIN Charles Etienne
French 19th-20th Centuries

PEREDA Antonio Sr
Spanish 17th Century

PERELLE Gabriel
French 1603-77

PEREYRA Vasco
Portuguese 1535-1609

PEREZ Andres
Spanish 1660-1727

PERGAUT Dominique
French 1729-1808

PERRIN Alphonse Henri
French 1798-1874

PERKINS Charles C
American 1823-86

PERMEKE Constant
Belgian 1886-1951

PERRET Aimé
French 1847-1927

PERRET Marius
French 1853-1900

PERRET Pedro
Spanish 1555-1639

PERRIER François
French 1584-1650

PERRIER Guillaume
French 1600-56

PERRONEAU Jean Baptiste
French 1715-83

Perroneau

PESCHEL Carl G
German 1798-1879

PESCHIER
Dutch 17th Century

Peschier.

PESNE Antoine
French 1685-1757

Ant. Pesne,

PETERSEN Eilif
Norwegian 1852-1928

Eilif Petersen

PETITJEAN Edmond Marie
French 1844-1925

PETO John Frederic
American 1854–1907

John F. Peto

PETROV-VODKIN Kuzma S.
Russian 1878–1939

PETTERNKOPEN A X C
Austrian 1822-89

Petternkopen.

PETZL Joseph
German 1803-71

PEUGNIEZ Pauline
French 19th-20th Centuries

Pauline
Peugniez.

PEVSNER Antoine
French 1884–1962

A. PEVSNER

PEYRON Jean François Pierre
French 1744-1814

P. Peyron.

PEYSON Pierre Frédéric
French 1807-77

Peyson.s.m.

PEZ Aimé
Belgian 1808-49

PEZET A
French 17th Century

A Pezet

PFEIFFER F J
French 1778-1835

P

PHILIPPOTEAUX H F E
French 1815-1884

F. Philippoteaux

PHILIPS Caspar Jacobsz
Dutch 1732-89

PHILLIP John
English 1817-67

PIATTI Prosper
Italian 1842-1902

P. Piatti

PIAZZA Martino
Italian 16th Century

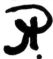

PIAZZETTA Giambattista
Italian 1682-1754

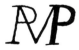

PICABIA Francis
French 1879-1953

Picabia,

F. Picabia,

Francis Picabia

PICARD Louis
French 19th-20th Centuries

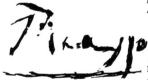

LOUIS PICARD

PICART Bernard
French 1673-1733

B, B.

PICART-LE-DOUX Charles
Alexandre
French 1881-1959

Picart le Doux,

⊕ .

PICASSO Pablo
Spanish 1881-1974

Picasso

PICOLET Cornelis
Dutch 1626-79

C Picolet

PICOU Robert
French 1593-1671

R P fer.

PIEMONT or **PIMONT** Nicolas
Dutch 1644-1709

PIMONT

PIERON Gustave Louis Marie
Belgian 1824-64

G. Pieron.

PIERRE Dieudonné
French 1807-38

PIERRE

PIERRE Gustave René
French 19th-20th Centuries

G Pierre

PIERRE Jean Baptiste Marie
French 1713-89

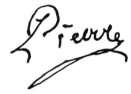

PIERSON Christoffel
Dutch 1631-1714

Chr: Pierson

PIETERS Toert
Dutch 19th-20th Centuries

E. Pieters

PIETERSZ Aert
Dutch 1550-1612

PIGAL Jean
French 1798-1872

Pigal

PIGNON Edouard
French 20th Century

Pignon

PILLEMENT Jean
French 1728-1808

Jean Pillement

PILS Isidore Alexandre Augustin
French 1813-75

J Pils,

J Pils.

PINE Robert Edge
English 1742-88

RE Pine

PINSON Nicolas
French 17th Century

N P

PINTURICCHIO Bernardus
Italian 1454-1513

pictoricvs,

BERNARDVS PINXIT,

BERNARDINVS.

PIOLA Domenico Sr
Italian 1627-1703

D o P.

PIOT René
French 1869-1934

René Piot.

PIPPIN Horace
American 1888-1947

H. PiPPiN

H . Pippin

PISANELLO Antonio di Puccio
Pisano
Italian 1395-1455

PISSARRO Camille
French 1830-1903

PISTORIUS E K G L
German 1796-1862

PITTONI Giovanni Battista Jr
Italian 1687-1767

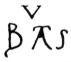

PLACE Francis
English 1647-1728

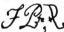

PLAES David van der
Dutch 1647-1704

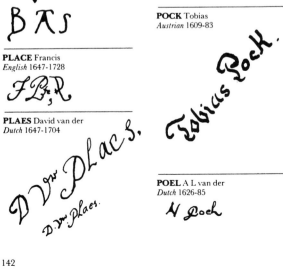

PLAES Pieter van der
Flemish 1595-1650

P.V.PLAS

PLANQUETTE Félix
French 19th-20th Centuries

Félix Planquette

PLANTEY Robert Gilles
French 19th-20th Centuries

Plantey

PLATZER Johann Georg
Austrian 1704-61

JPlatzer.

PLEGINCK Martin
German 16th Century

JP., MP

PLUMOT André
Belgian 1829-1906

André Plumot

PLUYM Karel van der
Dutch 1625-77

POCCETTI B B
Italian 1548-1612

BP.

POCK Tobias
Austrian 1609-83

POEL A L van der
Dutch 1626-85

N Poel

POEL Egbert Lievensz van der
Dutch 1621-64

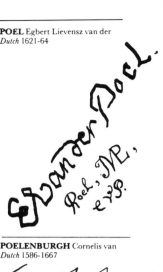

POELENBURGH Cornelis van
Dutch 1586-1667

POILLY François de Jr
French 1622-93

POINTELIN Auguste Emmanuel
French 1839-1933

Aug. Pointelin

POLIAKOFF Serge
Russian 20th Century

SERGE POLIAKOFF

POLLOCK Jackson
American 1912–1956

Jackson
Pollock

POMA A
see CIRCIGNAMO Niccolo

POMPE Gerrit
Dutch 17th Century

POMPE Walther
Flemish 1703-77

POMPON François
French 1855-1933

PoMPoN

PONSON Luc Raphael
French 1835-1904

POOL Juriaen II
Dutch 1665-1745

POOL Matthys
Dutch 1670-1732

JP , M.P.S.

POOLE Paul Falconer
English 1807-79

POORT Allert Jacob van der
Dutch 1771-1807

Allert v.d Poort

POORTER Bastiaan de
Dutch 1813-80

POORTER Willem de
Dutch 1608-48

W.D.P.

PORCELIUS Elias
German 1662-1722

EP., L., E.

PORCELLIS or **PORCSELLIS**
Jan (Joomens)
Dutch 1584-1632

Joomens porsellis

PORCELLIS Julius
Dutch 1609-45

I.Por.

PORTAELS Jan Frans
Belgian 1818-95

Y Partaels

PORTIELJE Edward Antoon
Belgian 19th-20th Centuries

Edward Portielje

PORTIELJE Gérard
Belgian 19th-20th Centuries

Gerard Portielje

POST Frans Jansz
Dutch 1612-80

F. POST,

F.POST.

POT Heindrick Gerritsz
Dutch 1585-1657

HPoT, H.

POTEMONT A T J M
French 1828-83

AM

POTHAST Bernard
Dutch 1882–1966

B. Pothast

POTHOVEN Hendrik
Dutch 1725-95

K.Pothoven ,

HP.f., ▦.

POTTER Paulus
Dutch 1625-54

POTTER Pieter Symonsz
Dutch 1597-1652

POURBUS Frans I
Flemish 1545-81

POURBUS Peeter Jansz
Flemish 1510-84

P4P.

POUSSIN Nicolas
French 1594-1665

N.

POWER John Wardell
Australian 19th-20th Centuries

POWER

POYNTER Sir Edward James
English 1836-1919

EJP

PRADIER Jean Jacques
French 1792-1852

Jc PRADIER!

PRAMPOLINI Enrico
Italian 1894-1956

PREISSLER Johann Justin
German 1698-1771

PRENDERGAST Maurice
American 1859–1924

PRESTEL T
German 1739-1808

PREVIATI Gaetano
Italian 1852-1920

PREVITALI Andreas
(Bargamansis)
Italian 1470-1528

PREVOST Jean
French 16th Century

PRINET René Francis Xavier
French 1861-1946

PRINS Pierre Ernest
French 1838-1913

PRINS Hendrick Johannes
Dutch 1757-1806

PRINTZ Christian August
Norwegian 1819-67

PRITT Henry
English fl c. 1859

PRITT T
English fl c. 1878

PROGER G K
German 16th Century

PROTAIS Paul Alexandre
French 1826-90

PROUT Samuel
English 1783-1852

PRUDHON Paul Pierre
French 1758-1823

PUGET François
French 1651-1707

PUGET Pierre
French 1620-94

PUIFORCAT Jean E
French 1897-1945

PUJOL A D Abel de
French 1787-1861

PUNI Ivan A.
Russian 1894–1956

PUTER Pieter de
Dutch 17th Century

PUTZ Léo
German 19th-20th Centuries

PUVIS DE CHAVANNES Pierre C
French 1824-98

PUY Jean
French 1876-1959

J Puy

PUYL Louis François Gérard
Dutch 1750-1824

LFG van der Puyl.

PUYTLINCK Christoffer
Dutch 17th Century

C. Puytlinck. f.

PYE John Jr
English 1782-1874

I. PYE

PYNACKER Adrian
Dutch 1622-73

Pijnacker

Pijnacker

Pijnacker.

PYNAS Jacob Symonsz
Dutch 1583-1631

Jac Pynas.

PYNAS Jan Symonsz
Dutch 1583-1631

Jan Pijnas

JPijnas, P.

PYNE James Baker
English 1800-70

J.B.PYNE

QUADAL Martin Ferdinand
Austrian 1736-1811

M.F.Quadal.

QUAGLIO Domenico Jr
German 1786-1837

D.Q , DQ.

QUAGLIO Lorenzo
German 1793-1869

L.Q,
L Q.

QUAST Pieter Jansz
Dutch 1606-47

PQ , Q , Q

QUEBORNE Cryspin van den
Dutch 1604-52

CQ, CQ,
CQ .

QUELLIN Artus
Flemish 1652-1700

A.Q

QUELLINUS Jean Erasmus
Flemish 1634-1715

IE Quellinus.

Quellinus

Q, Q

QUELVEE François Albert
French 19th-20th Centuries

François-Quelvee

QUERFURT August
German 1696-1761

AQ, AQ.
A.Q.

QUERFURT Tobias Sr
German 17th-18th Centuries

T. Querfurt.

QUESNEL Augustin
French 1595-1661

AVG QVESNEL

QUESNEL François Sr
French 1543-1619

Œ, Œ, Ł.

QUINAUX Joseph
Belgian 1822-95

J quinaux

QUINKHARD Jan Maurits
Dutch 1688-1772

QUINKHARD Julius
Dutch 1736-76

QUINTARD Lucien Charles Justin
French 1849-1905

QUIRIN Mark
Austrian 19th-20th Centuries

QUIROS Lorenzo
Spanish 1717-89

QUITER Herman Hendrik Sr
Dutch 1628-1708

QUIZET Alphonse Léon
French 1885-1955

RABUZIN Ivan
Yugoslavian 1921–

RACKHAM Arthur
English 1867-1939

RADEMAKER Abraham
Dutch 1675-1735

RADEMAKER Gerrit
Dutch 17th-18th Centuries

RADIMSKY Vazlav
Austrian 19th-20th Centuries

RAEMAEKERS Louis
Dutch 19th-20th Centuries

RAFAELLINO DE REGGIO
see MOTLA Raphael

RAFFAELLI Jean François
French 1850-1924

RAFFET Denis Auguste Marie
French 1804-60

RAHL Carl
Austrian 1812-65

RAHL Carl Heinrich
Austrian 1779-1843

RAIBOLINI Francesco di Marco
Italian 1450-1517

RAIMONDI Marcantonio
Italian 1480-1527

RAINEY William
English 1852-1936

RAJON Paul Adolphe
French 1843-88

RALLI Théodore Jacques
Greek 1852-1902

RALSTON William
English 1848-1911

RAM Johannes de
Dutch 1648-96

RAMBERG Johann Heinrich
German 1763-1840

RAMSAY Hugh
Australian 1877-1906

RAOUX Jean
French 1677-1734

RAPIN Alexandre
French 1839-89

RASSENFOSSE André Louis
Armand
Belgian 1862-1934

RAU Emil
German 19th-20th Centuries

RAUCH Charles
French 1791-1857

RAVEL E J E
Swiss 1847-1920

RAVEN Thomas
English 19th Century

RAVENSWAY Jan van Sr
Dutch 1789-1869

RAVENSWAY Jan van Jr
Dutch 1815-49

RAVESTEYN Anthony van Jr
Dutch 1580-1669

RAVESTEYN Arent van
Dutch 1625-90

RAVESTEYN Hubert van
Dutch 1638-91

RAVESTEYN Jan Antonysz van
Dutch 1570-1657

RAVIER August Frânçois
French 1814-95

RAY Man
American 1890–1976

REAL DEL SARTE Maxime
French 1888-1954

REALIER-DUMAS Maurice
French 1860-1928

RECHBERGER Franz
Austrian 1771-1841

RECLAM Friedrich
German 1734-74

147

REDON Odilon
French 1840-1916

REDOUTE Henri Joseph
French 1766-1852

REGAMEY Frédéric
French 1849-1925

REGAMEY G U
French 1837-75

REGEMORTER Ignatius Josephus
van
Flemish 1785-1873

REGNAULT Henri Alexandre
Georges
French 1843-71

REGNAULT Jean Baptiste
French 1754-1829

REGTERS Tiebout
Dutch 1710-68

REHFOUS Albert
Swiss 19th-20th Centuries

REICHMANN Georg Friedrich
German 1798-1853

REID Sir George
Scottish 1814-1913

REID John Robertson
Scottish 1851-1926

REIGNIER Claude
French 19th Century

REIGNIER Ferdinand
French 19th Century

REIJERS Nicolaas
Dutch 18th Century

REINDEL Albert Christoph
German 1784-1853

REISS Fritz
German 1857-1916

REITER Barthelemy
German 17th Century

REMBRANDT
see RIJN

REMINGTON Frédéric
American 1861-1909

REMOND Jean Charles Joseph
French 1795-1875

RENARD Emile
French 1850-1930

EMILE RENARD.

RENEFER J C R
French 1879-1957

RENESSE Constantin Adrien
Dutch 1626-80

RENI Guido
Italian 1575-1642

G.R, G'R'',

R, G.RIH,

RENOIR Pierre Auguste
French 1841-1929

RENTICK Arnold
Dutch 1712-74

RESTOUT Jean Jr
French 1692-1768

RETHEL Alfred
German 1816-59

AR, AR.

REYNAUD François
French 1825-1909

REYNOLDS Sir Joshua
English 1723-92

J Reynolds,

SR
IR

REYNTJENS Heinrich Engelbert
Dutch 1817-59

RHEAUME Jeanne
Canadian 1915–

RHEEN T J
Dutch 18th Century

RHEIN Fritz
German 19th-20th Centuries

RHOMBERT Joseph Anton
German 1786-1855

RIBERA Jusepe de
Spanish 1588-1656

RIBERA Pierre
French 19th-20th Centuries

RIBOT Théodule Augustin
French 1823-91

149

RICARD Louis Gustave
French 1823-73

RICCHINO Francesco
Italian 1518-68

RICCI Marco
Italian 1676-1729

RICCI Sebastiano
Italian 1659-1734

RICCIARELLI Daniele
Italian 1509-66

RICHARD A L M T
French 1782-1859

RICHARDS William T.
American 1833–1905

RICHARDSON John J
English 1836-1913

RICHARDSON Jonathan Sr
English 1665-1745

RICHARDSON Thomas Miles Sr
English 1784-1848

RICHIR Herman Jean Joseph
Belgian 19th-20th Centuries

RICHOMME Joseph Théodore
French 1785-1849

RICHTER Adrian Ludwig
German 1803-84

RICKETTS Charles
Swiss 1866-1931

RICO-Y-ORTEGA
Spanish 1833-1908

RIDEL Louis Marie Joseph
French 19th-20th Centuries

RIDINGER Johann Elias
German 1698-1767

RIEDEL Anton Heinrich
German 1763-1809

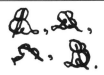

RIEDEL A H
German 1799-1883

RIESENER Louis Antoine Léon
French 1808-78

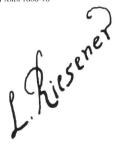

RIETSCHOOF Jansz Claes
Dutch 1652-1719

RIETTI Arturo
Italian 1863–1943

RIGAUD Benoit
Haitian 1911–

RIGAUD H F H M
French 1659-1743

RIGAUD Jacques
French 1681-1754

J·R

RIGAUD Jean Baptiste
French 18th Century

J.B.R.

RIGAUD Pierre Gaston
French 19th-20th Centuries

P.G.RIGAUD

RIGHI Federico
Italian 1908–

RIGHI

RIJN or **RYN** Rembrandt
Harmensz van
Dutch 1606-69

Rembrandt fo.
Rembrandt.
R.v.Ryn, R.R.
Ry. Rs.

RIKKERS Willem
Dutch 19th Century

WR, WR.

RILEY Thomas
English fl 1880-92

Thᵒ RILEY

RILLAERT Jan de Sr
Flemish 1495-1568

AR

RIMMER William
American 1816–1879

W. Rimmer

RING Pieter de
Dutch 1615-60

PD Ring.
Pr De
Ring, R.

RINGELING Hendrick
Dutch 1812-74

H.Ringeling.

RINGLI Gothard
Swiss 1575-1635

GR, G.

RIOPELLE Jean Paul
Canadian 1923–

J.P. Riopelle

RIOU Edouard
French 1833-1900

Riou

RITTER Wilhelm Georges
German 1850-1926

W.G. Ritter.

RIVALTZ Jean Pierre
French 1625-1706

PRivaS

RIVERA Diego
Mexican 1886–1957

Diego RIVERA

RIVERS Larry
American 1923–

Larry Rivers

RIVIERE Briton
English 1840-1920

B Riviere

RIVIERE (B J P) Henri
French 1864-1951

Henri Rivière.

RIVIERE Charles
French 1848-1920

CHARLES-RIVIÈRE.

RIZI
see RICCHINO Francesco

ROBAUDI A T
French 19th Century

ROBBE L M D R
Belgian 1806-87

ROBELLAZ Emile
Swiss 1844-82

ROBERT A N N
Belgian 1817-90

ROBERT Hubert
French 1733-1808

ROBERT Léopold Louis
French 1794-1835

ROBERT Nicolas
French 1614-85

ROBERT-FLEURY Joseph Nicolas
French 1797-1890

ROBERT-FLEURY Tony
French 1837-1912

ROBERTS David
Scottish 1796-1864

ROBERTS Thomas William
Australian 1856-1931

ROBIE Jean Baptiste
Belgian 1821-1910

ROBINSON Mabel C
English 19th-20th Centuries

ROCHE Marcel
French 1890-1959

ROCHEBRUNE Octave
Guillaume de
French 1824-1900

ROCHEGROSSE Georges Antone
French 1859-1938

ROCHLING Carl
German 1855-1920

ROCHUSSEN Carel
Dutch 1824-94

ROCQUETTE Johann de la
Dutch 17th Century

RODE Jean Henri
German 1727-59

RODE Cornelis (Nelis)
Danish 1742-94

RODIN René François Auguste
French 1840-1917

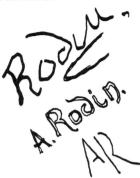

RODOLFO Arellano
Nicaraguan 1940–

ROEDIG Johannes Christianus
Dutch 1751-1802

ROELOFS Willem
Dutch 1822-97

ROEPEL Coenraet
Dutch 1678-1748

ROESTAETEN Pieter Geritsz van
Dutch 1630-1700

ROGER Louis
French 1874-1953

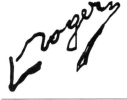

ROGERS William
English 1545-1604

ROGHMAN Roland
Dutch 1597-1686

ROHRICH Franz Wolfgang
German 1787-1834

ROLL Alfred Philippe
French 1846-1919

ROMANET Ernest Victor
French 19th-20th Centuries

ROMANI Juana
Italian 1869-1924

ROMANO Giulio
Italian 1499-1546

ROMBOUTS Gillis
Dutch 1630-78

ROMBOUTS Salomon
Dutch 1652-1702

ROMBOUTS Theodor
Flemish 1597-1637

ROMEYN Willem
Dutch 1624-94

ROMSTEDT Christian
German 18th Century

RONDEL Henri
French 1857-1919

RONNER-KNIP Henriette
Dutch 1821-1909

RONOT Charles
French 1820-95

ROOKER Michael Angelo
English 1743-1801
By courtesy of the Victoria
& Albert Museum

ROOS Jacob (Rosa di Napoli)
Italian 17th-18th Centuries

ROPS Felicien Joseph Victor
Belgian 1833-98

ROSEMALE D A
Dutch 1620-99

ROSENDAL or **ROOSENDAEL**
Nicolas
Dutch 1636-86

ROSENHAGEN Johannes
Dutch 1640-68

ROSIER Jean Guillaume
Belgian 1858-1931

ROOS Johann Heinrich
German 1631-85

ROOS Johann Melchior
German 1659-1731

ROOSENBOOM Margarete
Dutch 1843-96

ROOTIUS Jan Albertsz
Dutch 1615-74

ROQUEPLAN Camille Joseph
Etienne
French 1803-55

ROSA Salvator
Italian 1615-73

ROSAPINA Francesco
Italian 1762-1841

ROSLIN Alexandre
Swedish 1718-93

ROSSEELS Jacob
Flemish 1828-1912

ROSSET-GRANGER Paul
Edouard
French 19th-20th Centuries

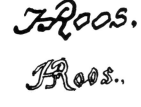
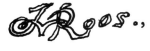

ROSSETTI Dante Gabriel
English 1828-82

ROSSI Joseph
French 1892-1930

ROSSI Lucius
French 1846-1913

ROSSINI Romano
Italian 1886–1951

ROSSUM Johan
Dutch 17th Century

ROTA Martin
Italian 1520-83

ROTENBECK George Daniel
German 1645-1705

ROTHKO Mark
American 1903–1970

ROTHWELL Selim
English 1815-81

ROTIG Georges Frederic
French 1873-1961

ROTTENHAMMER Johann
German 1564-1625

ROTTERMOND Peter
Dutch 17th Century

ROTTMANN Carl
German 1798-1850

ROTTMAYR VON ROSENBRUNN J F M
Austrian 1654-1730

ROUART Ernest
French 1874-1942

ROUAULT Georges
French 1871-1958

ROUBILLE Auguste Jean Baptiste
French 1872-1955

ROUILLARD Jean Sebastien
French 1789-1852

ROULLET Gaston
French 1847-1925

ROUSSEAU Henri
French 19th Century

ROUSSEAU Jean Jacques
French 19th-20th Centuries

ROUSSEAU Julien Félix Henri
(Le Douanier)
French 1844-1910

ROUSSEAU Philippe
French 1816-87

ROUSSEAU Théodore
French 1812-87

ROUSSEAU-DECELLE René
French 1881-1964

ROUSSEL Ker Xavier
French 1867-1944

ROUX Emile
French 19th Century

E.ROIIX.

ROWBOTHAM Thomas Leeson Jr
English 1823-75

T. L. Rowbotham
Juni 1850

ROWLANDSON Thomas
English 1756-1827

ROY Pierre
French 1880-1950

ROYBET Ferdinand
French 1840-1920

ROYE Jozef van de
Belgian 19th-20th Centuries

ROYE Willem Frederik van
German 1645-1723

ROYER Henri Paul
French 19th-20th Centuries

ROZIER Dominique Hubert
French 1840-1901

RUBENS Peter Paul
Flemish 1577-1640

RUIJVEN P J van
Dutch 1651-1716

RUIPEREZ Louis
Spanish 1832-67

RUISDAEL or **RUYSDAEL** Jacob
Isaakszoon
Dutch 1629-82

RUBIO Luigi
Italian 19th Century

RUELLES Pieter des
Dutch 17th Century

RUGENDAS Georg Philipp I
German 1666-1742

RUGGIERI Guido
Italian 16th Century

RUISDAEL Jakob Salomonsz
French 1630-81

RUISDAEL Salomon van
Dutch 1600-70

RUL Henri Pieter Edward
Belgian 19th-20th Centuries

RUNDT Carl Ludwig
German 1802-68

RUPPRECHT Tini
German 19th-20th Centuries

RUSINOL Santiago
Spanish 1861-1931

RUSKIN John
English 1819-1900

RUSS Karl
Austrian 1779-1843

RUSSELL Charles Marion
American 1864–1926

RUSSELL Walter
American 1867-1946

RUSU Miahi
Romanian 20th Century

M. RUSU

RUTHART Carl Andreas
German 1630-1703

RUYSCH Rachel
Dutch 1664-1750

RUYTEN Jan Michael
Belgian 1813-81

RUYTENSCHILDT Abraham Jan
Dutch 1778-1841

RUZICKA Othmar
Austrian 19th-20th Centuries

RYCK Cornelia de
Dutch 17th Century

RYCK Pieter Cornelisz van
Dutch 1568-1628

ⱤR

RYCKAERT David I
Flemish 1560-1607

DR

RYCKAERT David II
Flemish 1596-1642

RYCKAERT David III
Flemish 1612-61

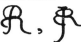

DR.

RYCKERE Bernaert
Flemish 1535-90

R, R

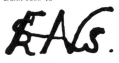

RYCKHALS Frans
Dutch 1600-46

RYN or **REYN** Jan van de
Flemish 1610-78

J ЄN VAN Ryn.

J·ENVANRyn:,

J de Reyn.

RYNVISCH Evert
Dutch 17th Century

CWR.

RYSEBRACK John Michael
Flemish 1693-1770

M.R

RYSSELBERGHER Theodor van
Belgian 1862-1926

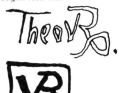

RYSWYCK Dirk van
Dutch 1596-1679

D.V·R.

SAAGMOLEN Martinus
Dutch 1620-69

SACCHI Andrea
Italian 1599-1661

A

SACCHI Pietro
Italian 1485-1528

SADELER Aegedius
Flemish 1570-1629

Æ, Æg.S.

Æ. A.

SADELER Jan
Flemish 1550-1600

Ɉ, 1S.$,

SADELER Justus
Flemish 1583-1620

SADELER Philipp
Flemish 17th Century

SADELER Raphael I
Flemish 1560-1628

SAENREDAM Jan Pietersz
Dutch 1565-1607

$, .

SAENREDAM Pieter Jansz
Dutch 1597-1665

P.Sanredam,

SAFTLEVEN Cornelis
Dutch 1607-81

CSaftlevn,
·C.S.

SAFTLEVEN Hermann
Dutch 1609-85

H Saft.Loven,
H., H.
S., O.

SAIN Edouard Alexandre
French 1830-1910

Sain

SAINT-ANDRE Simon Bernard de
French 1614-77

St A.

SAINT-AUBERT Antoine
François
French 1715-8b

S.Aubert

SAINT-AUBIN Augustin de
French 1736-1807

SAINT-AUBIN Gabriel Jacques de
French 1724-80

S.A.

SAINT-GERMIER Joseph
French 1860-1925

J.Saint-Germier

SAINT-JEAN Simon
French 1808-60

Saint-Jean

SAINT-MARCEL-CABIN Charles
Edme
French 1819-90

Saint-marcel

SAINT-PIERRE Gaston Casimir
French 1833-1916

Cg Saintpierres

SAINT-SAENS Mme C
French 19th Century

CSaint-Saens

SAINTIN Louis Henri
French 1846-99

Henri Saintin.

SALA Jean
Spanish 1867-1918

SALADINI Achille
French 19th Century

SALAMANCA Antonio
Italian 1500-62

S.AT.
AT.

SALIMBENI Ventura de Arcangelo
Italian 1568-1613

VSS

SALLAERT Anthonis
Flemish 1590-1657

ANTSALLAERT,
AS.A,

159

SALLE David
American 1952–

SALLINEN Tyko Konstantin
Finnish 19th-20th Centuries

SALMINCIO Andrea
Italian 17th Century

SALMSON Hugo Frederik
Swedish 1844-94

SALOME Emile
French 1833-81

SALOMON Bernard
French 1506-61

SALVAT François Martin
French 19th-20th Centuries

SAMACHINI Horatio
Italian 1532-77

SAMBACH Caspar
German 1715-95

SAND Maurice
French 1823-99

SANDERS Hercules
Dutch 1606-63

SANDRART Joachim von I
German 1606-88

SANDRART Jochann von
German 1588-1679

SANDYS Anthony Frederick
Augustus
English 1832-1904

SANT James
English 1820-1916

SANT-ACKER A F
Dutch 17th Century

SANTACROCE Francisco
Bernardo de Vecchi
Italian 15th Century

SANTAFEDE Francesco
Italian 16th Century

SANTAMARIA-Y-SEDANO
Marceliano
Spanish 19th-20th Centuries

SANTERRE Jean Baptiste
French 1651-1717

SANTI Raphael Urbinas
Italian 1483-1520

SANTVOORT Dirch Dirchsz van
Dutch 1610-80

SANTVOORT Pieter Dircksz van
Dutch 1604-35

SANUNTO Giulio
Italian 1540-80

SARABIA A
Spanish 16th-17th Centuries

SARABIA Jose de
Spanish 1608-69

SARACENI Carlo
Italian 1585-1620

SARGENT John Singer
American 1856-1925

SARIAN Martiros
Russian 1880–1972

SARLUIS Leonard
French 1874-1949

SARTO Andrea d'Agnolo
Andrea del
Italian 1487-1530

SASHIN Andrei T.
Russian 1896–1965

SAUERWEID A I
Russian 1783-1844

SAUNIER Noël
French 1847-90

SAUVAIGE Louis Paul
French 1827-85

SAVA
see PEIC Sava

SAVERY Jacob I
Dutch 1545-1602

SAVERY Jacob II
Dutch 1593-1627

SAVERY Jacob III
Dutch 1617-66

SAVERY Jan
Dutch 1597-1654

SAVERY Roeland J
Dutch 1576-1639

SAVIN Maurice Louis
French 19th-20th Centuries

SAVINIO Alberto
Italian 19th-20th Centuries

SAVOLDO Giovanni Girolamo
(a Brescia)
Italian 1480-1548

SAVOYON Carel van
Dutch 1621-65

SAVREUX Maurice
French 19th-20th Centuries

SAY William
English 1768-1834

SCACCIATI Andrea Jr
Italian 1725-71

SCALBERT Jules
French 19th-20th Centuries

SCHAAK B
Dutch 17th Century

SCHADOW Friedrich Wilhelm
German 1788-1862

SCHAEFELS Hendrick Frans
Belgian 1827-1904

SCHAEFELS Lucas
Belgian 1824-85

SCHAEP Henri Adolphe
Belgian 1826-70

SCHAEPKENS Theodor
German 1810-83

SCHAFFENHAUSER Elie
German 17th Century

SCHAFFNABURGENSIS
Matthaus
German 16th Century

SCHAFFNER Martin
German 1478-1546

SCHALKE Cornelis Simonsz van
der
Dutch 1611-71

SCHALCKEN Godfried
Dutch 1643-1706

SCHALLHAS Carl Philipp
Hungarian 1767-92

SCHAMPHELEER Edmond de
Belgian 1824-99

SCHAUFFELIN Hans Jr
German 1515-81

SCHAUFFELIN Hans Leonard
German 1480-1538

SCHEFFER Ary
French 1795-1858

SCHEFFER Henry
French 1798-1862

SCHEITS Matthias
German 1640-1700

SCHELLHORN C van
Dutch 19th Century

SCHELLINKS Daniel
Dutch 1627-1701

SCHELLINKS Willem
Dutch 1627-78

SCHELVER August Franz
German 1805-44

SCHENCK A F A
Danish 1828-1901

SCHENK Pieter I
Dutch 1660-1718

SCHEY Philipe
Flemish 17th Century

SCHEYERER Franz
Austrian 1770-1839

SCHEYNDEL Bernard van
Dutch 1649-1709

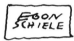

SCHIAMINOSSI Raffaello
Italian 1529-1622

RÆ. RF.

SCHIEBLIUS J G
Dutch 17th Century

SCHIELE Egon
Austrian 1890-1918

SCHIERFBERK Helena Sofia
Austrian 19th-20th Centuries

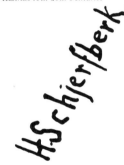

SCHIFF Mathias
French 1862-86

SCHIK Pieter
German 17th Century

SCHILCHER Anton von
German 1795-1827

SCHIRMER Johann Wilhelm
German 1807-63

SCHLEMMER Oscar
German 1888–1943

O. S.

SCHLEY Jacob van
Dutch 1715-79

J.V.S.

SCHLICHTEN Johann Franz
von der
German 1725-95

Von der Schlichten,

V.D.S, V.S.

SCHLITTGEN Hermann
German 1850-1930

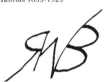

SCHMID Matthias
Austrian 1835-1923

SCHMIDT Georg Adam
Dutch 1791-1844

SCHMIDT Georg Friedrich
German 1712-75

SCHMIDT-ROTTLUFF Karl
German 1884-
By courtesy of the Berlin National
Gallery

SCHMUTZLER Léopold
German 19th-20th Centuries

SCHNEE Hermann
German 1840-1926

SCHNEIDER Amable Louis
French 1824-84

SCHNEIDER Otto J
American 19th-20th Centuries

SCHNETZ Jean Victor
French 1787-1870

SCHNITZLER Michael Johann
German 1782-1861

SCHNORE VON CAROLSFELD
H V F
German 1764-1841

SCHNORR VON CAROLSFELD
J V H
German 1794-1872

SCHODLBERGER Johann
Nepomuk
Austrian 1779-1853

SCHOEF J P
Dutch 17th Century

SCHOEL Hendrik van
Dutch 16th Century

SCHOEN Erhard
German 16th Century

SCHOENEWERK Alexandre
French 1820-85

SCHOEVARDTS Mathys
Flemish 17th Century

SCHOLTZ Robert Friedrich Karl
German 19th-20th Centuries

SCHOMMER François
French 1850-1935

SCHONFELDT Johann Heinrich
German 1609-82

SCHONGAUER Barthel
German 15th Century

SCHONGAUER Ludwig Sr
German 1440-92

SCHONGAUER Martin
German 1445-91

SCHONLEBER Gustav
German 1851-1917

SCHOONJANS Anton
(Parahasius)
Flemish 1655-1726

SCHOOR Abraham van
Dutch 17th Century

SCHOOTEN Joris van
Dutch 1587-1651

SCHOPFER Hans Sr
German 16th Century

SCHORN Carl
German 1803-50

SCHOTEL Petrus Jan
Dutch 1808-65

SCHOUBROECK or
SCHUBRUCK Pieter
Flemish 1570-1607

SCHOUMAN Aert
Dutch 1710-92

SCHOUMAN Isaak
Dutch 18th Century

SCHOXEN Carl
Norwegian 1841-76

C Schöyen

SCHREYVOGEL Charles
American 1865–1912

Chas. Schreyvogel

SCHREYER Adolphe
German 1828-99

SCHRODTER Adolf
German 1805-75

SCHRORER Hans Friedrich
German 1609-49

SCHUCHLIN Hans
German 1440-1505

SCHUER Theodorus Cornelisz
van der
Dutch 1628-1707

Thead oander Schier.

SCHULER Jules Theophile
French 1821-78

Theophile Schuler

SCHULZE Andreas
German 1955–

A. Schulze

SCHULTZBERG A Leonard
Swedish 1862-1945

SCHULTZBERG.

SCHUMAN J G
German 1761-1810

J.Sch.

SCHUPPEN H van
Flemish 16th-17th Centuries

HV

SCHUPPEN Pieter Louis van
Flemish 1627-1702

P.v.S.

SCHUT Cornelis I
Flemish 1597-1655

C.S. S.
V. W.

SCHUTZ Carl
Austrian 1745-1800

SCHUTZ Charles
German 17th Century

SCHUZ Christian Georg I
German 1718-91

Schüz.

SCHWARTZ Alfred
German 19th Century

Alf. Schwarz

SCHWARTZE Thérèse
German 1852-1918

SCHWEIGGER Georg
German 1613-80

S. G.

SCHWENINGER Carl Sr
Austrian 1818-87

SCHYNDEL Anna Van
Dutch 18th Century

Jv Schyndel

SCIP
see COMPAGNO Scipione

SCOREL Jan van
Dutch 1475-1652

SCOTT Georges Bertin
French 19th-20th Centuries

Georges Scott.

SCOTT Marian
Canadian 1906–

MScoTT

SCULTORI Adam
Italian 1530-85

SEBILLEAU Paul
French 20th Century

SEBRON Hippolyte Victor
Valentin
French 1801-79

SEDELMAYER Joseph Anton
German 18th-19th Centuries

SEDOFF Grigorij
Russian 1831-86

SEEGER Karl Ludwig
German 1808-66

SEEL Adolf
German 1829-1907

SEGALL Lasar
Brazilian 1890-1957

SEGANTINI Giovanni
Italian 1858-99

SEGHERS C J A
Belgian 1814-75

SEGHERS Daniel
Flemish 1590-1661

SEGHERS François
Belgian 19th-20th Centuries

SEGHERS H
Dutch 1590-1638

SEIGNAC Guillaume
French 19th Century

SEINSHEIM August Carl
German 1789-1869

SEITZ Otto
German 1846-1912

SELB Josef
German 1784-1832

SELLIER Charles François
French 1830-82

SELMY Eugene Benjamin
French 19th-20th Centuries

SEM Goursat
French 1863-1934

SENAVE Jacques Albert
Belgian 1758-1829

SERGENT Lucien Pierre
French 1849-1904

SERIN Harmen
Flemish 1678-1765

SERRES John Thomas
English 1759-1825

SERREUR H A C C
French 1794-1865

SERUSIER Louis Paul Henri
French 1863-1927

SEYBOLD or **SEIBOLD** Christian
German 1697-1768

SHARP Joseph Henry
American 1859-1934

SEYMOUR G L
English 19th Century

SERVIN Amédée Elie
French 1829-86

SHAW Charles E
English fl 1866

SEYMOUR-HADEN Francis
English 1818-1910

SEURAT Georges Pierre
French 1859-91

SHEELER Charles
American 1883–1965

SHERWOOD W P
English fl 1850-70

SEVERINI Gino
Italian 1883-1966

SEYSSAUD Rene
French 1867-1952

SHEVCHENKO Alexander V.
Russian 1883–1948

SHTERENBERG David P.
Russian 1881–1948

SIBERECHTS Jan
Flemish 1627-1700

SEVERN Arthur
English 1842-1931

SHAHN Ben
American 1898–

SHANNON Charles Haslewood
English fl 1885-89

167

SICHEM Carl
Dutch 16th-17th Centuries

SICHEM Christoffel van Jr
Dutch 1546-1624

SICKERT W R
English 1860-1942

SIEFFERT Paul
French 19th-20th Centuries

SIEGEN Ludwig
Dutch 1609-80

SIEGER Victor
Austrian 1843-1905

SIEURAC F J J
French 1781-1832

SIGALON Alexandre François
Xavier
French 1787-1837

SIGNAC Paul
French 1863-1935

SIGNOL Emile
French 1804-92

SIGNORELLI Luca (Cortonen)
Italian 1441-1523

SIGNORINI Telemaco
Italian 1835-1901

SILLEMANS E
Dutch 1611-53

SILLEN Herman Gustaf
Swedish 1857-1908

SILLET James
English 1764-1840

SILO Adam
Dutch 1674-1756

SILVESTRE Louis
French 1675-1760

SIMBERG Hugo Gerhard
Finnish 1873-1917

SIMON François
French 1818-96

SIMON Franz
Czechoslovakian 19th-20th Centuries

SIMON Lucen
French 1861-1945

SIMONS Frans
Belgian 1855-1919

SIMONS Michiel
Dutch 17th Century

SIMONSEN Niels
Danish 1807-85

SIMPSON William
English 1823-99

SINDING Otto Ludwig
Norwegian 1842-1909

SINEZUBOV Nikolai V.
Russian 1891–1948

SINIBALDI Jean Paul
French 1857-1909

SISLEY Alfred
French 1839-99

SJOLLEMA Dirck Pieter
Dutch 1760-1840

SKARBINA Franz
German 1849-1910

SKELTON William
English 1763-1848

SKREDSVIG Christian
Danish 1854-1924

SLABBAERT Karel
Dutch 1619-54

SLINGENEYER Ernest
Belgian 1820-94

SLOAN John
American 1871–1951

SLOCOMBE Frederick Albert
English 19th-20th Centuries

SMALL William
English 1843-1928

SMETH Hendrick de
Belgian 19th-20th Centuries

SMIT Johann Arnold
Dutch 1641-1710

SMITH Alfred
French 19th-20th Centuries

SMITH Carlo Frithjof
Norwegian 1859-1917

SMITH Gaspar
Dutch 1635-1707

SMITH John
English 1652-1743

SMITH Jori
Canadian 1907–

SMITH Sir Matthew O B E
English 1879-1959

SMITH—HALD Frithjof
Norwegian 1846-1903

SMITS Eugène Joseph Henri
Belgian 1826-1912

SMMER Christoph
German 16th Century

SMONT or **SMOUT** Lucas
Flemish 1620-74

SMYTHE Lionel Percy
English 1839-1918

SNAYERS Pieter
Flemish 1592-1666

SNELLINCK Geeraert
Flemish 16th-17th Centuries

SNELLINCK Jan van
Flemish 1549-1638

SNELLINCK Jan III
Flemish 1640-91

SNYDERS Frans
Flemish 1579-1657

SNYERS Peter
Flemish 1681-1752

SOEST or **ZOUST** Gerard van
English 1600-81

SOETE
see ZUTMAN Lambert

SOFRONOVA Antonina
Russian 1892–1966

SOHN Carl Ferdinand
German 1805-67

SOKOLOV Mikhail K.
Russian 1885–1947

SOLARIO Andreas
Italian 1460-1522

SOLIMENA Francesco
Italian 1657-1747

SOLIS Vergil Sr
German 1514-62

SOLOMAN Simeon
English 1840-1905

SOLVYNS Frans Balthazar
Belgian 1760-1824

SOMER Jan van
Dutch 1645-99

SOMER Mathias van
Dutch 17th Century

SOMER Paul van
Flemish 1576-1621

SOMERS Louis Jean
Belgian 1813-80

SOMM E C S Henry
French 1844-1907

SON Joris van
Flemish 1623-67

SONJE Jan Gabrielsz
Dutch 1625-1707

SOOLMAKER Jan Frans
Flemish 1635-85

SOREAU Jan
Dutch 17th Century

SORENSEN Carl Frederik
Danish 1818-79

SORGH Hendrick Maartensz
Dutch 1611-70

SOROLLA y BASTIDA Joaquin
Spanish 1863-1923

SOUCHON François
French 1787-1857

SOUCY Jean
Canadian 1915–

SOUKENS Jan
Dutch 1678-1725

SOUMY Joseph Paul Marius
French 1831-63

SOUTINE Haim (Chaim)
Russian 1894-1943

SOUTMAN Pieter Claes
Dutch 1580-1657

P. Sout

SOUVERBIE Jean
French 19th-20th Centuries

SOWDEN John
English 1838-1926

SOWDEN

SOYER Paul Constant
French 1823-1903

PAUL Soyer.

SOYER Raphael
American 1899–

RAPHAEL SOYER

SPADA Lionello
Italian 1576-1622

SPECKARD Hans
Flemish 16th Century

·H·S·P.

SPECKTER Erwin
German 1802-35

S.S.

SPEER Martin
German 1700-65

M.S.

SPEHNER—BENEZIT Marie
Salome
French 1870-1950

SPENCELAYH Charles
English 19th-20th Centuries

SPENCER Sir Stanley
English 1871-1959

S.S. SS.

SPENCER Watson G
English 1869-1934

G.SPENCER WATSON

SPILBERG Gabriel
German 15th-16th Centuries

G.S., GS.

SPILBERG Johann Sr
German 1619-90

Johan Spilberg,

SPILLING Karl
German 19th-20th Centuries

K. Spilling

SPINNY G J J de
Flemish 1721-85

G Spinny.

SPIRIDON Gheorghe
Romanian 20th Century

SPIRIDON

SPIRO Eugen
German 19th-20th Centuries

Eugen Spiro

SPITZWEG Carl
German 1808-85

Spitzweg,

SPORCKMANS Hubertus
Flemish 1619-90

SPRANGER Bartholomaeus
Flemish 1546-1611

BART SPRANGER.

SPREUWEN Jacob van
Dutch 17th Century

J SPREU.,

J.V.Spreuwen

SPRINGER Cornelis
Dutch 1817-1897

SPRINGINKLEE Hans
German 15th-16th Centuries

SPRUYT P L Joseph
Flemish 1727-1801

S, S.P.

SQUARCIONE Francesco
Italian 1394-1474

OP.SQVARCIONI,

STAAL Pierre Gustave Eugène
French 1817-82

G.STAAL.

STALBEMT Adriaen van
Flemish 1580-1662

STALBEMT,

VX-STALBEMT,

AS. Sta.

STALBURCH Jan van
Flemish 16th Century

STAELLERT Joseph
Belgian 1825-1903

Jos Stallaert.

STALPAERT Peeter
Dutch 1572-1635

Stalpaxt,

STAMPFER Hans Jacob
Swiss 1505-79

STANILAND Charles Joseph
English 1838-1908

STANTON George Clark
English 1832-94

E.Stanton.

STANZIONI Massimo
Italian 1585-1656

MX.

STAR or **STAREN** Dirck van
Dutch 16th Century
By courtesy of the Louvre

D ✩ **V,**

D **V.**

STAVERN Jan Adriensz van
Dutch 1625-68

STAVEREN,

AIS. S.

STEAD Fred
English 19th-20th Centuries

FRED STEAD

STEELINK Willem Jr
Dutch 1856-1928

STEEN Jan Havicksz
Dutch 1626-79

Steen,

Steen,

STEEN,

Steen.

STEENWYCK Abraham
Dutch 1640-98

AB.S.

STEENWYCK Herman van
Dutch 1612-56

H.Steenwyck,

H.Steenwyck

STEENWYK or **STEIN** Hendrik
van Jr
Flemish 1580-1649

STEER Philip Wilson
English 1860-1942

STEIN August Ludwig
German 1732-1814

STEINBERG Saul
Romanian 1914–

STEINER Emmanuel
Swiss 1778-1831

STEINLEN Theophile Alexandre
Swiss 1859-1923

STELLA Jacques de
French 1596-1657

STELLA Joseph
American 1877–1946

STENBERG Georgi G.
Russian 1900–1933

STENGELIN Alphonse
French 19th Century

STEPHAN Joseph
German 1709-86

STERIAN Margareta
Romanian 20th Century

STEUBEN C A G H F L (Baron de)
German 1788-1856

STEVENS Alfred
Belgian 1823-1906

STEVENS or **STEPHANI** Peeter
Flemish 1567-1624

STILKE Herman Anton
German 1803-60

STILL Clyfford
American 1904–

STIMMER Tobias
Swiss 1539-84

STOBBAERTS Jean Baptiste
Belgian 1838-1914

STOCK Henry John
English 1853-1931

STOFFE Jan Jacobsz
Dutch 1611-82

STOLKER Jan
Dutch 1724-85

STOLL Leopold
German 19th Century

STOMME Jan Jansz de
Dutch 17th Century

STONE Marcus C
English 1840-1921

STOOP Dirk
Dutch 1618-81

D. S.

STOOP Maerten
Dutch 1620-47

STORCK Abraham
Dutch 1635-1710

STORCK Jacobus
Dutch 17th Century

STORY Julian Russel
American 1850-1919

STOTHARD Thomas
English 1755-1834

STRAET or **STRADANS** Jan
van der
Flemish 1523-1605

STRAMOT Nicolas II
Dutch 1637-1709

STRANG William
English 1859-1921

STRANOVIUS or **STRANOVER**
Tobias
Czechoslovakian 1684-1724

STRAUCH Georg
German 1613-75

STRAUCH Lorenz
German 1554-1630

STREEK Hendrick van
Dutch 1659-1719

STREEK Jurian van
Dutch 1632-87

STREETON Sir Arthur
Australian 1876-1943

STRIEP Christian Jansz
Dutch 1634-73

STROUBANT François
Belgian 1819-1916

STRUPP J
German 18th Century

STRUYS Alexander Théodore
Honoré
Belgian 19th-20th Centuries

[signature: Akyander Struys]

STUBBS George
English 1724-1806

[signature: Geo. Stubbs]

STUBENRAUCH Hans
German 19th-20th Centuries

[signature: Hans Stubenrauch]

STURGESS J
English 19th-20th Centuries

[signature: J. Sturgess.]

STURMER Carl
German 1803-81

[signature: C St]

STURMER Johann Heinrich
German 1774-1858

[signature: SH, H.]

STURTEVANT Erich
German 19th-20th Centuries

[signature: E STURTEVANT]

STUVEN Ernest
German 1660-1712

[signature: Ernste Stuven, ES.]

STYKA Adam
French 19th-20th Centuries

[signature: ADAM STYKA]

[signature: Adam Styka.]

STYKA Jan
French 1858-1925

[signature: Jan Styka.]

STYKA Tadeus
French 19th-20th Centuries

[signature: TADÉ. STYKA.]

SUBLEYRAS Pierre Hubert
French 1699-1749

[signatures: Subleyras, P Subleyras, P. SUBLEYRAS.]

SUCHET Joseph François
French 1824-96

[signature: J. Suchet]

SUE Marie Louis
French 19th Century

[signature: Lüc]

SUETIN Nikolai M.
Russian 1897–1954

[signature: Суетин]

SULLY Thomas
English 1783-1872
By courtesy of the Metropolitan
 Museum of Art New York

[signature: TS.]

SURREY Phillip, H.
Canadian 1910–

[signature: Surrey]

SURVAGE Léopold
French 1879-1908

[signature: Survage]

SUSENIER Abraham
Dutch 1620-84

[signature: A·S·f·]

SUSTERMAN Cornelis
Flemish 1600-70

[signature: CS]

SUSTRIS Frederik
Dutch 1540-99

[signature: F S]

SUVEE Joseph Benoit
Flemish 1743-1807

SUZOR cote Marc Aurelle de Foy
Canadian 1864–1937

SVAROG Vasily S.
Russian 1883–1946

SWAINE Francis
English 1740-82

SWAN John McAllan
English 1847-1910

SWANNENBURGH Willem
Isaaksz I
Dutch 1581-1612

SWANEVELT Herman van
Dutch 1600-55

SWART Jan
Dutch 1500-53

SWEBACH Bernard Edouard
French 1800-70

SWEBACH J F J
French 1769-1823

SWEERTS Michael
Dutch 17th Century

SYLVESTRE Joseph Noël
French 1847-1926

SZYMANOWSKI Wacaw
Polish 1859-1930

TABAR F G L
French 1818-69

TACCONI or **TACHONIT**
Francesco di Giacomo
Italian 1458-1809

TAILLASSON Jean Joseph
French 1745-1809

TAMBI Vladimir A.
Russian 1906–1955

TANGUY Raymond Georges Yves
French 1900–1955

TANNING Dorothea
American 1912–

TANZIO Antonio d'Enrico
Italian 1575-1635

TARDIEU Jean Charles
French 1765-1830

TARDIEU Victor François
French 19th-20th Centuries

TASSAERT Nicolas François
Octave
French 1800-54

TATTEGRAIN Francis
French 1852-1915

TAUNAY Nicolas Antoine
French 1755-1830

TAVARA Don Fernando
Spanish 16th Century

TAVERNIER François
French 1659-1725

TAVERNIER Paul
French 19th-20th Centuries

TAYLER A Chevallier
English 1862-1925

TELLES Sergio
Brasilian 1916–

TEMPEL A L J
Dutch 1622-72

TEMPESTA Antonio
Italian 1555-1630

AT, Æ, Ā.

TENCY J B L
Flemish 18th Century

TENIERS Abraham
Flemish 1629-70

Teniers f.

TENIERS David II Jr
Flemish 1610-90

D. TENIERS,

D. Teniers,

DAVID. TENIERS,

D.T, Ð, Ð.

TENNIEL Sir John
English 1820-1914

TENRE Charles Henri
French 1864-1926

TER-MEULIN Frans Pieter
Dutch 1843-1927

TERWESTEN Augustin Sr
Dutch 1649-1711

TERWESTEN Matheus
Dutch 1670-1757

TESTA Pietro (il Lucchesino)
Italian 1611-50

TESTELIN Louis
French 1615-65

TETAR ELVEN Jean Baptiste
Dutch 1805-79

THAULOW Frits
Norwegian 1847-1906

THEAULON Etienne
French 1739-80

THELOT Antoine Charles
French 19th-20th Centuries

THEUVENOT A J B
French 19th Century

THIBAUT or **THYBAUT**
Wilhelm
Dutch 1524-97

THIEBAUD Wayne
American 1920–

THIEL Ewald
German 19th-20th Centuries

THIELE J F A
German 1747-1803

THIER Barend Hendrik
Dutch 1751-1814

THIEROT Henri Marie J
French 1863-1905

THIM Moses
German 17th Century

THIRION C V
French 1833-1918

THIRON Eugène Romain
French 1839-1910

THOMA Hans
German 1839-1924

THOMAS Adolphe Jean Louis
French 19th Century

THOMAS Gerard
Flemish 1663-1720

THOMAS Jan Jr
Flemish 1617-78

THOMAS Paul
French 19th-20th Centuries

THOMASSIN Simeon
French 1655-1753

THORNE-WAITE Robert
English 19th-20th Centuries

THORNTON Alfred H R
English 1863-1939

THULDEN Theodor van
Dutch 1606-76

THYS Pieter
Flemish 1624-77

TIBALDI Domenico
Italian 1541-83

TIBERIO i Diotallevi (da Assisi)
Italian 1470-1524

TIDEMAND Adolph
Norwegian 1814-76

TIELIUS or **TILIUS** Johannes
Dutch 1660-1719

TIEPOLO Giovanni Battista
Italian 1696-1770

TIEPOLO Giovanni Domenico
Italian 1727-1804

TILBORGH Gillis van Sr
Flemish 1578-1632

TILBORGH Gillis van Jr
Flemish 1625-78

TILENS or **TILEN** Johannes
Flemish 1589-1630

H TILEN,
TILENS.

TILLEMANS Peter
Flemish 1684-1734

P T

TINAYRE Jean Paul Louis
French 19th-20th Centuries

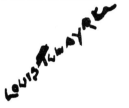

TINTORETTO Jacopo (Giacomo)
Italian 1518-94

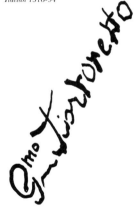

TIRSA Nikolai A.
Russian 1887–1942

TISCHBEIN Johann Friedrich
August
German 1750-1812

F Tischbein,

Fr. Tischbein.

TISCHBEIN Johann Heinrich Sr
German 1722-89

J Tischbein

TISCHBEIN Johann Heinrich Jr
German 1742-1808

H

TISCHBEIN Johann Heinrich
Wilhem
German 1751-1829

Tischbein

TISNIKAR Joze
Yugoslavian 1928–

TisniKaR

TISSIE-SARRUS
French 1780-1868

Tissie-Sarrus.

TISSIER Jean Baptiste Ange
French 1814-76

Ange Tissier

TISSOT James Jacques Joseph
French 1836-1902

J Tissot

TITCOMB Wilhelm Holt Yates
English 19th-20th Centuries

WHY TITCOMB

TITIAN
see VECELLI Tiziano

TITO Ettore
Italian 1859-1941

E. Tito

TOBAR Don Alonso Miguel de
Spanish 1678-1758

AM de Tobar.

TOBEY Mark
American 1890–1976

Tobey

TOL Dominicus van
Dutch 1635-76

D V ToL

TOMLIN Bradley Walker
American 1899–1953

Tom Lin

TOOBY Charles Richard
English 1863-1918

C. Tooby

TOOKER George
American 1920–

TOOKER

TOORENBURGH Gerrit
Dutch 1737-85

TOORNVLIET Jacob
Dutch 1635-1719

TOOROP Johannes Theodorus
Dutch 1858-1928

TOPINO-LEBRUIN F J B
French 1769-1801

TORRENTS Y DE AMATS S P N
French 1839-1916

TOULOUSE-LAUTREC-MONFA Henri Marie Raymond de
French 1864-1901

TOURNEMINE Charles Emile de
French 1812-72

TOURNIER Jean Jacques
French 1604-70

TOURSEL A V H
French 1812-53

TOUSSAINT Fernand
Belgian 19th Century

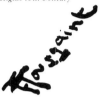

TOWNE Francis
English 1740-1816

TRAUTMAN Johann Georg
German 1713-69

TRAVIES VILLERS Charles Joseph
French 1804-59

TRAYER Jules
French 1924–1909

TRECK Jan Jansz
Dutch 1606-52

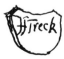

TREMOLIERE Pierre Charles
French 1703-39

TRINQUESSE Louis Rolland
French 1746-1800

TRINQUIER Antoine Guillaume
French 19th-20th Centuries

TRISKA
see BLUMENFELD Triska

TRONCY Emile
French 19th-20th Centuries

TROOST Cornelis
Dutch 1697-1750

TROOST Wilhelm I
Dutch 1684-1759

TROOSTWYK Wouter Joannes van
Dutch 1782-1810

TROSCHEL Hans
German 1585-1628

TROST Andreas
Austrian 17th-18th Centuries

TROUILLEBERT Paul Désiré
French 1829-1900

TROUVE Nicolas Eugène
French 1808-88

TROY François de
French 1645-1730

TROY Jean François de
French 1679-1752

TROYEN Constant
French 1810-65

TROYEN Rombout van
Dutch 1605-50

TRUBNER Heinrich Wilhelm
German 1851-1917

TSCHAGGENY Charles Philogène
Belgian 1815-94

TSCHAGGENY Edmond Jean
Baptiste
Belgian 1818-73

TSVETKOV Boris I.
Russian 1893–1943

TUCCARI Antonio
Italian 17th Century

TUNNARD John
British 1900–1971

TURNER Charles
English 1773-1857

TURNER Joseph Mallord William
English 1775-1851

TUSQUETS y MAIGNON
Raimondo
Italian 19th-20th Century

TWACHTMAN John Henry
American 1853–1902

TWOMBLY Cy
American 1929–

TYOBEY Mark
American 1890–1976

TYSSENS Jan Baptiste
Flemish 17th Century

UBELESQUI Alexandre
French 1649-1718

UCHERMANN Karl
Norwegian 19th-20th Centuries

UDALTSOVA Nadezdha A.
Russian 1886–1961

UDEN Lucas van
Flemish 1595-1673

UHDE Fritz Karl Hermann von
German 1848-1911

ULFSEN Nicolai Martin
Norwegian 1855-85

ULFT Jacob van der
Dutch 1627-89

ULIANOV Nikolai P.
Russian 1885–1949

H. Уланов

ULLMAN Benjamine
French 1829-84

B. ÚLMANN.

ULLMAN Eugène Paul
American 1877-1953

Eugene Paul ULLMAN

ULRICH Heinrich
German 1572-1621

H, H, HV.

UNGER Edouard
German 1853-94

UPPINK Harmanus
Dutch 1753-98

H: uppink

URBAN Hermann
American 19th-20th Centuries

H.
URBAN.

URBINAS
see SANTI Raphael Urbinas

URRABIETA ORTIZ y VIERGE
Daniel
French 1851-1904

VIERGE

UTRECHT Adriaen van
Flemish 1599-1652

A. VAN.
UTRECHT,
Adrichen van
Uytrecht,
Adriaen van utrecht

UTRILLO Maurice
French 1883-1955

Maurice Utrillo. V.

UTTER André
French 1886-1948

A. Utter,

André Utter,

UYTENBROUCK (W DEN BROUCK) Moyses
Dutch 1590-1648

M:V WBrouck,

MV BROUCK,

MV WB_R.

UYTEWAEL or **WTEWAEL**
Joachim
Dutch 1566-1638

IOACHINVTN,

Of WTEWAEL,

JV,

Jo WTe Wael.

UYTTERSCHAUT Victor
Belgian 1847-1917

VACCARO Andrea (Sandro)
Italian 1598-1670

VADDER Lodewyck de
Flemish 1605-55

VAILLANT Andries
Flemish 1655-93

A.

VAILLANT Bernard
Flemish 1632-98

VAILLANT Jacob
Flemish 1625-91

VAILLANT Jacques Gaston Emile
French 1879-1934

VAILLANT Wallerand
Dutch 1623-77

VALADON Jules Emmanuel
French 1826-1900

VALADON Marie Valentine
(Suzanne)
French 1865-1938

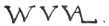

VALCKAERT Werner van der
Dutch 1585-1655

VALDES Lucas de
Spanish 1661-1724

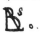

VALENSI Henry
French 19th-20th Centuries

VALENTIN Jean (Moise)
French 1594-1632

VALESIO Francesco
Italian 16th Century

VALESIO Giovanni Luigi
Italian 1583-1650

VALK Henrik de
Dutch 17th Century

VALKENBORCH Frederick
Flemish 1570-1623

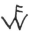

VALKENBORCH Gillis van
Flemish 1570-1622

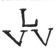

VALKENBORCH Lucas van
Flemish 1530-97

VALKENBORCH Martin van
Flemish 1535-1612

VALKENBURG Theodor (Dirk)
Dutch 1675-1725

VALLET Edouard
Swiss 1876-1929

VALLET Guillaume
French 1632-1704

VALLGREN Villé
French 19th-20th Centuries

VALLOTTON Félix Edouard
Swiss 1865-1925

VALMIER Georges
French 1885-1937

VALTAT Louis
French 1869-1952

VAN B
see BLARENBERGHE Louis
Nicolas van

VANMOUR Jean Baptiste
Flemish 1671-1737

VANNI F E C
Italian 1563-1610

VANNI Giovanni Battista
Italian 1599-1660

GV.

VANNI Michelangelo
Italian 1583-1671

VANNI Rafaello
Italian 1587-1678

VANNUCCI Pietro (Il Perugino)
Italian 1445-1523

VANNUCCIO Francesco
Italian 1361-88

VARGAS Andreas de
Spanish 1613-74

VARLEY John I
English 1778-1842

VAROTARI Alessandro
Italian 1588-1648

VAROTARI Dario Sr
Italian 1539-96

VASARELY Victor
Hungarian 1908–

VASARI Giorgio
Italian 1511-74

VAUTHIER Pierre Louis Léger
French 1845-1916

VAUTIER Marc Louis Benjamin
German 1829-98

VAYSON Paul
French 1842-1911

VEBER Jean
French 1868-1928

VECELLI Tiziano (Titian)
Italian 1490-1576

VECELLIO Tiziano
Italian 1570-1650

VEDDER Elihu
American 1836–1923

VEDOVA Emilio
Italian 1919–

VEEN Adrien van de
Dutch 1589-1680

VEEN Balthasar van der
Dutch 1596-1657

VEEN or **VENIUS** Otto
Flemish 1556-1629

VEERENDAEL or **VERENDAEL**
Nicolas van
Flemish 1640-91

VEGLIA Marco
Italian 15th-16th Centuries

VEIT Philipp
German 1793-1877

VELASCO Luis de
Spanish 16th-17th Centuries

VELASQUEZ Diego Rodriguez de
Silva y
Spanish 1599-1660

VELDE Adriaen van de
Dutch 1636-72

VELDE or **VELDEN** Anthony
van de
Dutch 1617-72

VELDE Esajas van de Jr
Dutch 1591-1630

VELDE Jan van de II
Dutch 1593-1641

VELDE Jan Jansz III
Dutch 1620-62

VELDE Peter van den
Flemish 1634-87

VELDE Willem van de Jr
English 1633-1707

VENENTI G C
Italian 1642-97

VENNE Adriaen Pietersz van de
Dutch 1589-1662

VENUSTI Marcello
Italian 1512-79

VERA Paul Bernard
French 19th-20th Centuries

VERBEECK F X H
Flemish 1686-1755

VERBEECK Pieter Cornelis
Dutch 1610-54

VERBOECKHOVEN Charles
Louis I
Belgian 1802-89

VERBOECKHOVEN Eugen
Joseph
Belgian 1789-1881

VERBOOM or **VAN BOOM**
Dutch 1628-70

VERBOOM Wilhelm Hendriksz
Dutch 1640-1718

VERBRUGGE Jean Charles
Flemish 1756-1831

VERBRUGGEN Gaspar Pieter
Flemish 1635-87

VERBRUGGEN Gaspar Pieter Jr
Flemish 1664-1730

VERBURGH Médard
Belgian 19th-20th Centuries

VERDIER François
French 1651-1750

VERDIER Marcel Antoine
French 1817-56

VERDOEL Adrien
Dutch 1620-95

VERDUN Jean
French 16th Century

VERDUSSEN Jan Peeter
Flemish 1700-63

VERELST Herman
Dutch 1641-90

VERELST or **VAN DER ELST**
Pieter Harmensz
Dutch 1618-68

VERELST or **VER ELST** Simon
Peetersz
Dutch 1644-1721

VERGELLIS Guiseppe Tiburzio
Italian 17th Century

VERHAERT Pieter
Flemish 1852-1908

VERHAGHEN Pierre Jan Joseph
Flemish 1728-1811

VERHAS Jan François
Belgian 1834-96

VERHEYDEN Isidor
Flemish 1846-1905

VERHEYDEN Mattheus
Dutch 1700-76

VERHOEVEN BALL Adrien
Joseph
Flemish 1824-82

VERKOLJE Jan Jr
Dutch 1650-93

I.VERKOLJE,

VERKOLJE Nicolaas
Dutch 1673-1746

VERKRUIS Theodor (della Croce)
Dutch 1707-59

VERLAT Charles Michel Maria
Belgian 1824-90

VERMEER
see MEER vander

VERMEYEN Jan Cornelisz
Dutch 1500-59

VERMOELEN Jacob Xavier
Flemish 1714-84

VERMORCKEN Edouard
Belgian fl 1840-95

EV., E.V.

VERNET Antoine Charles Horace
French 1758-1836

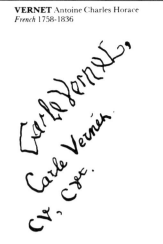

VERNET Claude Joseph
French 1714-89

VERNET Emile Jean Horace
French 1789-1863

VERON A P J (Bellecourt)
French 18th-19th Centuries

VERON Alexandre René
French 1826-97

VERONESE Paolo Caliari
Venetian 1528-88

VERSCHAEREN Jan Antoon
Belgian 1803-63

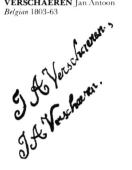

VERSCHUIER Lieve Pietersz
Dutch 1630-86

VERSCHURING Hendrik Sr
Dutch 1627-90

VERSCHUUR Walter
Dutch 1812-74

VERSCHWER or
VERSCHVOOR Willem
Dutch 17th Century

VERSPRONCK Jan Cornelisz
Dutch 1597-1662

VERSTAPPEN Martin
Belgian 1773-1853

VERSTEEG Michiel
Dutch 1756-1843

VERSTRAETE Theodor
Belgian 1850-1907

VERTANGEN Daniel
Dutch 1598-1684

VERTES Marcel
French 1895-1961

VERTUE George
English 1684-1756
By courtesy of the
British Museum

VERUDA Umberto
Italian 1868–1904

VERWEE Alfred Jacques
Belgian 1838-95

VERWER Abraham de
Dutch 16th-17th Centuries

VERWILT Francis
Dutch 1620-91

VEYRASSAT Jules Jacques
French 1828-93

VIANEN Paulus van Jr
Dutch 1613-52

VIARDOT Léon
French 1805-1900

VIBERT Pierre Eugène
Swiss 1875-1937

VICO Enea
Italian 1523-67

VICTOR or **FICTOR** Jacomo
Dutch 1640-1705

VICTORS or **VICTOOR** Jan
Dutch 1620-76

VIDAL Eugène Vincent
French 19th-20th Centuries

VIDAL Louis
French 18th Century

VIDAL Vincent
French 1811-87

VIELLEVOYE Josef Bartholomeus
Belgian 1788-1855

VIEN Joseph Marie
French 1716-1809

VIERGE
see URRABIETA ORTIZ y
VIERGE Daniel

VIGEE-LE-BRUN Marie Louise
Elisabeth
French 1755-1842

VIGNAL Pierre
French 1855-1925

VIGNE Félix de
Belgian 1806-62

VIGNON Claude
French 1593-1670

VIGNON Claude François
French 1633-1703

VIGNON Victor Alfred Paul
French 1847-1924

VILLAMENA Francisco
Italian 1566-1624

VILLARD Antoine
French 1867-1934

VILLERS Gaston de
Belgian 19th-20th Centuries

VILLON Jacques
French 1875-1963

VILLON Raymond Duchamp
French 1876–1918

VINCENT
see GOGH Vincent Willem van

VINCENT François André
French 1746-1816

VINCENT George
English 1796-c1830

VINCENT-CALBRIS Sophie
French 1822-1919

VINCI Leonardo da
Italian 1452-1519

VINCK Franz Kaspar Huibrecht
Belgian 1827-1903

VINEA Francesco
Italian 1845-1902

VINKEBONS or
VINCKEBOONS David
Flemish 1576-1629

VINNE V J van der
Dutch 1736-1811

VIOLA Raoul
French 19th Century

VIOLLAT E J
French 19th Century

VISSCHER Claes Jansz
Dutch 1550-1612

VISSCHER Cornelis de
Flemish 1520-86

VISSCHER Cornelis de
Dutch 17th Century

VITRINGA Wigerus
Dutch 1657-1721

VIVARINI Alvise
Italian 1445-1505

VIVARINI Bartholommeo a
Muraro
Italian 1432-99

VLADIMIROV Ivan A.
Russian 1869–1947

VLAMINCK Maurice de
French 1876-1958

VLIGER Eltie de
Dutch 17th Century

VLIEGER Simon Jacobsz de
Dutch 1600-53

VLIET Hendrik Cornelisz van der
Dutch 1611-75

VLIET Jan Joris van der
Dutch 17th Century

VLIET Willem Willemsz van der
Dutch 1584-1642

VOET Karel
Dutch 1670-1743

VOGEL Hugo
German 1855-1934

VOGELAER H J
German 19th-20th Centuries

VOGELAER Pieter
Flemish 1641-1720

VOGTHER Heinrich Sr
German 1490-1556

VOILLEMOT André Charles
French 1823-93

VOILLES Jean
French 1744-96

VOIRIN Jules Antoine
French 1833-98

VOIRIN Léon Joseph
French 1833-87

VOIS Adrian de
Dutch 1631-80

VOLAIRE J A (Le Chevalier)
French 1729-1802

VOLKMANN Hans Richard von
German 1860-1927

VOLLEVANS Jan Sr
Dutch 1649-1728

VOLLEVANS Jan Jr
Dutch 1685-1758

VOLLMER Adolf Friedrich
German 1806-75

VOLLON Alexis
French 19th-20th Centuries

VOLLON Antoine
French 1833-1900

VOLMARIN C H
Dutch 1604-45

C H Volmarin.

VONCK Elias
Dutch 1605-52

Elias. Vonck,

Elias Vonck.

VONCK Jan
Dutch 17th Century

VOOGD Hendrik
Dutch 1766-1839

H. Voogd

VOORHOUT Johannes I
Dutch 17th-18th Centuries

M

VOORST Dirck van
Dutch 17th Century

DVVoorst.

VOORT Cornelis van der
Flemish 1576-1624

CV.D.VOORT,

CW.

VORSTERMAN Lucas Jr
Flemish 1624-67

L , V.

VORSTERMAN O
Dutch 17th Century

VORTEL Wilhelm
German 1793-1844

K

VOS Cornelis de
Flemish 1585-1651

DC VOS,

Cornelis deVos,

C. DE VOS.

VOS Jan de
Dutch 17th Century

J. D. VOS.

VOS Martin de
Flemish 1532-1603

M. DE VOS,

DVF. M.D.V.

VOS Martin de Jr
Flemish 1576-1613

R. DC. VOS.

VOS Simon de
Flemish 1603-76

S. D. Vos,

SD.

VOUET Simon
French 1590-1649

VOYSARD E C
French 1746-1812

B.

VRANCX Sebastien
Flemish 1573-1647

VREL Jan
Dutch 17th Century

T.VREL.

VRELANT Willem
Dutch 1410-1481

W

VRIENDT Albrecht de
Belgian 1843-1900

Albrecht de vrien?st

VRIENDT Juliaan de
Belgian 1842-1935

Juliaan De Vriendt.

VRIES Abraham de
Belgian 1590-1650

VRIES Adriaen de
Dutch 1550-1626

VRIES Hans Vredeman de
Dutch 1527-1604

VRIES Michiel de
Dutch 17th-18th Centuries

VRIES Paul Vredeman de
Flemish 1567-1630

VRIES Roelant Jansz de
Dutch 1631-1681

VROOM C H
Dutch 1591-1661

VROOM Frederik Hendriksz
Dutch 1600-67

VROOM Hendrik Cornelisz
Dutch 1566-1640

VUILLARD Edouard
French 1868-1940

VUILLEFROY F D de
French 19th-20th Centuries

WAAL J D
Dutch 18th Century

WAARD Antoni de
Dutch 1689-1751

WACKIS B
French 17th Century

WAEL Cornelis de
Flemish 1592-1667

WAEL Lucas Janszen de
1591-1661

WAES Aert van
Dutch 1620-64

WAGENBAUER Maximilian Josef
German 1774-1829

WAGNER J E
French 18th Century

WAGNER Otto
German 1803-61

WAGREZ Jacques Clément
French 1846-1908

WAIN Louis
English 19th Century

WALCKIERS Gustave
Belgian 1831-91

WALHAIN Charles Albert
French 1877-1936

WALKER Frederick
English 1840-75

WALKER Horatio
Canadian 1858-1938

WALKER Robert
English 1607-58
By courtesy of the Ashmolean
 Museum Oxford

WALLAERT Pierre Joseph
French 1755-1812

WALLER Samuel Edmund
English 1850-1903

WALRAVEN Isaak
Dutch 1686-1765

WALSCAPELE Jacob van
Dutch 1644-1727

WALTER P F P
French 1816-55

WALTON Frank
English 1840-1928

WAMPE Bernard Joseph
French 1689-1750

WANDELAAR Jan
Dutch 1690-1759

WANS J C
Flemish 1628-84

WAPPERS Gustaf B
Belgian 1803-74

WARD E M
English 1816-79

WARD James
English 1769-1859

WARD John
English 1803-47

WARHOL Andy
American 1928–1987

WARNBERGER Simon
German 1769-1847

WAROQUIER Henry de W
French 19th-20th Centuries

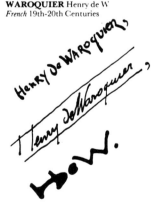

WARSCHAWSKY Alexander
American 19th-20th Centuries

WASHINGTON Georges
French 1827-1910

WASSENBERGH Jan Abel
Dutch 1689-1750

WATELET Louis Etienne
French 1780-1866

WATERHOUSE John William
English 1849-1917

WATERLO Anthonie
Flemish 1610-90

WATERLOW Sir Ernest Albert
English 1850-1919

WATERSCHOODT Heinrich van
Dutch 17th-18th Centuries

WATSON George
English 1767-1837

WATTEAU François Louis Joseph
French 1758-1823

WATTEAU Jean Antoine
French 1684-1721

WATTEAU Louis Joseph
French 1731-98

WATTS George Frederic
English 1817-1904

WAUTERS Charles Emile
Belgian 1846-1933

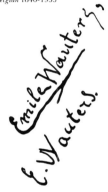

WAXCHLUNGER Johann Paul
German 1660-1724

WEBER Max
American 1881–1961

WEBER Otto
German 1832-88

WEBSTER Herman Armour
American 19th-20th Centuries

WEBSTER Thomas
English 1800-86

WECBRODT Ferdinand
Austrian 1838-1902

WEEDON Augustus Walford
English 1838-1908

WEEKS Edwin Lord
American 1849-1903

WEENIX Jan
Dutch 1640-1719

WEENIX Jan Baptist Sr
Dutch 1621-63

WEERDT Adriaan de
Flemish 1510-90

WEERT Jacob de
Flemish 16th Century

WEERTS Jean Joseph
French 1847-1927

WEGELIN Adolf
German 1810-81

WEGMAN Bertha
Danish 1847–1926

WEGUELIN John Reinhard
English 1849-1927

WEHME Zacharias
German 1550-1606

WEINER Hans
German 1570-1619

WEIR Harrisson William
English 1824-1906

WEISGERBER Albert
German 1878-1915

WEISS B I
German 1740-1814

WEISSENBRUCH Johannes
German 1824-80

WEISZ Adolphe
French 19th-20th Centuries

WELLER Thomas
English 19th Century

WELLIVER Neil
American 1929–

WELLS William Frederick
English 1762-1836

WENBAN Sion Longley
American 1818-97

WENDELSTADT C F
German 1786-1840

WERENSKIOLD Erik Theodor
Norwegian 1855-1938

WERFF Adriaan van der
Dutch 1659-1722

WERFF Pieter van der
Dutch 1665-1722

WERNER Alexander Friedrich
German 1827-1908

WERTMULLER Adolf Ulrik
Swedish 1751-1811

WEST Benjamin Sr
English 1738-1820

WESTALL Richard
English 1765-1836

WESTENBERG Pieter George
Dutch 1791-1873

WET or **WETT** Jacob Willemsz de
Dutch 1610-72

WETHERBEE George Faulkner
American 1851-1920

WEVER Cornelis
Dutch 18th Century

C: Wever

WEXELSEN C D
Norwegian 1830-83

C. Wexelsen.

WEYDEN Rogier van der
Flemish 1399-1464

V, V.

WEYERMAN Jacob Campo
Dutch 1677-1747

Weyerman

WEYROTTER Franz Edmund
Austrian 1730-71

F.E.W.

WHEATLEY John
English 19th-20th Centuries

John Wheatley

WHEELWRIGHT Rowland
English 19th-20th Centuries

R Wheelwright
R Wheelwright

WHISTLER James Abbot McNeill
American 1834-1903

Whistler,
Whistler,

WHITE Ethelbert
English 1891-1972

Ethelbert White

WHITING Frederic
English 19th-20th Centuries

FREDERIC WHITING

WHITTREDGE Thomas Worthington
American 1820–1910

W. Whittredge

WICAR J B J
French 1762-1834

EQ. Ioan.es Bapta Wicar,

Wicar,

WICKENBURG Alfred
Austrian 19th-20th Centuries

AW.

WICKENDEN Robert
English 19th-20th Centuries

R.J.W.

WIDHOPFF D O
French 1867-1933

J.O.Widhopff

WIEBK Bartholt
Dutch 17th Century

Bartholt Wiebk.

WIERINGEN Cornelis Claesz van
Dutch 1580-1633

CCVieRmgen,
CW. CCW.

WIERIX Antoon
Flemish 1552-1624

AN: W.

WIERIX Hieronymus
Flemish 1553-1619

HEW, HEW.

WIERIX Hieronymus
Flemish 16th-17th Centuries

HI.W, W.

WIGMANA Gerard
Dutch 1637-1711

Wigmana.

WIIK Maria Katarina
Finnish 1853-1928

M.Wiik.

WILDENS Jan
Flemish 1586-1653

JAN WILDENS

WILDER J C J
German 1783-1838

cb.W.

WILKIE Sir David
English 1785-1841

D.Wilkie,
W, W.

WILKIN Frank W
English 1800-42

WILLAERTS Abraham
Dutch 1603-69

WILLAERTS Adam
Dutch 1577-1669

WILLARTS Isaak
Dutch 1620-94

WILLEBOIRTS Thomas
Flemish 1614-54

WILLEMS Florent
Belgian 1823-1905

WILLEMS Wimolt
Dutch 17th Century

WILLENBECHER John
American 1936–

WILLERS A
Dutch 17th-18th Centuries

WILLIGEN C J van der
Dutch 1630-76

WILLING Nicolas
Dutch 1640-78

WILLMAN M L L
German 1630-1706

WILSON Ian
American 1940–

WILSON John
English 1774-1855

WILSON Richard
English 1713/14-82

WILTSCHUT Huig van Dorre
Dutch 18th Century

WIMMER Rudolf
German 1849-1915

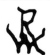

WIMPERIS Edmund Monson
English 1835-1900

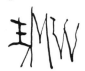

WINDTER J W
German 1696-1765

WINGHE Jeremias van
German 1578-1645

WINNE Lievin de
Belgian 1832-1880

WINTER Joseph Georg
German 1751-89

WINTERHALTER Franz Xavier
German 1806-73

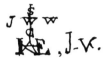

WINTZ Raymond H
French 19th-20th Centuries

WIRGMAN Theodore Blake
English 1848-1925

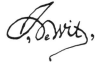

WIT Jakob de
Dutch 1695-1754

WIT Jan de
Dutch 17th Century

WITHOOS Matthias
Dutch 1627-1703

WITHOOS Pieter
Dutch 1654-93

WITTE Emanuel de
Dutch 1617-92

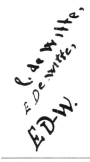

WITTE Gaspar de
Flemish 1624-81

GASPAR DE
WITTE.

WITTEL Gaspar van
Dutch 1653-1736

GV.W.

WLERICK Robert
French 1882-1944

WOCHER M F D
Swiss 1760-1830

MWOCHER.

WOEIRIOT Pierre
French 1532-96

WOHLGEMUTH Michael
German 1434-1519

WOLFAERTS Artus
Flemish 1581-1641

AW, A.W.

WOLFERT Jan Baptist
Flemish 1625-87

WONDER Pieter Christoffel
Dutch 1780-1852

P.C.W.,
PCW,
P.C.W.

WOOD George Bacon, Jr.
American 1832–1909

G.B.Wood Jr.

WOODHOUSE William
English 1857-1939

WOODS Albert
English 1871-1944

ALB. WOODS

WOODS Henry
English 1846-1921

Henry Woods

WOODVILLE Richard Caton
English 1825-55

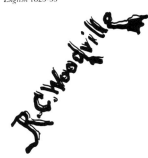

WOOG Raymond
French 19th-20th Centuries

WORLIDGE Thomas
English 1700-66

WORM Nicolaas van der
Dutch 1757-1828

WORMS Jules
French 1832-1924

WOSTRY Carlo
Italian 19th-20th Centuries

WOU Claes Claesz
Dutch 1592-1665

WOUDANT J
Dutch 1570-1615

WOUTERS Frans
Flemish 1614-59

WOUTERS Gomaer
Flemish 17th Century

WOUTERS Jan Ludewick
Flemish 18th Century

WOUWERMAN Jan
Dutch 1629-66

WOUWERMAN Philips
Dutch 1619-68

WOUWERMAN Pieter
Dutch 1623-82

WRIGHT John Michael
English 1623-1700

WUCHTERS Abraham
Danish 1610-82

WULFHAGEN Franz
German 1624-70

WULFRAET Mathys
Dutch 1648-1727

WUNNENBERG Carl
German 1850-1929

WUST Alexander
American 1837-76

WUTKY Michael
Swiss 1739-1823

WUZER Johann Mathias
Swiss 1760-1838

WYCK Thomas
Dutch 1616-77

WYETH Andrew
American 1917–

WYETH Jamie
American 20th Century

WYLD William
English 1806-89

WYLIE Robert
English 1839-77

WYNANTS Jan
Dutch 17th Century

WYNEN Dominicus van (Ascanius)
Dutch 1661-90

WYNTRACK Dirck
Dutch 1625-78

WYTMAN Matheus
Dutch 17th Century

WYTSMANN Rodolphe
Belgian 1860-1927

XAVERY Jacob
Dutch 1736-69

YEATS Jack B
Irish 1871-1957

YON Edmond Charles Joseph
French 1836-97

YSEMBRANT
see ISEMBRANT A

YSENDYCK
see ISENDYCK Anton van

YVON Adolphe
French 1817-93

ZACCHIA Lorenzo
Italian 1524-87

ZADKINE Ossip
French 1890-1967

ZAIS Guiseppe
Italian 1709-84

ZAK Eugène
Polish 1884-1926

ZANETTI Antonio Maria
Italian 1680-1757

ZARRAGA Angel
Mexican 1886-1946

ZAUFFELY or **ZOFFANY** John
English 1733-1810
By courtesy of the Manchester
Art Galleries

ZEEGELAAR Gerrit
Dutch 1719-94

ZEEMAN R
Dutch 1623-67

ZEITBLOOM Bartholome
German 1455-1518

ZELGER Jacob Joseph
Swiss 1812-85

ZENONI Domenico
Italian 16th Century

ZETTER Paul de
German 1600-67

ZEVIN Lev, Y.
Russian 1903–1942

ZICKENDRAHT Berhand
German 1854-1937

ZIEGLER Henry Bryan
English 1793-1874

ZIEGLER Jules Claude
French 1804-56

ZIEM F F G P
French 1821-1911

ZIESEL Georg Frederik
Flemish 1756-1809

ZIGAINA Giuseppe
Italian 1924–

ZIMMERMANN Franz
Swiss 19th-20th Century

ZIMMERMANN Friedrich
German 1823-84

ZIMMERMANN Joseph Anton
German 1705-97

ZINGG Jules Emile
French 19th-20th Centuries

ZIX Benjamin
French 1772-1811

ZO Henri A
French 1873-1933

ZOFFANY
see ZAUFFELY John

ZONARO Fausto
Italian 1854-1929

ZONST
see SOEST Gerhard

ZOPPO Marco Ruggeri
Italian 1433-98

ZORN Anders Leonard
Swedish 1860-1920

ZUBER Jean Henri
French 1844-1909

ZUBER-BUHLER Fritz
Swiss 1822-96

ZUBERLEIN Jacob
German 1556-1607

ZUCCARO Fredrico
Italian 1542-1609

ZUCHERRI Luigi
Italian 1904–1974

ZULOAGA y ZABALETA Ignacio
Spanish 1870-1945

ZURBARAN Francisco
Spanish 1598-1664

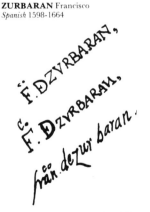

ZUTMAN or **SOETE** Lambert
Flemish 1510-67

ZWAERDECROON Bernardus
Dutch 1617-54

ZWENGAUER Anton
German 1810-84

ZYL Gerard Pietersz van
Dutch 1607-1665

ZYLVELT Anton
Dutch 17th Century

ZYDERVELD Willem
Dutch 1796-1846

Visual Index

This visual index includes all of the monograms, pictorial devices or signatures which, if found on a painting, would not immediately suggest their artist's name. For this reason we have included Russian names signed in the Cyrillic alphabet, and have listed them under the first letter which looks like an Arabic letter.

It has been difficult to decide where to position many of the devices. In general, however, you will find that within the shape of a symbol, a letter of the alphabet suggests itself. We have arranged them all into the alphabetical groups which seem most appropriate. We have always worked top to bottom or left to right, except where a letter is very clearly to view. In these cases we have opted for that most obvious letter. Where it has not been possible to use the letter system we have grouped under the heading Pictorial Marks.

Against each entry you will see the artist's name. Turn to the relevant page in the main index to find full details.

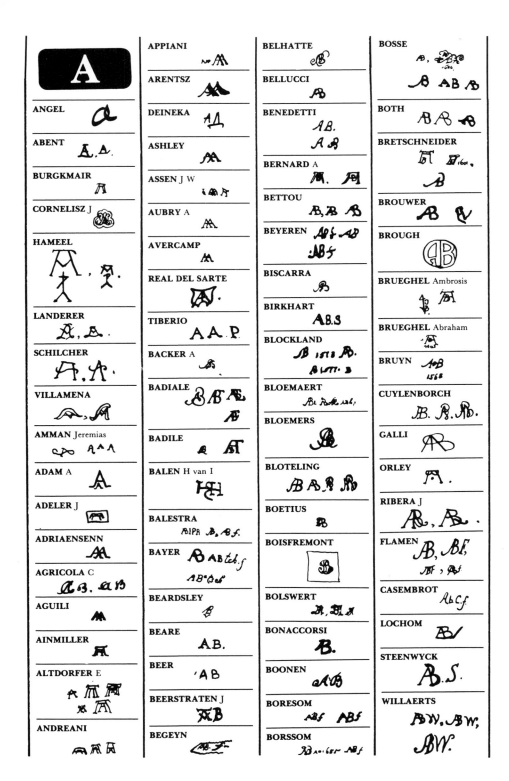

A

ANGEL

ABENT

BURGKMAIR

CORNELISZ J

HAMEEL

LANDERER

SCHILCHER

VILLAMENA

AMMAN Jeremias

ADAM A

ADELER J

ADRIAENSENN

AGRICOLA C

AGUILI

AINMILLER

ALTDORFER E

ANDREANI

APPIANI

ARENTSZ

DEINEKA

ASHLEY

ASSEN J W

AUBRY A

AVERCAMP

REAL DEL SARTE

TIBERIO

BACKER A

BADIALE

BADILE

BALEN H van I

BALESTRA

BAYER

BEARDSLEY

BEARE

BEER

BEERSTRATEN J

BEGEYN

BELHATTE

BELLUCCI

BENEDETTI

BERNARD A

BETTOU

BEYEREN

BISCARRA

BIRKHART

BLOCKLAND

BLOEMAERT

BLOEMERS

BLOTELING

BOETIUS

BOISFREMONT

BOLSWERT

BONACCORSI

BOONEN

BORESOM

BORSSOM

BOSSE

BOTH

BRETSCHNEIDER

BROUWER

BROUGH

BRUEGHEL Ambrosis

BRUEGHEL Abraham

BRUYN

CUYLENBORCH

GALLI

ORLEY

RIBERA J

FLAMEN

CASEMBROT

LOCHOM

STEENWYCK

WILLAERTS

ALLEGRETTI — A.C.

ALLEGRI — A.C

ARTARIA — a 1811.

SASHIN — A. САШИН

CARDON — AG

CANALETTO — A.C . AC.

CAPRIOLA — AG

CARRACCI — A AC A

CASOLANO —

COOPER Abraham —

COOPER Alexander —

COOSEMANS — A.C.

COYPEL C — AC

CRABETH A — A.C

CZECHOWICZ —

CUYP A — .Ac.

ALBERTI —

BLOCK A — ACB.

BRUYN N — ACB.

RB

COLOMBO —

FLEISCHMANN A J — A.C.F.

AACHEN — ACH.

CARRACCI — A.C.P.

ADMIRAL — AD

DABLER — AD

DAHLSTEIN —

DELFOS — A D fect

DEVERIA — AD

DIEPENBEECK — AT

DIEPRAAM — AD. A.

DURAND — AD

DUNOUY — A, AD, A.

DURER A —

BORCHT H — AB AB AB

BRUYN A — AB

DRIFT — ADD

HAEN A — AH

LIMBORCH — AD. AD.

VRIES A — AV, AV

WAARD — A.D.W

ALTDORFER E —

ELSHEIMER — AE. , AE.

NEYTS A — AN, AN

DAVID A — AD

SADELER A — AE, AE. Aeg.S. AR.

VICO — AEV.

ABELS — Af:

ALBERTI F — AF. AF.

CARRACCI A — A.F.

CORTE F — FF AF

FALCONE — A.F. Af,

FALDONI — A.F.

FRANCKEN A — AF, AF, AF

FRANCO G — AE, AE

FUCHS A — AE, AE

FURNERIUS — AF

FUSSLI J — A.F

GIOVANNI A — Φ~AF

ANTOINE — AF

LUCINI — AF AE.

MEMLING —

BOUDEWYNS A — AB.f AB. AB.f.

BALESTRA — AB.f

FOSSATI — AFG.f

MUTRIE —

SCHELVER — AE S.

AGRICOLA C — AGf

207

ALDEGREVER	**HAELWEGH** A	**ALKOCK**	**MAIR**
ALLEGRAIN	**HERRERA** A	**KAUFMANN** A	
CAMPANA	**HERZLINGER**	**KEY** Adrien	**MANTEGNA**
CARRACCI A	**HOUBRAKEN**	**KUBIN**	
GATINE			**MARELLI**
GEDDES	**HUBERTI** A	**VRIES** A	
		LAMME	**MICHELANGELO**
GONCHAROV	**HEERE**	**LA FARGE**	**MIROU**
GENOELS	**AMMAN** J	**LINSCHOTEN**	**MOZART**
	ARP	**LONGHI**	**ZANETTI**
	AZELT	**HAELWEGH**	**LABAS**
GHANDINI	**SEVERN**	**CANO**	**CARAVAGGIO**
GLOCKENDON	**BONDICI**		**BRAMBILLA**
	ARNOLD		
	ASSEN J	**CASTELLAN**	**KOKER**
GODERIS		**ALAUX**	**HIRSCHVOGEL**
	JANSSENS A	**GIRODET de ROUCY TRIOSON**	
GRAFF A	**DALLINGER von DALLING**	**RICHTER**	**MAZZOLA**
GRAFF J	**GRAFF** J		**MAZZUOLI**
HOUBIGANT	**RUYTENSCHILDT**	**AMEROM**	
KEERINCK	**GERASIMOV** A	**MAGANZA**	**NETT**

208

LILIO	**SCHOONJANS**	**SARABIA A**	**AUDER**
CABEL	**PEZ**	**SAUERWEID**	**HIMPEL**
SALAMANCA	**QUELLIN**	**SCACCIATI**	**TANZIO**
CAMPI	**QUERFURT**	**SCHODTER**	**TEMPESTA**
WIERIX	**RADEMAKER**	**SCULTORI**	**TROST**
OFFERMANS	**RAVESTEYN**	**SEDELMAYER**	**TUCCARI**
OSTERLIND	**REINDEL**	**SEINSHEIM**	**MUSI**
ANGEL	**RENTICK**	**SIEURAC**	**NARDI**
AQUILA	**RETHEL**	**SILO**	**NEER A**
GHISI A	**RHOMBERT**	**SMITH A**	**VACCARO**
PARISINI	**RIEDEL**	**STALPAERT**	**VAILLANT**
PAZZI	**RODIN**	**STALBEMT**	**VEEN A**
PIETERSZ	**ADAM A**	**STORCK**	**VENNE**
PRESTEL	**AMSLER**	**SUSENIER**	**VOLLMER**
PAULI A	**COELLO**	**ARETIN**	**CUYLENBORCH**
PAULI J	**SACCHI A**	**DALLAIRE**	**DIEPENBEECK**
POTEMONT	**SALLAERT**	**JUAN de SEVILLA**	**DREVER**
PALAMEDES			
AERTSEN			

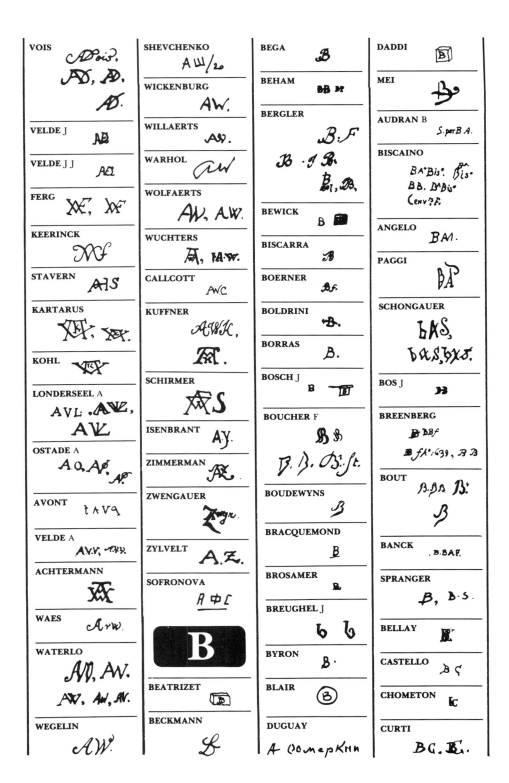

VOIS

VELDE J

VELDE J J

FERG

KEERINCK

STAVERN

KARTARUS

KOHL

LONDERSEEL A

OSTADE A

AVONT

VELDE A

ACHTERMANN

WAES

WATERLO

WEGELIN

SHEVCHENKO

WICKENBURG

WILLAERTS

WARHOL

WOLFAERTS

WUCHTERS

CALLCOTT

KUFFNER

SCHIRMER

ISENBRANT

ZIMMERMAN

ZWENGAUER

ZYLVELT

SOFRONOVA

B

BEATRIZET

BECKMANN

BEGA

BEHAM

BERGLER

BEWICK

BISCARRA

BOERNER

BOLDRINI

BORRAS

BOSCH J

BOUCHER F

BOUDEWYNS

BRACQUEMOND

BROSAMER

BREUGHEL J

BYRON

BLAIR

DUGUAY

DADDI

MEI

AUDRAN B

BISCAINO

ANGELO

PAGGI

SCHONGAUER

BOS J

BREENBERG

BOUT

BANCK

SPRANGER

BELLAY

CASTELLO

CHOMETON

CURTI

BERCHEM	BECKET	RYCKERE	VLADIMIROV
			И. Владимиров
CASTELLO	GIOVANNI A	SOLVYNS	**C**
CAPITELLI	KURDOV	TIEPOLO	CARLEGLE
		BT.	
BARBIEREI	BRASSER	BOCKSBERGER J	CUMPATA
DIEPENBEECK	LENS B	VOYSARD	ALIGNY
CARO	VALDES	AST	ALGAROTTI
CERVERA	BELIN	VAILLANT	PAVLOV
Bern^us CerF.		BV.	1923
BARBIEREI	LEBEDEV	HELST	ANDRIESSEN
			CA
BEATRIZET	BRANDMULLER	SCHEYNDEL	CARON
FRANCO G	MURILLO		CALDER
BFV.			
BEGEYN	BOBA		ADLIVANKIN
			С. Адливанкин
GENNARI		BUYTEWECH	CARRACCI A
B G			
GHEYN	BRANDI	WEISS	KOELBE
BUTTNER	BOSSI	WEST	CHALON
		B.W	
BLANKERHOFF	PASSAROTTI	KHODASHEVICH	CAMASSEI
		В. Ходасевич	CAM.
	PICART	BOILLEY	FAVART
BOUCKHORST	POCCETTI	ZIX	
	BP.		CF,
HOLBEIN H	BOCKSBERGER J	ZWAERDECROON	HELMSAUER
JENICHEN	QUAST	LEBEDEV	VERONESE
	SALOMON	В. Лебедев	

CAMPAGNOLA	**CORBUTT**	**PERKINS**	**GOLTZIUS** C
NAUDET	**COURTOIS**	**CANUTI**	**GREEN**
CALDARA	**CRAESBEECK**	**DROOGSLOOT**	**BRUHL**
RENESSE	**FILOSI**	**DUSART** C	**GALESTRUZZI**
GELDER A	**SCOREL**	**DUVELLY**	
CARRENO MIRANDA DE	**BOLSWERT** S A	**DECKER**	**WIERINGEN**
SCHUT	**BARKHAUS**	**JONGH** F	**CAMOIN**
OSELLI	**BEGAS**	**GERASIMOV**	**CHARDIN**
CARRACCI A	**CAMPION TERSAN DE**	**MAN**	**CORNELISZ** C
BENSO	**CAPRIOLI**	**CARRACCI** F	**HILDEBRANDT**
BIRNBAUM	**CIGNANI**	**COLLIGNON**	**HOFER**
BISSCHOP	**COLOMBINI**	**CUSTODIS**	**SMMER**
BOSCH Cornelius	**CONGIO**	**FENTZEL**	**WILDER**
BOURGEOIS Du Castelet	**CONJOLA**	**FUES**	**CALLOT**
BUYS C	**CORNEILLE** C	**POILLY**	**CAMPAGNOLA** G
CASTIGLIONE	**CORT**	**CHAPRON**	**CROISSANT**
CHOMETON	**CRESPI** G	**CASTIGLIONE**	**SARACENI**
	FELLINI	**CORNELIS**	**COCTEAU**
		GALLE C	

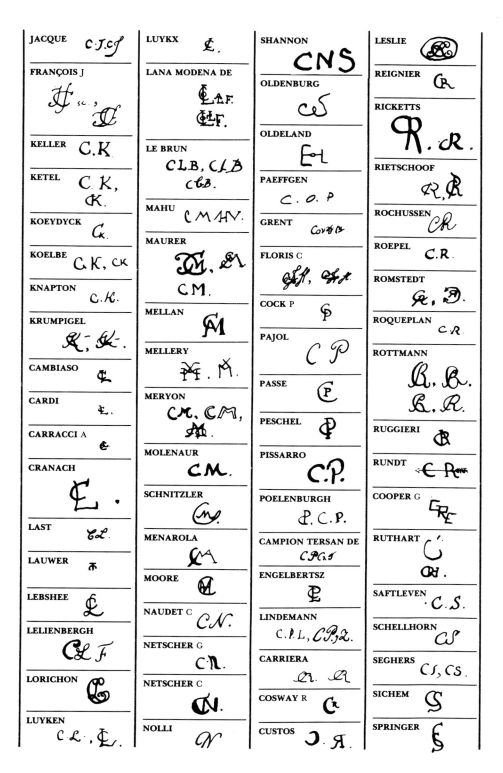

JACQUE	LUYKX	SHANNON	LESLIE
FRANÇOIS J	LANA MODENA DE	OLDENBURG	REIGNIER
KELLER	LE BRUN	OLDELAND	RICKETTS
KETEL		PAEFFGEN	RIETSCHOOF
KOEYDYCK	MAHU	GRENT	ROCHUSSEN
KOELBE	MAURER	FLORIS C	ROEPEL
KNAPTON		COCK P	ROMSTEDT
KRUMPIGEL	MELLAN	PAJOL	ROQUEPLAN
CAMBIASO	MELLERY	PASSE	ROTTMANN
CARDI	MERYON	PESCHEL	
CARRACCI A		PISSARRO	RUGGIERI
CRANACH	MOLENAUR	POELENBURGH	RUNDT
LAST	SCHNITZLER	CAMPION TERSAN DE	COOPER G
LAUWER	MENAROLA	ENGELBERTSZ	RUTHART
LEBSHEE	MOORE	LINDEMANN	SAFTLEVEN
LELIENBERGH	NAUDET C	CARRIERA	SCHELLHORN
LORICHON	NETSCHER G	COSWAY R	SEGHERS
LUYKEN	NETSCHER C	CUSTOS	SICHEM
	NOLLI		SPRINGER

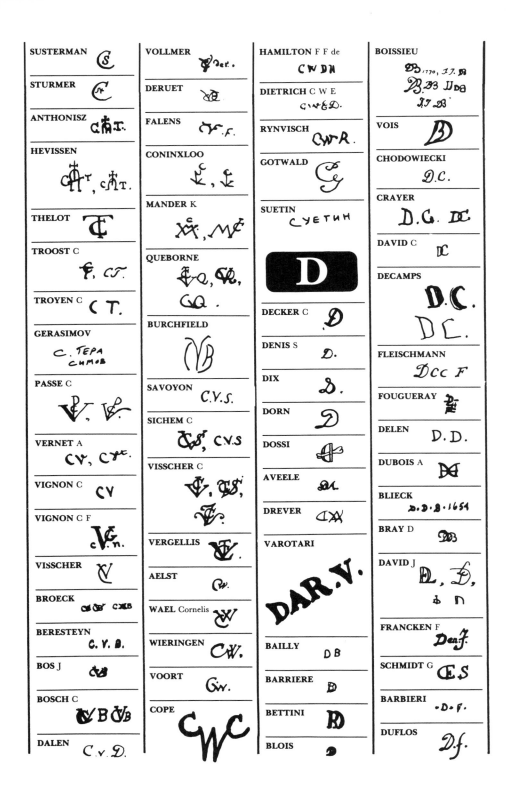

SUSTERMAN

STURMER

ANTHONISZ

HEVISSEN

THELOT

TROOST C

TROYEN C

GERASIMOV

PASSE C

VERNET A

VIGNON C

VIGNON C F

VISSCHER

BROECK

BERESTEYN

BOS J

BOSCH C

DALEN

VOLLMER

DERUET

FALENS

CONINXLOO

MANDER K

QUEBORNE

BURCHFIELD

SAVOYON

SICHEM C

VISSCHER C

VERGELLIS

AELST

WAEL Cornelis

WIERINGEN

VOORT

COPE

HAMILTON F F de

DIETRICH C W E

RYNVISCH

GOTWALD

SUETIN

D

DECKER C

DENIS S

DIX

DORN

DOSSI

AVEELE

DREVER

VAROTARI

BAILLY

BARRIERE

BETTINI

BLOIS

BOISSIEU

VOIS

CHODOWIECKI

CRAYER

DAVID C

DECAMPS

FLEISCHMANN

FOUGUERAY

DELEN

DUBOIS A

BLIECK

BRAY D

DAVID J

FRANCKEN F

SCHMIDT G

BARBIERI

DUFLOS

214

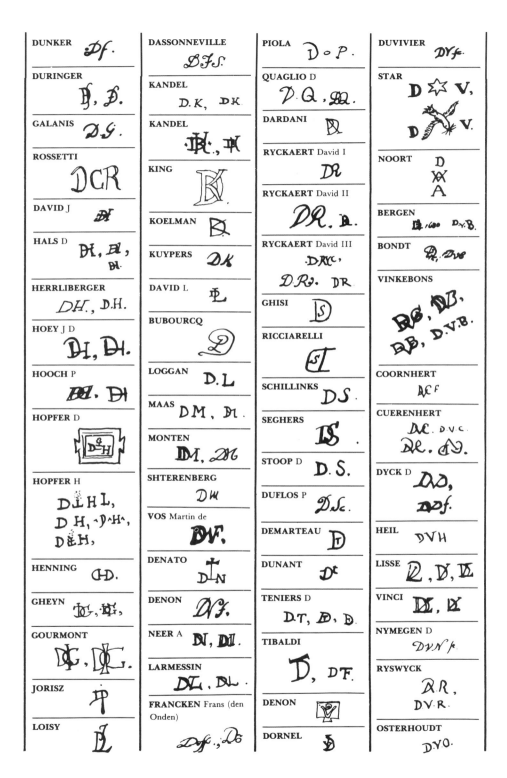


- DUNKER
- DURINGER
- GALANIS
- ROSSETTI
- DAVID J
- HALS D
- HERRLIBERGER
- HOEY J D
- HOOCH P
- HOPFER D
- HOPFER H
- HENNING
- GHEYN
- GOURMONT
- JORISZ
- LOISY


- DASSONNEVILLE
- KANDEL
- KANDEL
- KING
- KOELMAN
- KUYPERS
- DAVID L
- BUBOURCQ
- LOGGAN
- MAAS
- MONTEN
- SHTERENBERG
- VOS Martin de
- DENATO
- DENON
- NEER A
- LARMESSIN
- FRANCKEN Frans (den Onden)


- PIOLA
- QUAGLIO D
- DARDANI
- RYCKAERT David I
- RYCKAERT David II
- RYCKAERT David III
- GHISI
- RICCIARELLI
- SCHILLINKS
- SEGHERS
- STOOP D
- DUFLOS P
- DEMARTEAU
- DUNANT
- TENIERS D
- TIBALDI
- DENON
- DORNEL


- DUVIVIER
- STAR
- NOORT
- BERGEN
- BONDT
- VINKEBONS
- COORNHERT
- CUERENHERT
- DYCK D
- HEIL
- LISSE
- VINCI
- NYMEGEN D
- RYSWYCK
- OSTERHOUDT

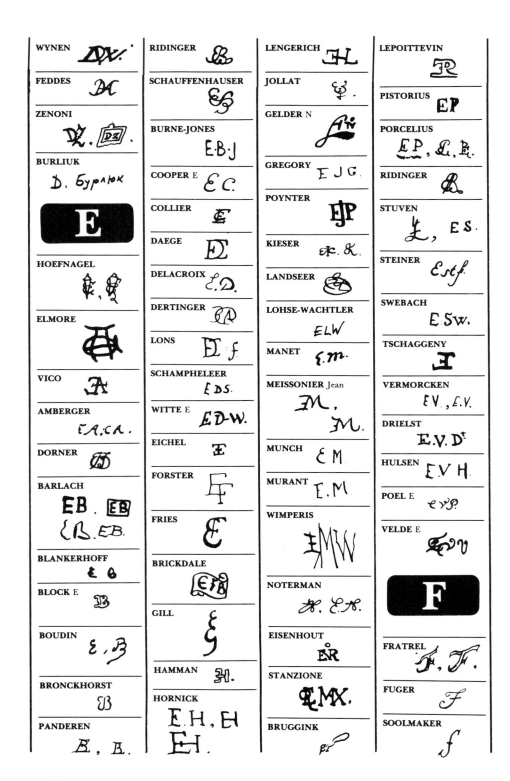


WYNEN
FEDDES
ZENONI
BURLIUK
E
HOEFNAGEL
ELMORE
VICO
AMBERGER
DORNER
BARLACH
BLANKERHOFF
BLOCK E
BOUDIN
BRONCKHORST
PANDEREN


RIDINGER
SCHAUFFENHAUSER
BURNE-JONES
COOPER E
COLLIER
DAEGE
DELACROIX
DERTINGER
LONS
SCHAMPHELEER
WITTE E
EICHEL
FORSTER
FRIES
BRICKDALE
GILL
HAMMAN
HORNICK


LENGERICH
JOLLAT
GELDER N
GREGORY
POYNTER
KIESER
LANDSEER
LOHSE-WACHTLER
MANET
MEISSONIER Jean
MUNCH
MURANT
WIMPERIS
NOTERMAN
EISENHOUT
STANZIONE
BRUGGINK

LEPOITTEVIN
PISTORIUS
PORCELIUS
RIDINGER
STUVEN
STEINER
SWEBACH
TSCHAGGENY
VERMORCKEN
DRIELST
HULSEN
POEL E
VELDE E
F
FRATREL
FUGER
SOOLMAKER

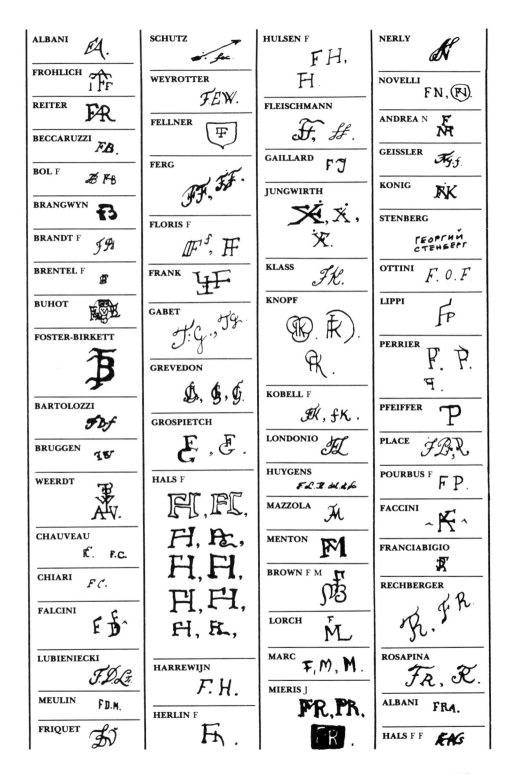

ALBANI	SCHUTZ	HULSEN F	NERLY
FROHLICH	WEYROTTER	FLEISCHMANN	NOVELLI
REITER	FELLNER		ANDREA N
BECCARUZZI	FERG	GAILLARD	GEISSLER
BOL F		JUNGWIRTH	KONIG
BRANGWYN	FLORIS F		STENBERG
BRANDT F	FRANK	KLASS	OTTINI
BRENTEL F	GABET	KNOPF	LIPPI
BUHOT			PERRIER
FOSTER-BIRKETT	GREVEDON	KOBELL F	PFEIFFER
BARTOLOZZI	GROSPIETCH	LONDONIO	PLACE
BRUGGEN	HALS F	HUYGENS	POURBUS F
WEERDT		MAZZOLA	FACCINI
CHAUVEAU		MENTON	FRANCIABIGIO
CHIARI		BROWN F M	RECHBERGER
FALCINI		LORCH	
LUBIENIECKI		MARC	ROSAPINA
MEULIN	HARREWIJN	MIERIS J	ALBANI
FRIQUET	HERLIN F		HALS F F

ГЕОРГИЙ СТЕНБЕРГ

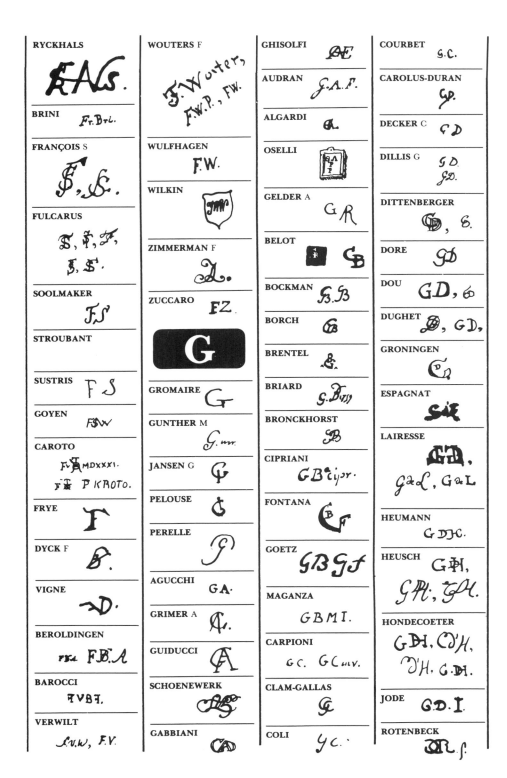

RYCKHALS

BRINI — Fr. Bri.

FRANÇOIS S

FULCARUS

SOOLMAKER

STROUBANT

SUSTRIS

GOYEN

CAROTO — MDXXXI. • P KROTO.

FRYE

DYCK F

VIGNE

BEROLDINGEN — F.B.A

BAROCCI

VERWILT — I.V.W, F.V.

WOUTERS F — F.W.P., FW.

WULFHAGEN — F.W.

WILKIN

ZIMMERMAN F

ZUCCARO — FZ.

G

GROMAIRE

GUNTHER M

JANSEN G

PELOUSE

PERELLE

AGUCCHI — GA.

GRIMER A

GUIDUCCI

SCHOENEWERK

GABBIANI

GHISOLFI

AUDRAN — G.A.F.

ALGARDI

OSELLI

GELDER A — GR

BELOT

BOCKMAN — G.B

BORCH

BRENTEL

BRIARD

BRONCKHORST

CIPRIANI — GB Cipr.

FONTANA

GOETZ

MAGANZA — GBMI.

CARPIONI — GC. GC inv.

CLAM-GALLAS

COLI — yc.

COURBET — G.C.

CAROLUS-DURAN

DECKER C — GD

DILLIS G — GD. GD.

DITTENBERGER — G.

DORE — GD

DOU — GD, 60

DUGHET — GD,

GRONINGEN

ESPAGNAT

LAIRESSE — GaL, GaL

HEUMANN — G DHC.

HEUSCH — GH, GH, GH.

HONDECOETER — GH, GH, GH, GH.

JODE — GD.I.

ROTENBECK

EDELINCK G. 24. X.	**GREUTER** GG, FGF, FG	**GOEIMARE** G, G	**GRIMER** CM
FRENZEL F, F	**GRUNEWALD M**	**GRUNER**	**MOSTAERT** GM
GEISSLER	**GRUNEWALD H**	**GOLE** G.F, Gr, G.E, GF	**MUNTHE** G.MNE, GM. CM. GM.
GENTI	**HARDORFF**	**GIETLEUGHEN** G	**MITELLI** GM, CM.
GONTIER	**HERREYNS**	**JOLLAT** G.F, G.Jollat	**GHISI G** GMF
WATTS	**HONDIUS** GH, GH	**KLAPHAUER** GKF	**LIST** GL
GRIMALDI G F G / C.F.W.	**HONTHORST** GH, GH, GH	**KELLER G**	**GALLE** GB, G, PG,
GANDOLFI	**HULSWIT** GH.	**KOPP** CK	**GRIGORIEV** Борисъ Григорьевъ
GELDER CGF.	**HUQUIER** FH F	**KARG** G.K.P.	**GAREIS** G.G.
GELDORP CG	**HENRIQUEZ DE CASTRO** G.H.JC.	**PROGER** GP, GP	**PALMA** G.P, GP
GEORGET G.G	**GERKE** GY	**GAUCHEREL** GL, GL	**PENCZ** GP, G, D, G, G,
GIOLITO FERRARI DE	**GHEYN**	**GERRIT** G	**PERRIER** GP
MANNOZZI	**GUCKEISEN** $, $	**HELMONT**	**RADEMAKER** G.R
GEYSER G.G.P	**GIMIGNANI**	**LALLEMOND**	**REICHMANN** R, G.
		LEEUW G.e.	
		LUNDENS	
		GOSSAERT G.	

RENI

GR, GR, R, GRIH, GR, GR.

RICARD

GR, GR, R, GR.

RINGLI

GR, G

ROSSETTI

RUGGIERI

R, GR.

BLANKERHOFF

GₗB

SCHALCKEN

GS, GS.

SCHWEIGGER

S, G.

SPILBERG

G.S., GS.

SWANNENBURGH

G, G.

SCHMIDT

VANNI G GV.

VINCENT G

VENENTI GDF, GD

KUGELGEN GVK.

KUIL GK

NYMEGAN gvr.

SCHMIDT G GVS.

VALKENBORCH G VV.

WITTEL GV.W.

WOUTERS G G W.

WOEIRIOT GVB

GLINK

GANZ Gze

H

FRANCKEN H

HERDER

HONDIUS H

HUYSUM H.

SADELER

GONCHAROVA

H.

TOULOUSE-LAUTREC-MONFA

ABBE H.F. TA TA.

ADAM H HA.

ADAM H HA

ALLARD

AMMAN J A

ASPER

AVERCAMP HA, W

HANS N HA

HOPFGARTEN

ECKERT HAE

HIRSCHVOGEL HAF, AF

STILKE

NAUMOVSKI В. НАУМОВСКИ

BARY HBA HB

BERCKMAN HBI

BLOEMAERT H HB Je.1651. 1633

BOGAERT HB 1631

BLOMAERTS HB

BOCK H HB 1537. HB.

BOCKSBERGER J HB, HB.

BORGIANI HB,

BROSAMER HB

BRUYN B HB 1550

BRY HB

BURGKMAIR HB 1508 HB HB

DYCK F HB.

HENNEBERGER G HB.

HENNEBERGER G Jr HB

SINEZUBOV H. Синезубов

HOGENBERG N HH, HH.

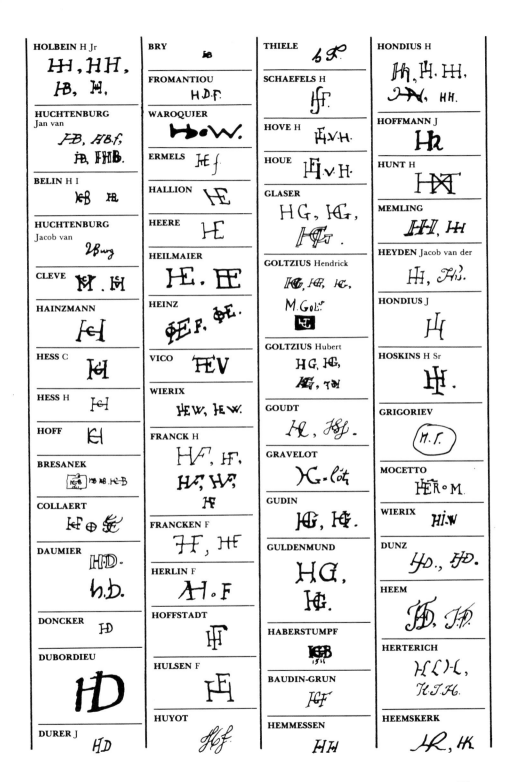

HOLBEIN H Jr

HUCHTENBURG Jan van

BELIN H I

HUCHTENBURG Jacob van

CLEVE

HAINZMANN

HESS C

HESS H

HOFF

BRESANEK

COLLAERT

DAUMIER

DONCKER

DUBORDIEU

DURER J

BRY

FROMANTIOU

WAROQUIER

ERMELS

HALLION

HEERE

HEILMAIER

HEINZ

VICO

WIERIX

FRANCK H

FRANCKEN F

HERLIN F

HOFFSTADT

HULSEN F

HUYOT

THIELE

SCHAEFELS H

HOVE H

HOUE

GLASER

GOLTZIUS Hendrick

GOLTZIUS Hubert

GOUDT

GRAVELOT

GUDIN

GULDENMUND

HABERSTUMPF

BAUDIN-GRUN

HEMMESSEN

HONDIUS H

HOFFMANN J

HUNT H

MEMLING

HEYDEN Jacob van der

HONDIUS J

HOSKINS H Sr

GRIGORIEV

MOCETTO

WIERIX

DUNZ

HEEM

HERTERICH

HEEMSKERK

KELLERTHALER

KOENE

KUPREIANOV
H.K.

DUBBELS

HERLIN

LAUTENSACK Hans

LAUTENSACK Heinrich

LEYS

LIEFERINCK
H.HL.

LODEL

SAFTLEVEN

LEROY

MARR

MAUPERCHE

MULICH

KASHINA

HONE

PADER

PADTBRUGGE

PAULY

PECHSTEIN
H.P.

POT
HPoT, HP.

POTHOVEN
Hf,

DALEM

LEMBKE

RAMBERG

RAVESTEYN
H.v.R. HR.
HR

RIEDEL

ROHRICH

ROTTENHAMMER
HR.

MANUEL H
HR.

RIGAUD H
H. Rig.

VOLKMANN
HR.v.V.

SCHAUFFELIN H Jr

SCHOEL

SCHOPFER

SIMBERG

STAMPFER

HISBENS
HSB

BEHAM H

SCHRORER

SCOREL

SPRINGINKLEE

SPECKARD
·H·S·P.

SCHUPPEN

MEMLING

TROSCHEL

HAELBECK

ULRICH
HV, HV, HV.

VERNET

VOGTHER

BRY

HAGEDORN

VERSCHURING
H.V.g. HS

LUYCK
HVL, ML. HVL.
HL.

BORCHT

STEENWYK
HVS.

SWANEVELT

WATERSCHOODT
H.V.W.

HENSEL

HOWITT

HOWARD

WEINER
HW, W.

VOORHOUT J

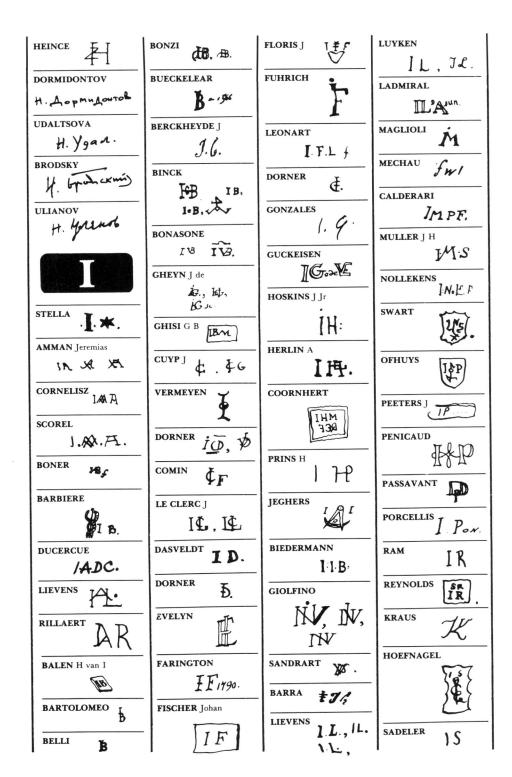

HEINCE	BONZI	FLORIS J	LUYKEN
DORMIDONTOV	BUECKELEAR	FUHRICH	LADMIRAL
UDALTSOVA	BERCKHEYDE J	LEONART	MAGLIOLI
BRODSKY	BINCK	DORNER	MECHAU
ULIANOV	BONASONE	GONZALES	CALDERARI
I	GHEYN J de	GUCKEISEN	MULLER J H
STELLA	GHISI G B	HOSKINS J Jr	NOLLEKENS
AMMAN Jeremias	CUYP J	HERLIN A	SWART
CORNELISZ	VERMEYEN	COORNHERT	OFHUYS
SCOREL	DORNER	PRINS H	PEETERS J
BONER	COMIN		PENICAUD
BARBIERE	LE CLERC J	JEGHERS	PASSAVANT
DUCERCUE	DASVELDT	BIEDERMANN	PORCELLIS
LIEVENS	DORNER	GIOLFINO	RAM
RILLAERT	EVELYN		REYNOLDS
	FARINGTON	SANDRART	KRAUS
BALEN H van I		BARRA	HOEFNAGEL
BARTOLOMEO	FISCHER Johan	LIEVENS	
BELLI			SADELER

223

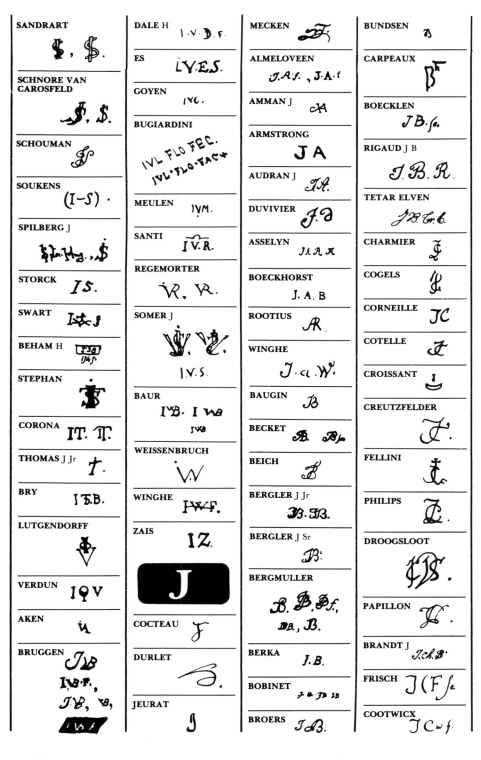

SANDRART	DALE H	MECKEN	BUNDSEN
SCHNORE VAN CAROSFELD	ES	ALMELOVEEN	CARPEAUX
SCHOUMAN	GOYEN	AMMAN J	BOECKLEN
SOUKENS	BUGIARDINI	ARMSTRONG	RIGAUD J B
SPILBERG J	MEULEN	AUDRAN J	TETAR ELVEN
STORCK	SANTI	DUVIVIER	CHARMIER
SWART	REGEMORTER	ASSELYN	COGELS
BEHAM H	SOMER J	BOECKHORST	CORNEILLE
STEPHAN		ROOTIUS	COTELLE
CORONA	BAUR	WINGHE	CROISSANT
THOMAS J Jr	WEISSENBRUCH	BAUGIN	CREUTZFELDER
BRY	WINGHE	BECKET	FELLINI
LUTGENDORFF	ZAIS	BEICH	PHILIPS
VERDUN	J	BERGLER J Jr	DROOGSLOOT
AKEN	COCTEAU	BERGLER J Sr	PAPILLON
BRUGGEN	DURLET	BERGMULLER	BRANDT J
	JEURAT	BERKA	FRISCH
		BOBINET	COOTWICX
		BROERS	

WANS	**FERGUSON**	**VLIET** W	**WERNER**
DASSONNEVILLE	**FLEISCHBERGER**	**WINTER**	**WAGNER** J
WIT Jakob de	**FRANS** H	**HAUER**	**MORTIMER**
BEYER	**MILLET**	**HARTMAN**	**RAMBERG**
FREY J	**BRONCKHORST**	**FEHLING-WITTING**	**RODE** J
WAAL	**GALLE** J	**HARZEN**	**ROOS**
WEERT	**GHERING**	**HAZARD**	**THOMA**
EECKELE	**GLAUBER**	**HERZ**	**HERP**
EPISCOPIUS	**GRIFFIER** John	**HOGENBERG**	**HEYDEN** Jacob
JOSI	**GRIFFIER** Jan	**HOLBEIN** H	**HUMBACH**
JULIENNE	**GROOT**	**HOLZER**	**JACQUEMART**
COCTEAU	**GUNTHER**	**HOPPENHAUT**	**AVRIL**
QUELLINUS	**HERTEL**	**HULSMANN**	**BOISSIER**
NYPOORT	**VLIET** J	**HUMBACH**	**EECKHOUT**
EPISCOPIUS	**GLAUBNER**	**MULLER** J H	**SANDRART**
FALBE	**MANSFELD**	**LIPCHITZ**	**KERVER**
FALK	**HAMILTON** W	**BREYER**	**KOBELL**
FELON		**BURGH** H	**KAUKE**
		HUBER J	**LABORDE**

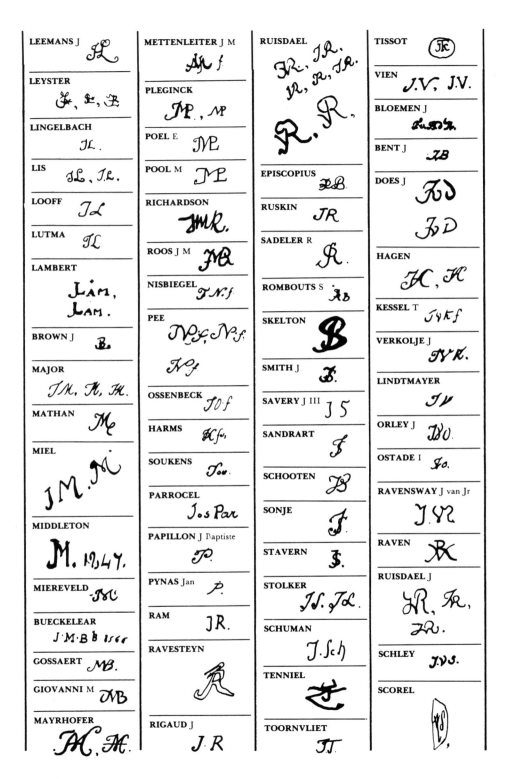

LEEMANS J	METTENLEITER J M	RUISDAEL	TISSOT
LEYSTER	PLEGINCK		VIEN J.V., J.V.
LINGELBACH	POEL E		BLOEMEN J
LIS	POOL M	EPISCOPIUS	BENT J
LOOFF	RICHARDSON	RUSKIN JR	DOES J
LUTMA	ROOS J M	SADELER R	
LAMBERT	NISBIEGEL	ROMBOUTS S	HAGEN
BROWN J	PEE	SKELTON	KESSEL T
MAJOR		SMITH J	VERKOLJE J
MATHAN	OSSENBECK	SAVERY J III J 5	LINDTMAYER
MIEL	HARMS	SANDRART	ORLEY J
	SOUKENS	SCHOOTEN	OSTADE I
	PARROCEL Jos Par	SONJE	RAVENSWAY J van Jr
MIDDLETON	PAPILLON J Baptiste	STAVERN	RAVEN
MIEREVELD	PYNAS Jan	STOLKER	RUISDAEL J
BUECKELEAR	RAM JR	SCHUMAN	
GOSSAERT	RAVESTEYN	TENNIEL	SCHLEY J.VS.
GIOVANNI M		TOORNVLIET JJ	SCOREL
MAYRHOFER	RIGAUD J J·R		

226

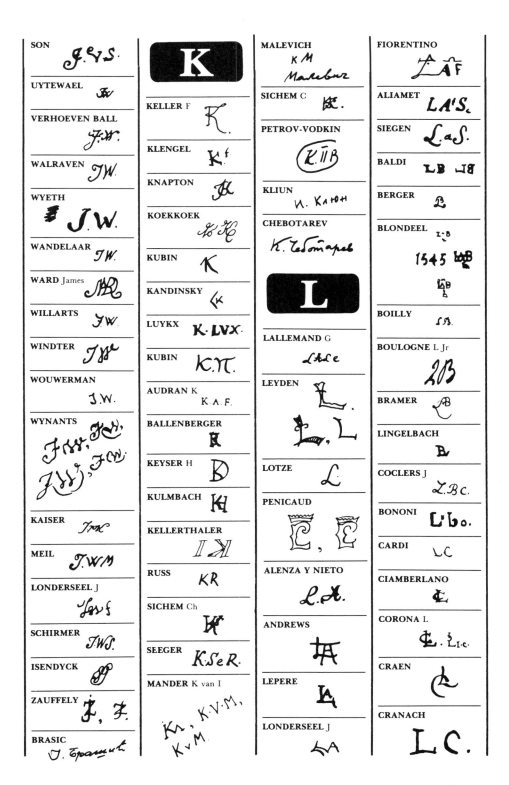

SON

UYTEWAEL

VERHOEVEN BALL

WALRAVEN

WYETH

WANDELAAR

WARD James

WILLARTS

WINDTER

WOUWERMAN

WYNANTS

KAISER

MEIL

LONDERSEEL J

SCHIRMER

ISENDYCK

ZAUFFELY

BRASIC

K

KELLER F

KLENGEL

KNAPTON

KOEKKOEK

KUBIN

KANDINSKY

LUYKX

KUBIN

AUDRAN K

BALLENBERGER

KEYSER H

KULMBACH

KELLERTHALER

RUSS

SICHEM Ch

SEEGER

MANDER K van I

MALEVICH

SICHEM C

PETROV-VODKIN

KLIUN

CHEBOTAREV

L

LALLEMAND G

LEYDEN

LOTZE

PENICAUD

ALENZA Y NIETO

ANDREWS

LEPERE

LONDERSEEL J

FIORENTINO

ALIAMET

SIEGEN

BALDI

BERGER

BLONDEEL

BOILLY

BOULOGNE L Jr

BRAMER

LINGELBACH

COCLERS J

BONONI

CARDI

CIAMBERLANO

CORONA L

CRAEN

CRANACH

227

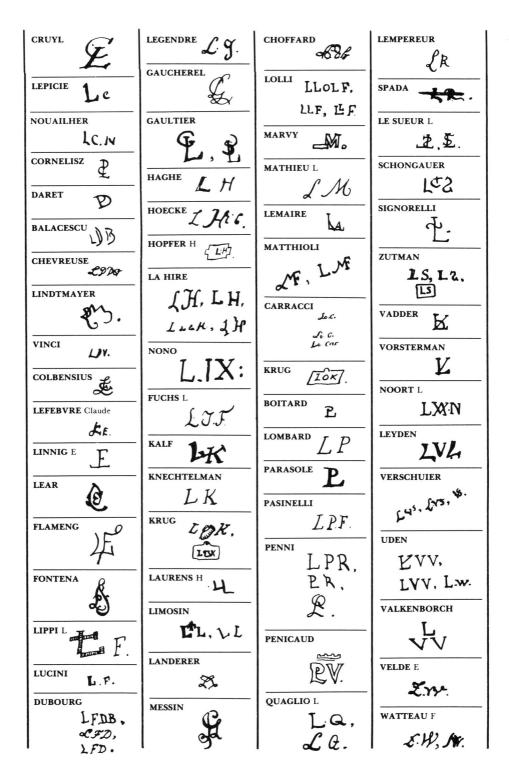

CRUYL	LEGENDRE	CHOFFARD	LEMPEREUR	
LEPICIE	GAUCHEREL	LOLLI	SPADA	
NOUAILHER	GAULTIER	MARVY	LE SUEUR L	
CORNELISZ	HAGHE	MATHIEU L	SCHONGAUER	
DARET	HOECKE	LEMAIRE	SIGNORELLI	
BALACESCU	HOPFER H	MATTHIOLI	ZUTMAN	
CHEVREUSE	LA HIRE	CARRACCI	VADDER	
LINDTMAYER	NONO	KRUG	VORSTERMAN	
VINCI	FUCHS L	BOITARD	NOORT L	
COLBENSIUS	KALF	LOMBARD	LEYDEN	
LEFEBVRE Claude	KNECHTELMAN	PARASOLE	VERSCHUIER	
LINNIG E	LEAR	KRUG	PASINELLI	UDEN
FLAMENG	LAURENS H	PENNI	VALKENBORCH	
FONTENA	LIMOSIN		VELDE E	
LIPPI L	LANDERER	PENICAUD	WATTEAU F	
LUCINI	MESSIN	QUAGLIO L		
DUBOURG				

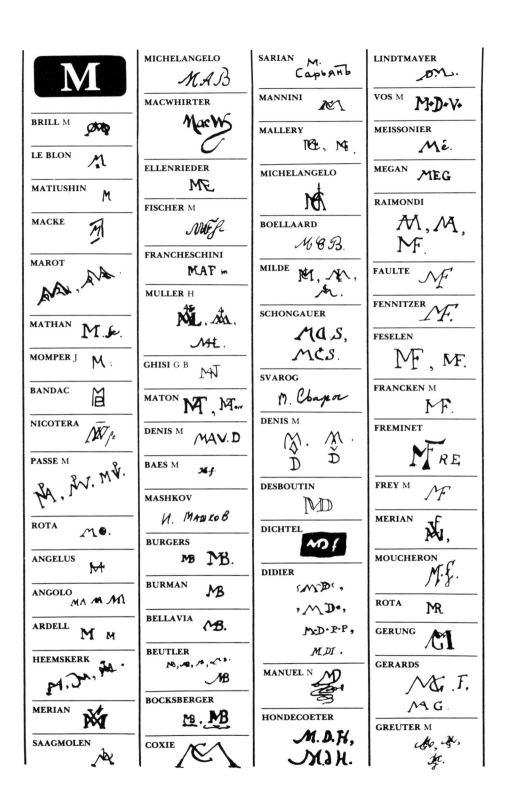

M

BRILL M	
LE BLON	
MATIUSHIN	
MACKE	
MAROT	
MATHAN	
MOMPER J	
BANDAC	
NICOTERA	
PASSE M	
ROTA	
ANGELUS	
ANGOLO	
ARDELL	
HEEMSKERK	
MERIAN	
SAAGMOLEN	

MICHELANGELO	
MACWHIRTER	
ELLENRIEDER	
FISCHER M	
FRANCHESCHINI	
MULLER H	
GHISI G B	
MATON	
DENIS M	
BAES M	
MASHKOV	
BURGERS	
BURMAN	
BELLAVIA	
BEUTLER	
BOCKSBERGER	
COXIE	

SARIAN	
MANNINI	
MALLERY	
MICHELANGELO	
BOELLAARD	
MILDE	
SCHONGAUER	
SVAROG	
DENIS M	
DESBOUTIN	
DICHTEL	
DIDIER	
MANUEL N	
HONDECOETER	

LINDTMAYER	
VOS M	
MEISSONIER	
MEGAN	
RAIMONDI	
FAULTE	
FENNITZER	
FESELEN	
FRANCKEN M	
FREMINET	
FREY M	
MERIAN	
MOUCHERON	
ROTA	
GERUNG	
GERARDS	
GREUTER M	

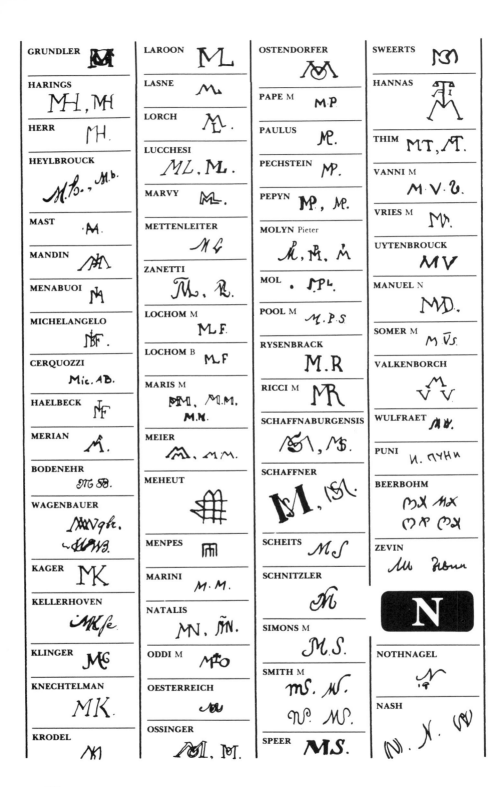

GRUNDLER

HARINGS

HERR

HEYLBROUCK

MAST

MANDIN

MENABUOI

MICHELANGELO

CERQUOZZI

HAELBECK

MERIAN

BODENEHR

WAGENBAUER

KAGER

KELLERHOVEN

KLINGER

KNECHTELMAN

KRODEL

LAROON

LASNE

LORCH

LUCCHESI

MARVY

METTENLEITER

ZANETTI

LOCHOM M

LOCHOM B

MARIS M

MEIER

MEHEUT

MENPES

MARINI

NATALIS

ODDI M

OESTERREICH

OSSINGER

OSTENDORFER

PAPE M

PAULUS

PECHSTEIN

PEPYN

MOLYN Pieter

MOL

POOL M

RYSENBRACK

RICCI M

SCHAFFNABURGENSIS

SCHAFFNER

SCHEITS

SCHNITZLER

SIMONS M

SMITH M

SPEER

SWEERTS

HANNAS

THIM

VANNI M

VRIES M

UYTENBROUCK

MANUEL N

SOMER M

VALKENBORCH

WULFRAET

PUNI

BEERBOHM

ZEVIN

N

NOTHNAGEL

NASH

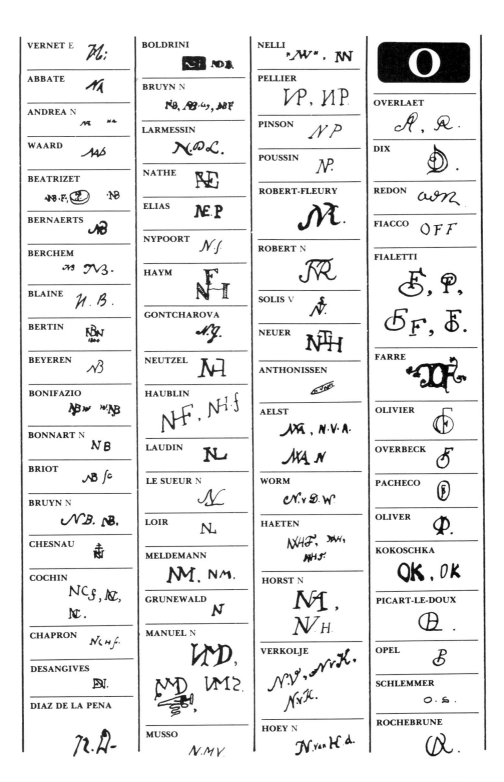

VERNET E

ABBATE

ANDREA N

WAARD

BEATRIZET

BERNAERTS

BERCHEM

BLAINE

BERTIN

BEYEREN

BONIFAZIO

BONNART N

BRIOT

BRUYN N

CHESNAU

COCHIN

CHAPRON

DESANGIVES

DIAZ DE LA PENA

BOLDRINI

BRUYN N

LARMESSIN

NATHE

ELIAS

NYPOORT

HAYM

GONTCHAROVA

NEUTZEL

HAUBLIN

LAUDIN

LE SUEUR N

LOIR

MELDEMANN

GRUNEWALD

MANUEL N

MUSSO

NELLI

PELLIER

PINSON

POUSSIN

ROBERT-FLEURY

ROBERT N

SOLIS V

NEUER

ANTHONISSEN

AELST

WORM

HAETEN

HORST N

VERKOLJE

HOEY N

O

OVERLAET

DIX

REDON

FIACCO

FIALETTI

FARRE

OLIVIER

OVERBECK

PACHECO

OLIVER

KOKOSCHKA

PICART-LE-DOUX

OPEL

SCHLEMMER

ROCHEBRUNE

231

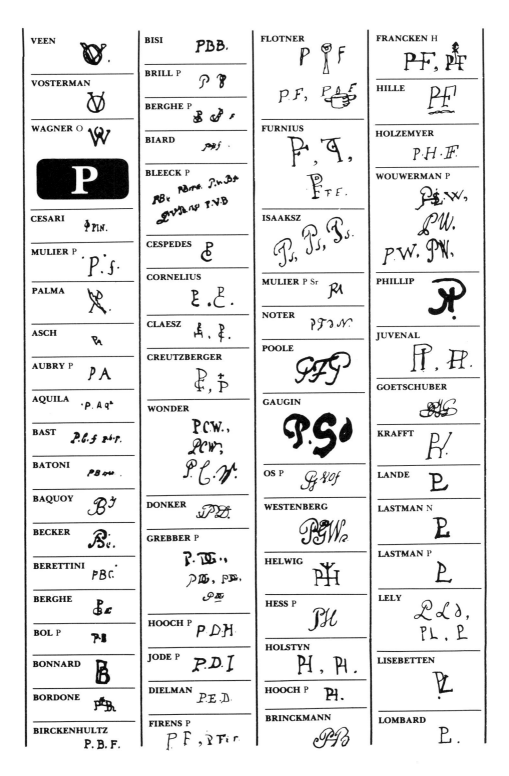

VEEN	BISI	FLOTNER	FRANCKEN H
VOSTERMAN	BRILL P	FURNIUS	HILLE
WAGNER O	BERGHE P		HOLZEMYER
P	BIARD		
	BLEECK P	ISAAKSZ	WOUWERMAN P
CESARI	CESPEDES	MULIER P Sr	
MULIER P	CORNELIUS	NOTER	PHILLIP
PALMA	CLAESZ	POOLE	
ASCH	CREUTZBERGER		JUVENAL
AUBRY P	WONDER	GAUGIN	GOETSCHUBER
AQUILA			KRAFFT
BAST		OS P	LANDE
BATONI	DONKER	WESTENBERG	LASTMAN N
BAQUOY	GREBBER P		LASTMAN P
BECKER		HELWIG	
BERETTINI		HESS P	LELY
BERGHE		HOLSTYN	
BOL P	HOOCH P		LISEBETTEN
BONNARD	JODE P	HOOCH P	
BORDONE	DIELMAN	BRINCKMANN	LOMBARD
BIRCKENHULTZ	FIRENS P		

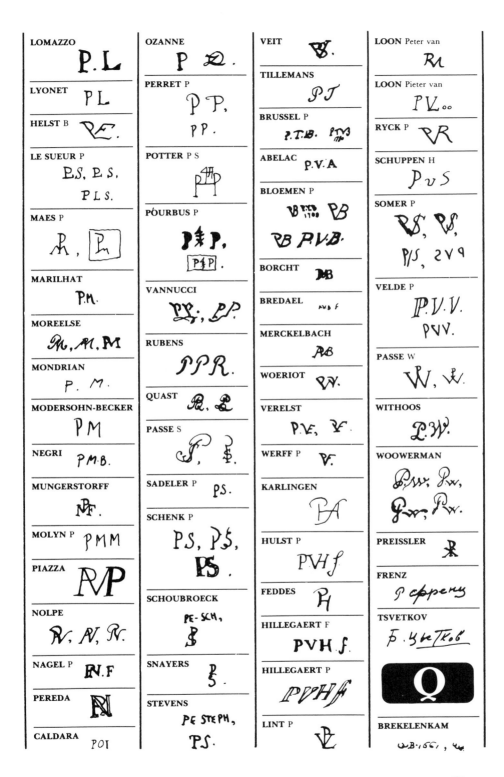

LOMAZZO

LYONET

HELST B

LE SUEUR P

MAES P

MARILHAT

MOREELSE

MONDRIAN

MODERSOHN-BECKER

NEGRI

MUNGERSTORFF

MOLYN P

PIAZZA

NOLPE

NAGEL P

PEREDA

CALDARA

OZANNE

PERRET P

POTTER P S

POURBUS P

VANNUCCI

RUBENS

QUAST

PASSE S

SADELER P

SCHENK P

SCHOUBROECK

SNAYERS

STEVENS

VEIT

TILLEMANS

BRUSSEL P

ABELAC

BLOEMEN P

BORCHT

BREDAEL

MERCKELBACH

WOERIOT

VERELST

WERFF P

KARLINGEN

HULST P

FEDDES

HILLEGAERT F

HILLEGAERT P

LINT P

LOON Peter van

LOON Pieter van

RYCK P

SCHUPPEN H

SOMER P

VELDE P

PASSE W

WITHOOS

WOOWERMAN

PREISSLER

FRENZ

TSVETKOV

Q

BREKELENKAM

QUESNEL F

QUIRIN

CHEDDEL

BREKELENKAM

R

KRAUS

MAZZOLA

RAHL C H

RAVESTEYN

REID G

REIGNIER F

RICHARDSON J Sr

RIETSCHOOF

PATTISON

RIJN

ROBINSON

TOULOUSE-LAUTREC-MONFA

SANTI

SCHIAMINOSSI

VANNI R

RAVESTEYN H

BONHEUR

BORCHT P

RIDINGER

BAADEN

CANTAGALLINA

EARLOM

GARDELLE

HALS R

BORGIANI

DUGUAY

HATHAWAY

SCHAUFFELIN H L

WICKENDEN

LOCHON

MEYER R

RICCI M

ROTTERMOND

MANUEL H

PICOU

ROGHMAN

RING

SCHOLTZ

OEFELE

TROYEN R

MANETTI

ROMBOUTS G

SANTI

AUDENAERD

SCHIAMINOSSI

ORLEY R

SCHMID

WESTALL

WILSON R

WIMMER

WENDELSTADT

S

SPECKTER

SPITZWEG

STALBEMT

SAINT-AUBIN G

SAINT-AUBIN A

SALMINCO

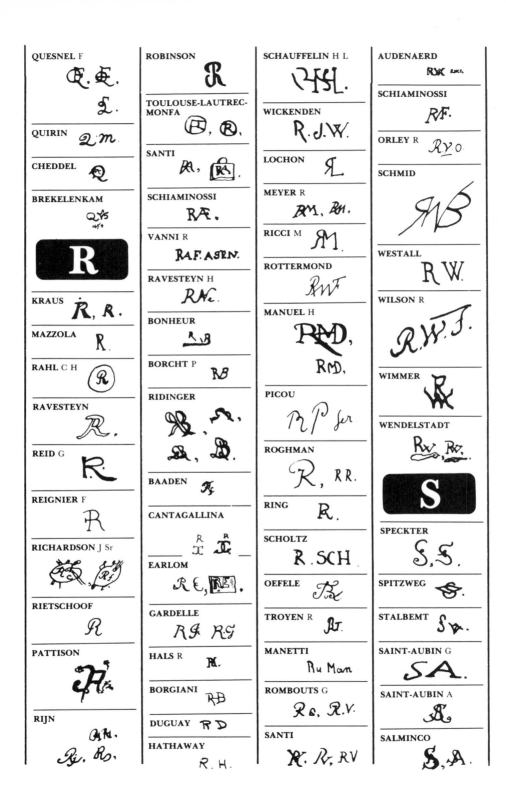

STORCK A — *S A.*

LAMSWEERDE — *S.A.L., Sad., SAL., Sad.*

SALAMANCA — *S. A.*

BACH A — *SB*

BASSANO J — *SB*

BOTTICELLI S — *SB.*

BOURDON S — *SB.*

SCHORN — *SC.*

SCHUTZ Carl — *SC*

SELLIER — *S*

SICHEM C — *S, S,*

SCHIK — *Scht.*

NOUAILHER — *SD, SD*

BELLA — *SB, SB,*

DUPERAC — *SDl*

VOS S — *SV.*

SCHOEN — *S.E., SE.*

SANDYS — *(monogram)*

SANTAFEDE — *SF*

SANUNTO — *S · F*

SOOLMAKER — *SF, SF.*

STEIN — *Sf.*

GIONOMO — *S G*

GUILLAIN — *SG. vo., SGS.*

GESSNER — *S.G.f.*

HOOGSTRATEN S — *SH, SH.*

SOMM — *SH. · S*

STURMER J — *SH, H.*

WOHLGEMUTH — *SB, SB.*

HOLBEIN S — *SB.*

SAENREDAM — *S, S.*

SADELER Jan — *S*

SADELER Justus — *SI*

SAVERY Jacob — *S.*

SAVERY Jan — *S*

SANT — *SP.*

SMITH G — *S*

STELLA — *S*

SWART — *S*

WINGHE — *JW, JV, J·V.*

SLABBAERT — *S.*

STRAUCH L — *S, S.*

LE CLERC S — *S l e C f*

SPRUYT — *S, S.P.*

DENTE — *R.*

ROSA — *R. R. R. R.*

RUISDAEL S — *R, SR, SR.*

SOLOMAN — *S*

SPENCER S — *S.S. SS.*

STIMMER — *SI*

SAINT-ANDRE — *St A.*

STRAUCH — *(monogram)*

VACCARO — *SV, V.*

VOUET — *SV, V, V.*

VRANCX — *GV.*

HOOGSTRATEN S — *SvH*

VLIEGER — *S.VL.J.*

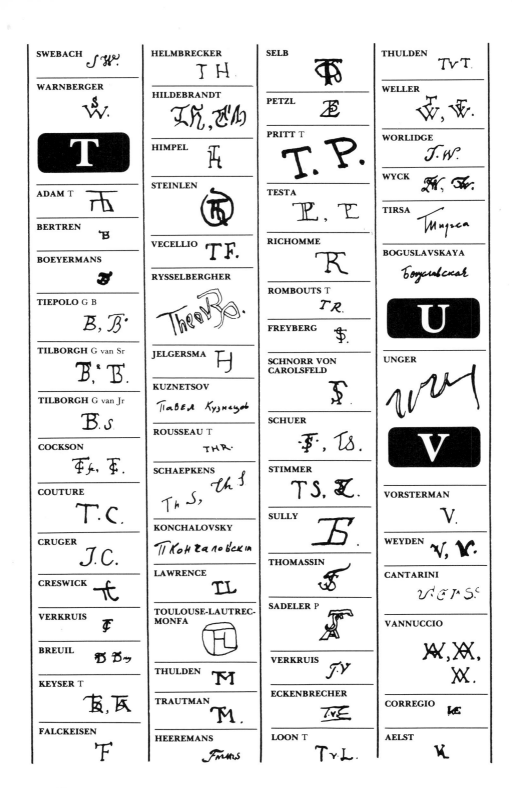

SWEBACH

WARNBERGER

T

ADAM T

BERTREN

BOEYERMANS

TIEPOLO G B

TILBORGH G van Sr

TILBORGH G van Jr

COCKSON

COUTURE

CRUGER

CRESWICK

VERKRUIS

BREUIL

KEYSER T

FALCKEISEN

HELMBRECKER

HILDEBRANDT

HIMPEL

STEINLEN

VECELLIO

RYSSELBERGHER

JELGERSMA

KUZNETSOV

ROUSSEAU T

SCHAEPKENS

KONCHALOVSKY

LAWRENCE

TOULOUSE-LAUTREC-MONFA

THULDEN

TRAUTMAN

HEEREMANS

SELB

PETZL

PRITT T

TESTA

RICHOMME

ROMBOUTS T

FREYBERG

SCHNORR VON CAROLSFELD

SCHUER

STIMMER

SULLY

THOMASSIN

SADELER P

VERKRUIS

ECKENBRECHER

LOON T

THULDEN

WELLER

WORLIDGE

WYCK

TIRSA

BOGUSLAVSKAYA

U

UNGER

V

VORSTERMAN

WEYDEN

CANTARINI

VANNUCCIO

CORREGIO

AELST

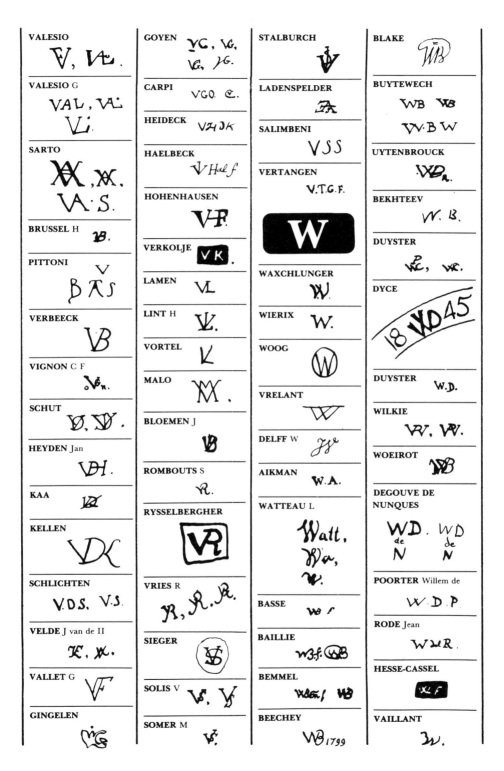

Column 1

VALESIO

VALESIO G

SARTO

BRUSSEL H

PITTONI

VERBEECK

VIGNON C F

SCHUT

HEYDEN Jan

KAA

KELLEN

SCHLICHTEN

VELDE J van de II

VALLET G

GINGELEN

Column 2

GOYEN

CARPI

HEIDECK

HAELBECK

HOHENHAUSEN

VERKOLJE

LAMEN

LINT H

VORTEL

MALO

BLOEMEN J

ROMBOUTS S

RYSSELBERGHER

VRIES R

SIEGER

SOLIS V

SOMER M

Column 3

STALBURCH

LADENSPELDER

SALIMBENI

VERTANGEN

W

WAXCHLUNGER

WIERIX

WOOG

VRELANT

DELFF W

AIKMAN

WATTEAU L

BASSE

BAILLIE

BEMMEL

BEECHEY

Column 4

BLAKE

BUYTEWECH

UYTENBROUCK

BEKHTEEV

DUYSTER

DYCE

DUYSTER

WILKIE

WOEIROT

DEGOUVE DE NUNQUES

POORTER Willem de

RODE Jean

HESSE-CASSEL

VAILLANT

VALKENBORCH	**LEEUW** Willem van der	**SCHELLINKS** Willem	**CHAUVEAU**
WALKER Frederic	**LODGE**	**SWANNENBURGH**	**Y**
HAUSSOULLIER	**MARLOWE**	**GAMBARO**	**CARAGLIO**
HENSEL	**MORRIS**	**VAILLANT** Wallerand	**FOORT**
HOEVENAAR			**Z**
HOGARTH	**NERENZ**	**VALCKAERT**	**ANDREA** Zoan
	WAEL Lucas	**WENDELSTADT**	**ZEITBLOOM**
HOLLAR	**POMPE** Walter		**GHISI** Giorgio
NIVINSKI	**RALSTON**	**LEEUW** Willem van der	**DOLENDO**
HUBERT	**RIKKERS**	**OTTLEY**	
	ROGERS	**VELDE**	**ZUBERLEIN**
TURNER Joseph	**ROMEYN**		**ZIEGLER** Henny Bryan
JONGMAN	**SAY**	**X**	**ZACCHIA**
TROOSTWYK		**AUMULLER**	**ZETTER**
KNYFFE	**SCHADOW**	**ELANDTS**	**WEHME**